# MANGA
## FOR THE BEGINNER
# chibis

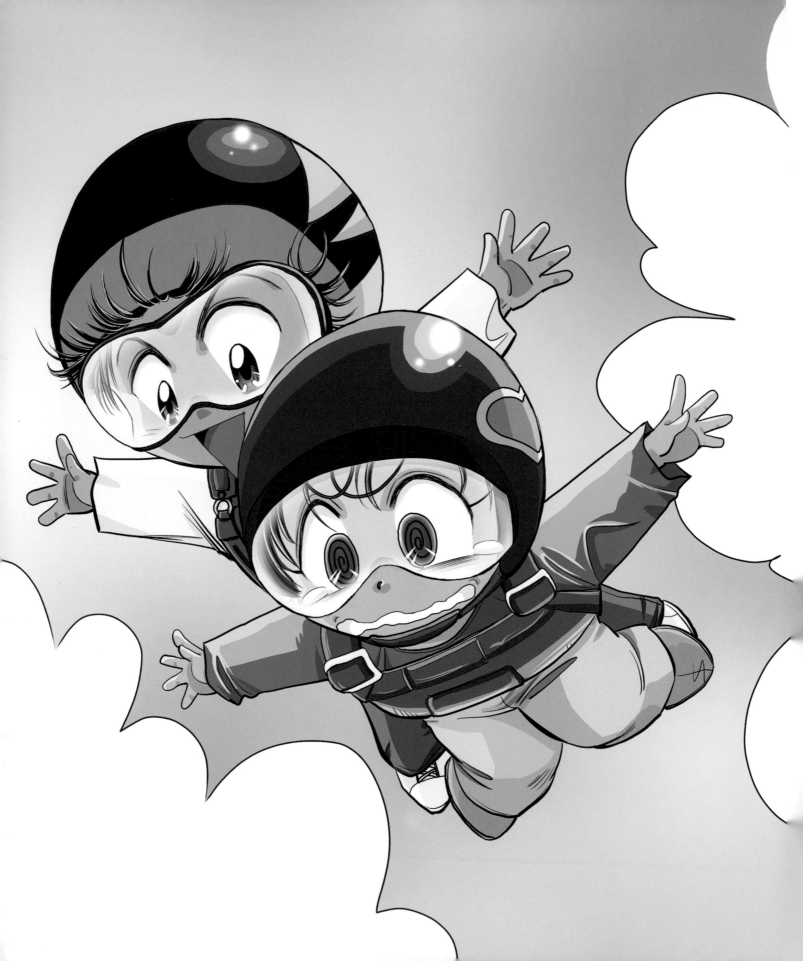

# MANGA
## FOR THE BEGINNER
# chibis

**Everything You Need to Start Drawing the Super-Cute Characters of Japanese Comics**

## CHRISTOPHER HART

Watson-Guptill Publications / New York

**Contributing artists:**

Denise Akemi

Romulo Fajardo

Christopher Hart

Morgan Long

Ecky Oesjadi

Yuu Sanau

Diana Devora

Aurora Garcia

Agnes Lim

Chihiro Milley

Adetyar Rakhman

Nao Yazawa

Design / Rosanne Kang / woolypear

Published in the United States by Watson-Guptill Publications

an imprint of the Crown Publishing Group

a division of Random House, Inc., New York

www.crownpublishing.com

www.watsonguptill.com

WATSON-GUPTILL is a registered trademark and the WG and Horse designs
are trademarks of Random House, Inc.

**Library of Congress Cataloging-in-Publication Data**

Hart, Christopher.

Manga for the beginner chibis : everything you need to start drawing the
super-cute characters of Japanese comics / Christopher Hart.

p. cm.

Includes index.

ISBN 978-0-8230-1488-0 (pbk.)

1. Comic books, strips, etc.—Japan—Technique. 2. Cartooning—Technique.
3. Comic strip characters—Japan. I. Title. II. Title: Everything you need to start
drawing the super-cute characters of Japanese comics.

NC1764.5.J3H369287 2010

741.5'1—dc22

2009029134

Printed in China

SPECIAL THANKS TO

Lauren Shakely, Candace Raney,
Victoria Craven, Alisa Palazzo,
Brian Phair, Autumn Kindlespire,
and, of course, you, the reader!

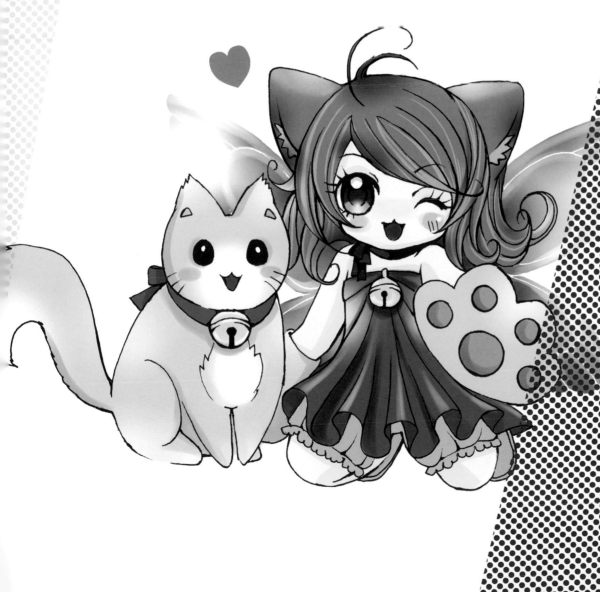

# Contents

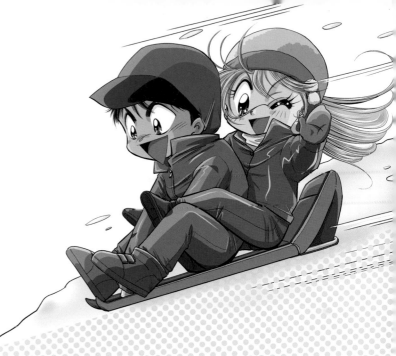

# Introduction

CHIBIS (PRONOUNCED CHEE-BEES) are the cutest and funniest characters in all of manga. Manga is made up of many genres, but only chibis—those miniature characters with huge personalities—appear in every one of them.

Originally, normal characters turned into a chibi only when they would have a sudden, giant outburst of emotions. When characters became overwhelmed, they would suddenly "go chibi," instantly transforming down to outrageously cute, mini-proportions—all the while ranting and raving and letting off steam. It's a hilarious sight, used for comic relief in comedies as well as in dramas.

Chibi characters soon became so popular that they were given their very own genre. Graphic novels devoted solely to chibis began to spring up. Toys and licensed gear were being "chibified" all over the manga universe. Anime conventions were morphing into chibi conventions! Everyone was going chibi crazy!

But the thing that makes chibis special for manga artists like you and me is that they are not only fun to draw but easy, too! So if you're a beginner, you can pick no better place to start drawing manga characters than with chibis. In this book, you'll learn how to draw all types of chibis, from mischievous school kids to magical girls, adorable fairies, action characters, and more. You'll learn the basics of proportions, action poses, body language, and expressions. Plus, you'll also get the secrets for drawing costumes as well as color suggestions.

Chibis also have popular monster pals, and you won't want to miss these. Little magical monster friends are favorites among chibi fans. They will make your heart melt. They're so fluffy and cute, you just want to squeeze them! These buddies are inseparable from their human chibi counterparts. And guess what? We have a whole section devoted to showing you how to draw them with their chibis.

In addition, we even have delightful chibi-size animals, which you'll now be able to draw with ease thanks to the special visual hints that accompany each one. And if you want to put your chibis in an environment with other chibis, in order to maximize the humor in a scene, we've got that, too, with the secrets of staging.

Everything you need to create a world of chibis is in these pages and at your disposal. You might start off as a beginner, but you won't stay a beginner for long, because with this book, you'll be on your way drawing cute and funny chibis in no time!

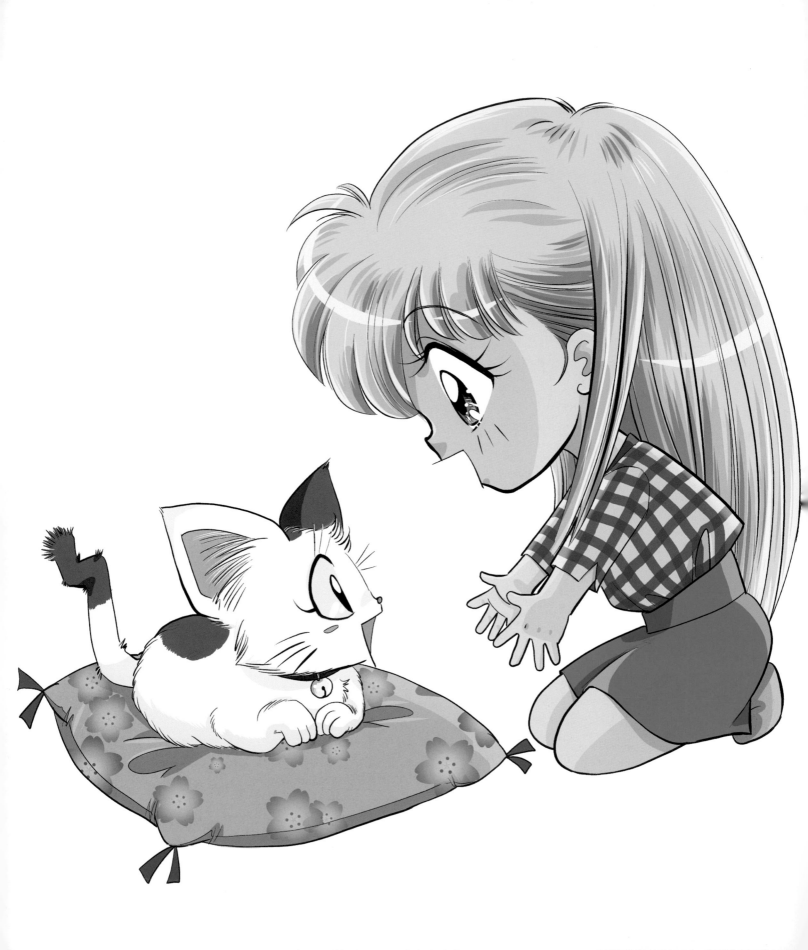

# Chibi Basics

**CHIBI PROPORTIONS ARE DIFFERENT** from those of the rest of the characters in the manga universe. Certain aspects have to be emphasized and exaggerated to make them ultra-cute. We're going to start off by focusing on the large head shape, the tiny body, and those giant eyes. Keep your chibi simple; don't overcomplicate the face. The fewer lines, the better!

# CHIBI PROPORTIONS

Chibis typically have giant heads on small, childlike bodies and round little hands and feet. So appealing are chibis that what began as only a special effect in manga graphic novels and anime has become a highly popular genre in its own right. The most popular proportion for drawing chibis is about three head lengths tall. That means that if you were to stack three chibi heads one on top of the next, it would equal the chibi character's total height.

However, three heads is by no means the only chibi proportion that manga artists follow. In fact, some manga artists specialize in the highly stylized, super-exaggerated chibis, which are just two heads tall and excruciatingly adorable! Other, even more exaggerated, chibis have heads that are twice as big as their bodies. These make wonderfully engaging mascots for graphic novels, anime, Web sites, and toys. You can draw your chibi any size you want; however, when you start to make them taller than three heads, they begin to look like normal-size people and leave the realm of chibis. So be sure to keep their heads large in proportion to their bodies.

AVERAGE CHIBI
(THREE HEADS TALL)

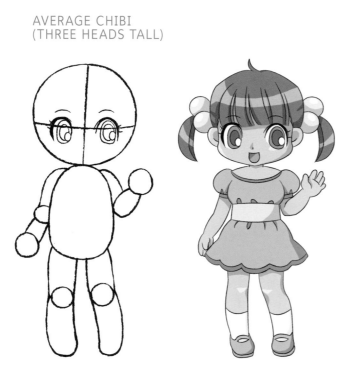

SUPER-EXAGGERATED
(TWO HEADS TALL)

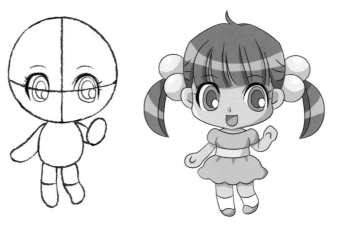

EXTREME CHIBI
(HEAD TWICE AS TALL AS BODY)

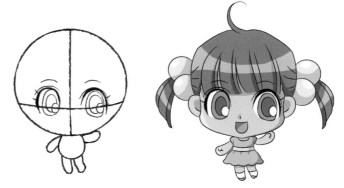

# EVERYONE CAN BE "CHIBIFIED"!

Ever been embarrassed? Afraid? Angry? Does your face get all scrunched up or red in extreme emotional states? Well, if you were a manga character, then this would result in a dominolike effect, producing a wild chibi transformation. An uncontrollable surge of emotions triggers manga characters to suddenly "turn chibi" and exhibit a broad, chibi expression for an instant, before snapping back to their normal selves just as quickly.

These transformations take place even in dramas to provide a bit of comic relief. But it's especially common to see them in shoujo and shounen (manga subgenres that we'll get to a little later on). Strike the word *subtlety* from your vocabulary when drawing ordinary-expressions-turned-chibi. In fact, the only way to really tell just how over the top to take these expressions is to compare them to regular manga expressions. Chibi expressions use lots of special effects to enhance their crazy look. We won't spare any of these goodies.

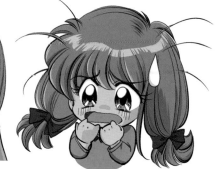

NORMAL MANGA
WORRIED
*Regular manga styles show a lot of whites of the eyes and a small, round mouth.*

CHIBI
WORRIED
*Her eyes go huge, her mouth goes wide, and her hair goes completely nuts! Put both sets of knuckles in the mouth.*

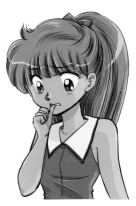

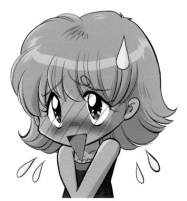

NORMAL MANGA
CONCERN
*Normal concern is a moderate expression.*

CHIBI
CONCERN
*As she goes completely chibi, her eyes grow insanely wide, and her mouth becomes nothing more than a squiggly noodle. Blush marks mimic tears. And her nose completely disappears.*

NORMAL MANGA
EMBARRASSED
*The head tilts slightly downward. A few blush lines go across the face.*

CHIBI
EMBARRASSED
*Lots of sweat flies off of this nervous little lady. The blush streaks extend across the entire length of the face. Her huge mouth dips below the outline of the face, for a funny expression.*

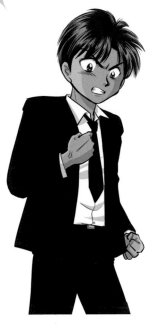

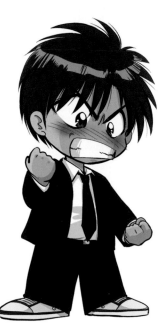

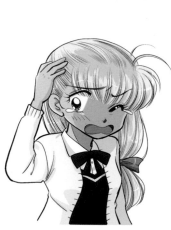

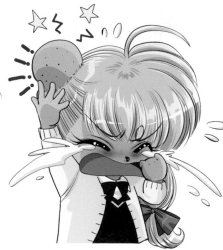

## NORMAL MANGA UPSET
*Slightly gritted teeth and cocked eyebrows do the trick.*

## CHIBI UPSET
*Everything is the same as the normal guy, only bigger. Bigger shaggy hair, bigger gritted teeth, bigger scowling eyes, bigger blush marks.*

## NORMAL MANGA PAIN
*One eye is open and one eye squints, because it really smarts! The mouth does a sideways figure eight. A couple of tears squirt out of the sides of her eyes.*

## CHIBI PAIN
*Whoa! Look at that chibi-style welt. And those tears have turned into real gushers! In fact, the entire face has squashed down into a mass of hysteria! The mouth is making such a whine that it breaks through the outline of the face itself, dipping below the chin.*

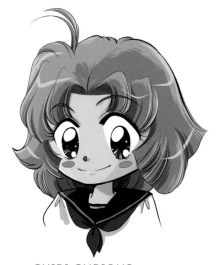

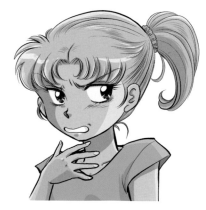

## NORMAL MANGA CURIOUS
*This character, both as a regular girl and as a chibi, wears the sailor-suit school uniforms commonly seen in manga high school adventure and romance stories. The combination of a sweet little smile, wide eyes, and slightly puzzled eyebrows results in a curious demeanor.*

## CHIBI CURIOUS
*Widen the face and smile, and enlarge the eyes. Blush dots can be placed under the eyes instead of eyelashes. Give her bigger hair, relative to her head.*

## NORMAL MANGA DISGUST
*A slight grimace, with teeth showing, lets us know that she is slightly repulsed.*

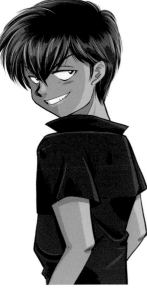

## NORMAL MANGA SNEAKY

*Sleepy eyes combine with a toothy grin to produce a sneaky smile. A shock of hair falls casually over the forehead, which also contributes to his sly expression.*

## CHIBI SNEAKY

*This sneaky expression has almost turned evil. The face has been squashed into a wide, cherubic sphere, with even bigger eyes and beady little pupils. The mouth has been lowered to the very bottom of the face, which gives him a conniving look. The hair is massive, taking up, fully, one-half of the entire head.*

## NORMAL MANGA HUNGRY

*Mmm! A smile while chomping down means a satisfied customer. The eyebrows angle slightly down, which reads as anticipation of the first bite.*

## CHIBI HUNGRY

*Munch, munch, munch! Burp! With the first bite, the slice almost goes halfway into his face! Cross the eyes to give him a crazy look. Note the drool bubbles splashing all about.*

## CHIBI DISGUST

*Stick out your tongue and say, "Yuck!" Green blush marks underscore the grossed-out expression. The hair gets a little squirrelly. The mouth gets so wide that it almost runs off the face.*

## NORMAL MANGA EXHAUSTED

*Here's the classic look of fatigue: one leg down, the other leg up. He rests his elbow on his knee. His mouth is opened slightly for him to suck some air. His head hangs low on the shoulders.*

## CHIBI EXHAUSTED

*This chibi can't pose his body in the same way as the teenage boy, because he's too short and chunky to do all that bending! (See page 38 for more on this limited-action topic.) So he'll have to settle for sitting with his legs straight ahead, knees locked, and both hands on the ground. Instead of taking just a few breaths, the chibi is in a full-out pant, with tongue out and sweat flying off him. Notice the errant strands of hair about his head.*

# THE CHIBI HEAD

Now that we've got the basic idea of the chibi down, let's get to the particulars. Chibis are among the easiest faces to draw in manga, because the features are so basic, which makes them a perfect starting place for beginners. The noses are all but dots, and the mouths are simple. But the eyes take a bit of work—and fill up most of the face. However, if you're willing to put in just a little bit of effort, you'll come up with adorable results!

The eyes, like all of the features, are always placed low on the face. That's because chibis are depicted as youthful mini-people, even in the instances where they are adult characters, and proportionally, eyes are always placed low on youngsters. Their faces are also round, without any hint of angularity, which makes their step-by-step constructions easy to follow. Let's try a few basic head angles.

## Chibi Girl Front View

The temptation is to start off with those great big eyes, but it works best to begin with the outline of the face and then work your way to the features. Sketch some guidelines to divide up the face evenly so that you can place the ears at the same height, and the eyes, too. When drawing a head shot, it's a good idea to add the neck and shoulders, so it doesn't look like a disembodied head just floating in space. That kinda creeps me out.

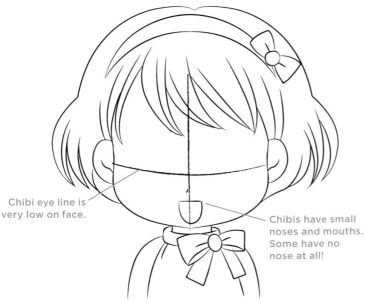

Chibi eye line is very low on face.

Chibis have small noses and mouths. Some have no nose at all!

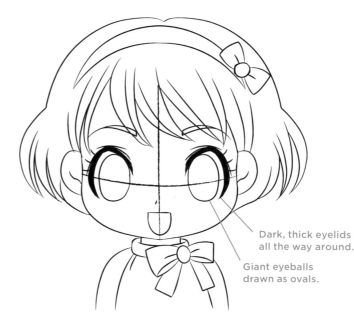

Dark, thick eyelids all the way around.

Giant eyeballs drawn as ovals.

## Quick Tip

If you want, you can trace over your original drawing onto tracing paper or other lightweight paper so that you're left with a clean copy without any guidelines or erasing marks. Professional manga artists draw on light boxes for just this purpose.

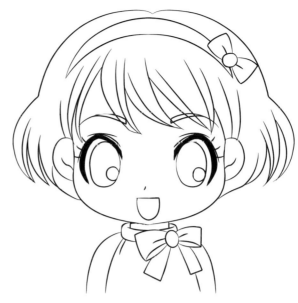

*Purple and yellow complement each other as a zippy color theme that pops off the page. Good for girls as well as guys.*
  *And, purple hair? Purple eyebrows? Fanciful colors go great with humorous characters.*

## Chibi Boy Front View

Boys' and girls' head shapes are the same—it's the eyes (no eyelashes here) and hairstyles that are different (plus, the boys' eyebrows are a bit thicker). Brown hair is fine but subdued; we want our character to really stand out, so we give him a green top!

Note the standard chibi hallmarks again: the huge eyes set low and wide on the head, the mouth set even lower, the hair flopping down over the forehead, and the hardly even noticeable neck.

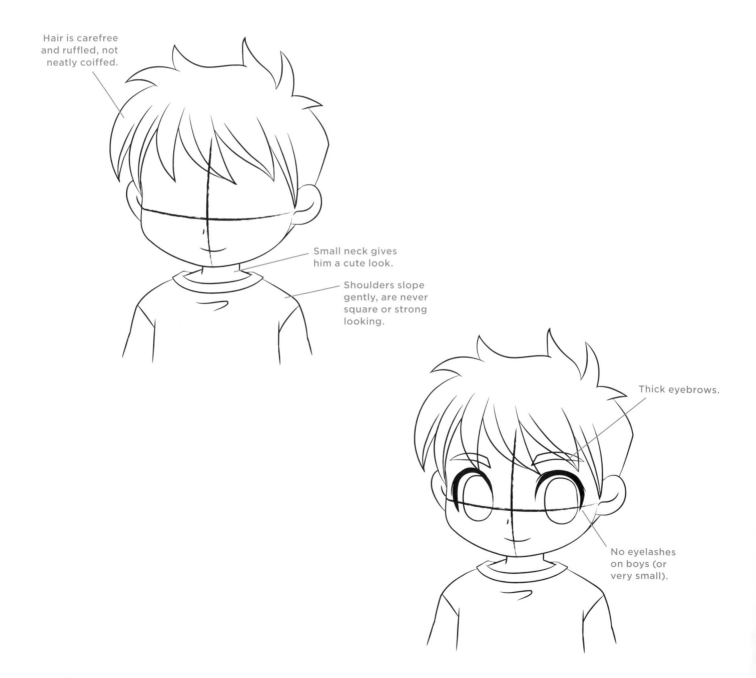

Hair is carefree and ruffled, not neatly coiffed.

Small neck gives him a cute look.

Shoulders slope gently, are never square or strong looking.

Thick eyebrows.

No eyelashes on boys (or very small).

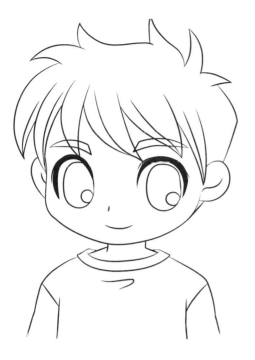

## EYE DETAILS

You'll notice that the pupils are a darker shade of the iris color, rather than being black, as pupils really are. This is a way of getting more color into the image, and it's a common practice among manga colorists. Always leave the eye shines white, though. (See page 22 for more on chibi eyes.)

*Greens and blues are good colors for casual, after-school outfits.*

## Profiles

In profile, or the side view, faces look quite young because of the deeply curved, sweeping line that makes up the forehead and bridge of the nose. Be sure to exaggerate this part. From the tip of the nose to the chin, the face travels steeply back along a diagonal, as indicated by the blue arrow below. It works the same way on boys as on girls. The nose is small and upturned.

### Quick Tip

In the side view, some artists prefer to draw the iris/pupil area slightly concave. It's an appealing look. Try it.

Draw hair on far side of part, wrapping around other side of head for a three-dimensional feeling.

Full underside of jaw.

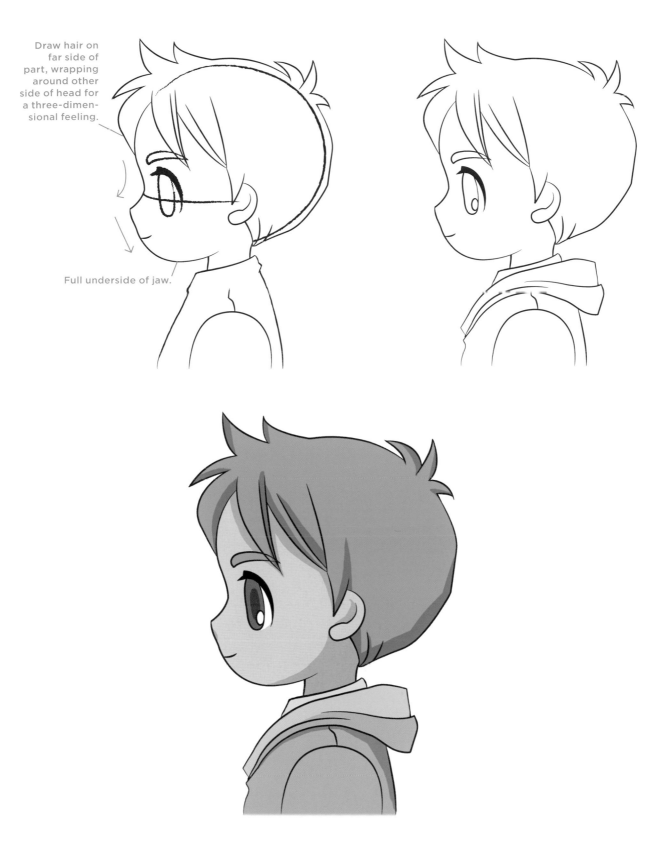

# CHIBI EYE EXPRESSIONS

Chibis have uneven emphasis among their facial features, with the eyes being most important and doing most of the work. The mouth will sometimes grow to ridiculous proportions for an instant, before settling back down again. But nevertheless, it's those eyes that usually are the main focus.

There are also certain eye expressions that have become conventions in manga. These are immediately recognized by *otaku* (manga fanatics) as specific emotional states. It's important to know how to draw them so that your reader will instantly know what your character is feeling. It's easy once you know the key. Why try to reinvent the wheel? Here's your source material. Some of these expressions are "stand-alones," and some are accompanied by special effects. Let's try them out.

## ASLEEP
*The eyelids curve downward, with prominent eyelashes (often on boys as well as girls). The eyebrows curve upward in a hopeful manner.*

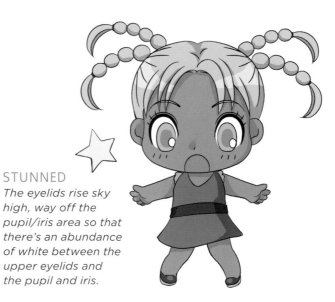

## HURT
*One eye opens wide, while the other squints tight with blush marks under it. Tear bubbles percolate out from the corners of the eyes.*

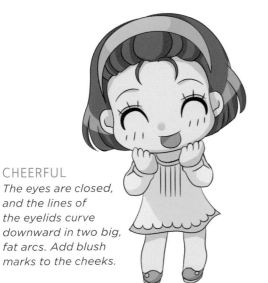

## CHEERFUL
*The eyes are closed, and the lines of the eyelids curve downward in two big, fat arcs. Add blush marks to the cheeks.*

## STUNNED
*The eyelids rise sky high, way off the pupil/iris area so that there's an abundance of white between the upper eyelids and the pupil and iris.*

## CONFUSED

*Big eyes with one eyebrow going up and the other going down. Blush marks are lopsided—under one eye only!*

## SLY

*The eyebrows tilt down. Heavy eyelids cut off the tops of the eyeballs. The character shoots a sideways glance out of the corner of his eyes.*

## BORED TO DEATH

*The eyelids lower onto the eyeballs. Won't be much longer till they close all the way. Come on! Numerators and denominators can't be that dull, can they?*

## SUPREME EFFORT!

*Dark, curling eyelids with fierce eyebrows push down toward the bridge of the nose. Heavy blush lines appear in diagonal strokes across his cheeks.*

# HAIR SHINES

It's the hair shine—that white area—that gives manga hair its look of luster. There are two main ways to indicate it. In the first style, the highlight is drawn as a wave. In the second approach, the accent looks more like a lightning bolt. Both are effective; however, the wave is softer and more feminine. The lightning bolt is more dramatic and gives the character an added jolt of energy.

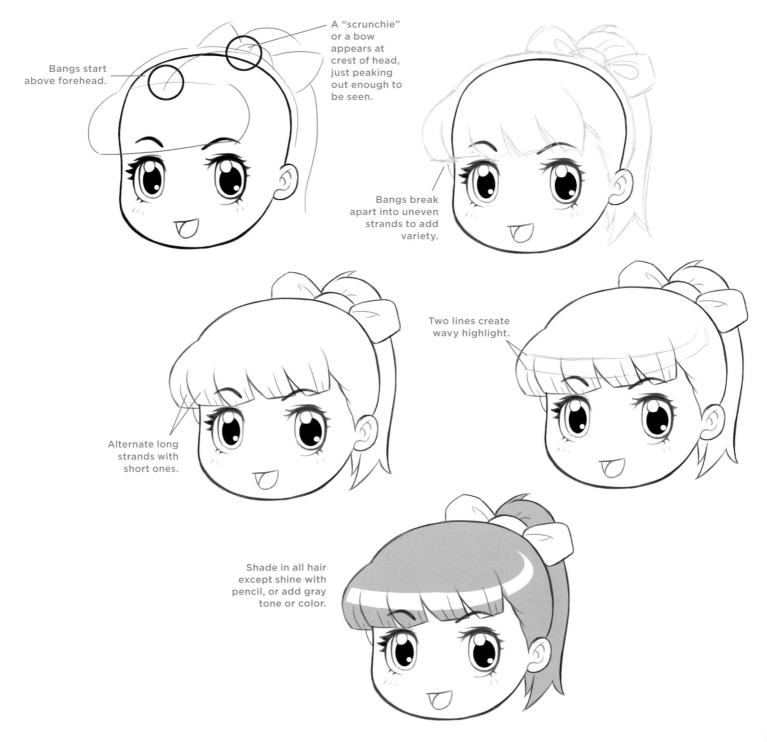

A "scrunchie" or a bow appears at crest of head, just peaking out enough to be seen.

Bangs start above forehead.

Bangs break apart into uneven strands to add variety.

Two lines create wavy highlight.

Alternate long strands with short ones.

Shade in all hair except shine with pencil, or add gray tone or color.

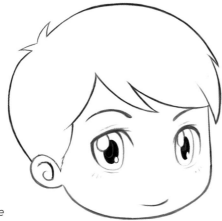

## LIGHT HAIR

*In a black-and-white picture, light hair frequently is given no shine at all, because to do so would require darkening everything around the shine, and the character wouldn't look blonde anymore.*

## BLACK HAIR

*Black hair on boys shows the zigzag shines the best. This one is a horizontal lightning bolt, momentarily interrupted by the part.*

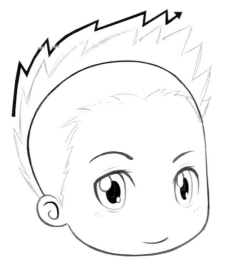

## SPIKED HAIR

*There are certain circumstances when no highlight should appear. Spiked hair looks so much like a lightning bolt anyway that adding a jagged highlight would be overkill. So no highlights are necessary.*

**WHEN'S THE LIGHTNING BOLT BEST?**

The lightning-bolt hair shine works well when the hairstyle is parted in the middle.

# THE CHIBI BODY

Now we'll practice drawing chibi bodies in the poses commonly seen in manga. We'll begin with the front, side, and 3/4 views. Since chibis are so round and short, drawing bodies has never been simpler to tackle! The torso of a chibi is one basic shape. Many chibis show no neck at all; instead, the head attaches directly to the shoulder area.

In addition, we've all noticed just how tall the chibi head is compared to the height of the body. But what's sometimes overlooked is just how wide the head is, too. It's much wider than the entire body—and that's what makes it so darn cute! The eyes are spaced far apart, making full use of the considerable width of the head. And just one note about the legs: Chibis never have long legs, always short and thick ones. Sometimes, the legs get widest at the bottom, toward the feet. That's a stylistic choice.

## Chibi Girl Front View

School adventures are at the center of some of the most popular graphic novels in manga. Far from being drab, the outfits are generally attractive and preppy. That's one of the reasons why high school stories look so appealing. Out of school, kids are dressed more casually but are still neatly attired like the boys on pages 29 and 33. In other genres, however, costumes can get pretty wild, like the gothic types and the magical girl varieties that we'll get to later on.

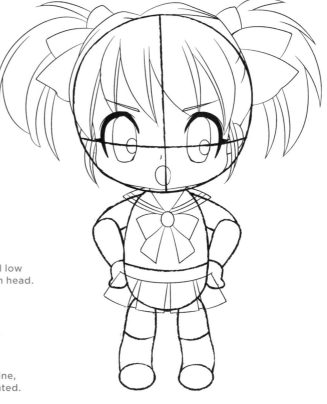

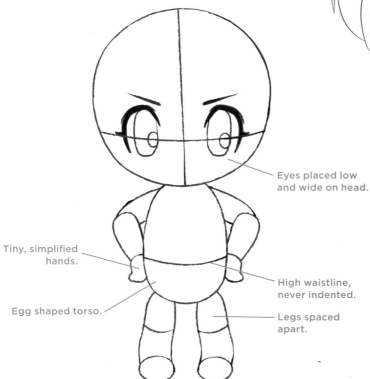

Eyes placed low and wide on head.

Tiny, simplified hands.

High waistline, never indented.

Egg shaped torso.

Legs spaced apart.

*This is a classic sailor-style uniform. Japanese schoolgirls wear many versions of it in public school. And it's often used as the basis for magical girl costumes.*

## WORKING METHODS

Some artists prefer to start at step 3. Others, despite conventional wisdom, always draw the features first and the body outline second. I don't recommend it. But hey, as long as they're trying to improve their drawings, who's to say they shouldn't follow their instincts? The "rules" in this book are just suggestions. But they *are* suggestions based on collected wisdom of how most professional artists have learned and honed their craft. Most of us draw the way this book teaches, starting from basic shapes and progressing to more advanced ones—from the general to the specific. It's a time-tested method. Still, all of us have our own idiosyncrasies. That's what makes us individuals. And you have to follow your own path. Whichever way you choose, the tips and hints in this book will help you develop and improve your manga skills. Choose what works for you.

## Chibi Boy Front View

This casual kid wears a knockabout outfit for playing with his buddies. The boy chibi body has the same basic construction as the girl character, but his shoulders are a bit more built up and so are his arms. Still, he's no bodybuilder! The main differences between him and the girl are his costume and hairstyle. So if you can draw a girl chibi, you can draw a boy, too!

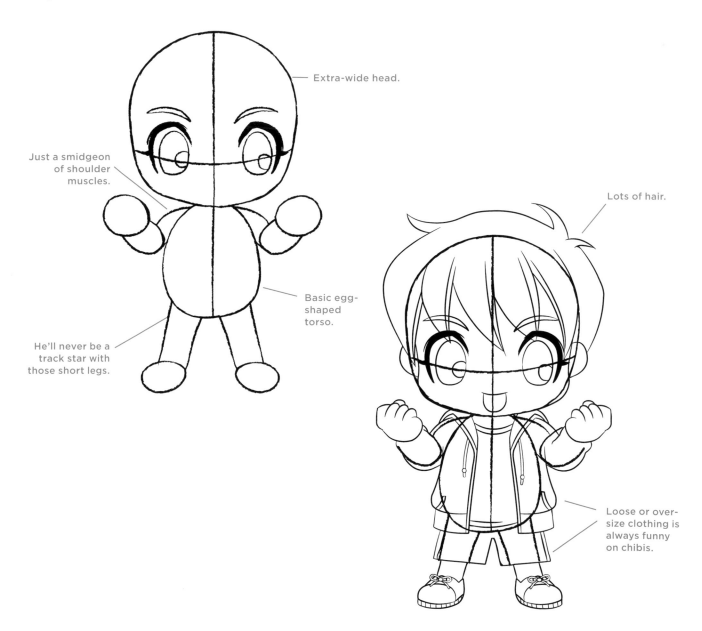

Extra-wide head.

Just a smidgeon of shoulder muscles.

Basic egg-shaped torso.

He'll never be a track star with those short legs.

Lots of hair.

Loose or over-size clothing is always funny on chibis.

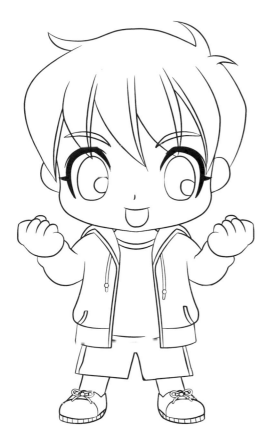

*Don't be afraid to give chibis lots of hair just because their heads are already big. The added size only makes them funnier and cuter.*

## CHIBI CLOTHES

You'll find that costumes look funnier on chibis than on most other manga characters. Chibi clothing is never formfitting and often looks too large, like hand-me-downs. Don't adjust your chibi to make the clothing fit better. One reason clothing looks big on chibis is because chibis have no noticeable waistlines; they have an egg-shaped torso—that's what keeps them chubby and cute looking.

# Side View

While you can hide the rear leg behind the front one in a side view of the body, I wouldn't recommend it. There's an animation term for two legs positioned together: It's called "twinning." It's when two limbs are positioned exactly the same way, parallel to each other, doing the same thing. With twinning, the character looks stiff and immobile, like a statue. The eye views it as redundant and boring. To avoid this, simply bend one of the knees so that we see two legs. By making one knee bent and keeping the other straight, you add variety to the pose. The exception to this is on chubby, cute characters, who tend to look appealing with two stiff legs side by side when standing.

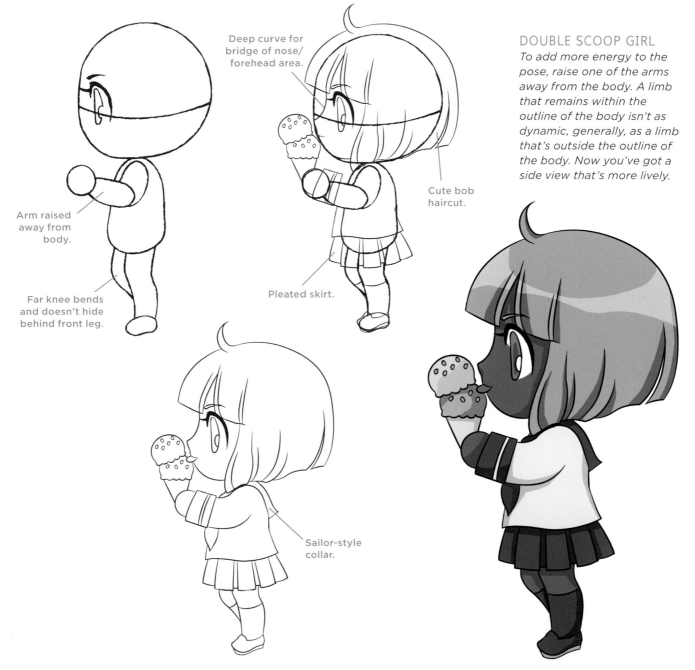

Deep curve for bridge of nose/forehead area.

Arm raised away from body.

Far knee bends and doesn't hide behind front leg.

Cute bob haircut.

Pleated skirt.

Sailor-style collar.

## DOUBLE SCOOP GIRL

*To add more energy to the pose, raise one of the arms away from the body. A limb that remains within the outline of the body isn't as dynamic, generally, as a limb that's outside the outline of the body. Now you've got a side view that's more lively.*

## BASEBALL BOY
*Once again, we've lifted up the arm, moving it outside of the body outline. Now this pose has some life to it.*

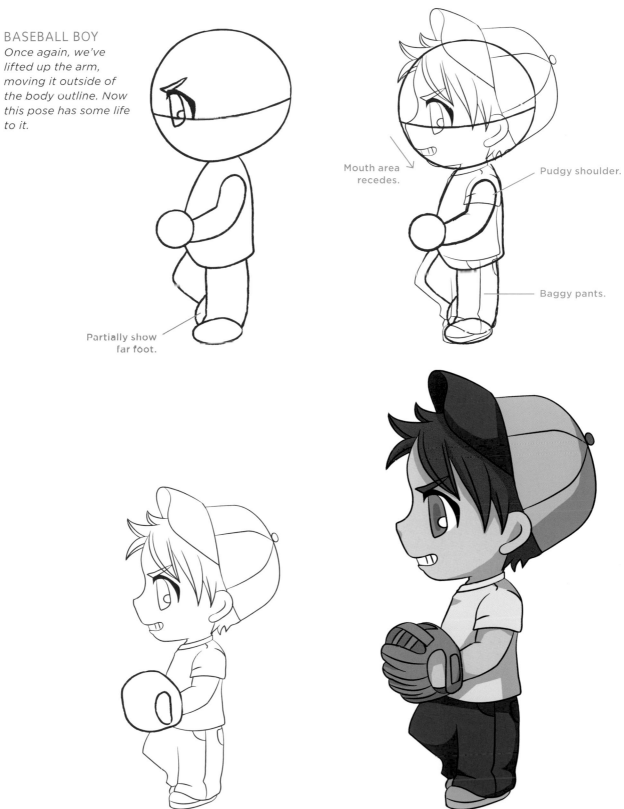

Partially show far foot.

Mouth area recedes.

Pudgy shoulder.

Baggy pants.

## 3/4 Views, Both Sides

The 3/4 view is the most frequently used pose. It's also a natural angle, one that's easy on the reader's eyes. It reveals more of the character than a side view and shows more depth than a front view. It takes a little getting used to for the artist, however, because a little bit of perspective is involved. But once you get the hang of it, you'll always be able to do it. So let's not shy away. As with all things chibi, it's more fun than it is challenging.

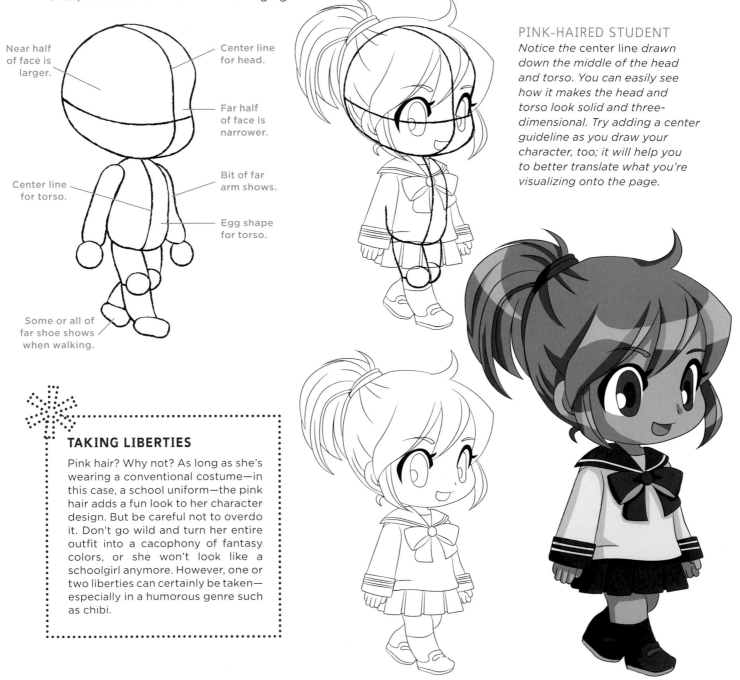

Near half of face is larger.

Center line for head.

Far half of face is narrower.

Center line for torso.

Bit of far arm shows.

Egg shape for torso.

Some or all of far shoe shows when walking.

PINK-HAIRED STUDENT
*Notice the center line drawn down the middle of the head and torso. You can easily see how it makes the head and torso look solid and three-dimensional. Try adding a center guideline as you draw your character, too; it will help you to better translate what you're visualizing onto the page.*

### TAKING LIBERTIES

Pink hair? Why not? As long as she's wearing a conventional costume—in this case, a school uniform—the pink hair adds a fun look to her character design. But be careful not to overdo it. Don't go wild and turn her entire outfit into a cacophony of fantasy colors, or she won't look like a schoolgirl anymore. However, one or two liberties can certainly be taken—especially in a humorous genre such as chibi.

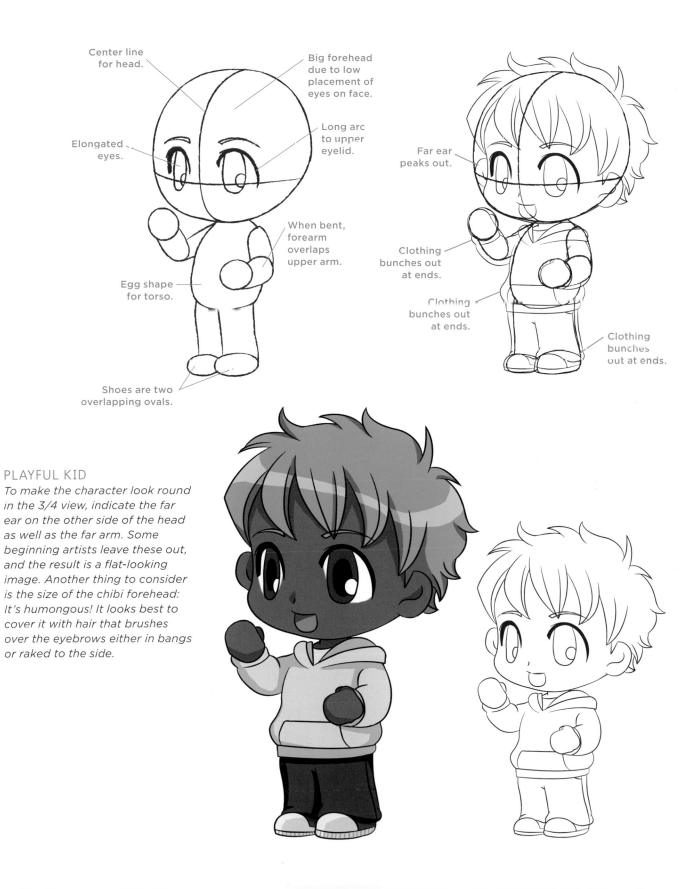

Center line for head.

Big forehead due to low placement of eyes on face.

Elongated eyes.

Long arc to upper eyelid.

When bent, forearm overlaps upper arm.

Egg shape for torso.

Shoes are two overlapping ovals.

Far ear peaks out.

Clothing bunches out at ends.

Clothing bunches out at ends.

Clothing bunches out at ends.

## PLAYFUL KID

*To make the character look round in the 3/4 view, indicate the far ear on the other side of the head as well as the far arm. Some beginning artists leave these out, and the result is a flat-looking image. Another thing to consider is the size of the chibi forehead: It's humongous! It looks best to cover it with hair that brushes over the eyebrows either in bangs or raked to the side.*

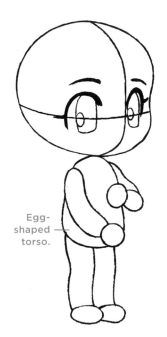

Egg-shaped torso.

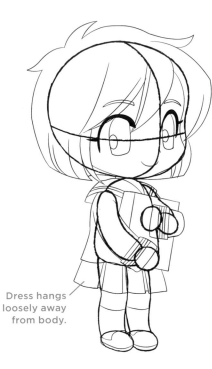

Dress hangs loosely away from body.

## HONORS STUDENT

*Here's a design secret: Props are an essential element of character design; they're not just icing on the cake. We'll cover props and accessories in greater detail in the following chapter, but for now, note that this super-achiever is made to look studious because of two props: her book and her glasses. Without them, she'd appear to be an average girl.*

Hair is cut off sharply at bottom in cute bob style.

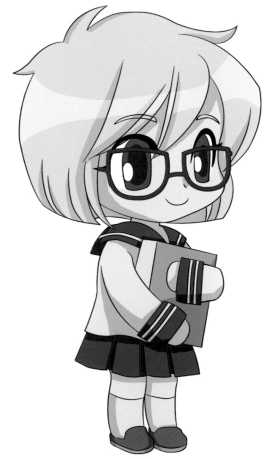

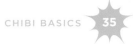

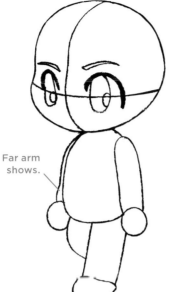

Far arm
shows.

Part of
far shoe
shows.

## HOMEWORK BOY

*Again, to make a character look three-dimensional, indicate the far ear on the other side of his head, as well as the far arm and, in this case, a little bit of the heel of the far foot as it rises up off the ground. Also, make sure that the straps of the backpack loop over and under the shoulders. Even though chibis are small, you still have to use logic in designing the character, its wardrobe, and the accessories.*

Far ear
peeks out.

# "TURNAROUND" VIEWS

Some artists, often American ones, draw chibis with skinny bodies. But that robs them of their cuteness. It's simply not a good approach for most chibi characters. In order to make them sweet and appealing, keep them thick and slightly on the chubby side. The ones that have super-skinny bodies are usually drawn specifically for shounen (pronounced show-nen), which is the boys' action style of manga. Though exciting, shounen chibis are less popular than the shoujo chibis (girl *and* boy humor) that make up the majority of this book and that we see here in these "turnaround" views. Note that the standard shoujo chibi hallmarks all appear here and do so in every view of the character.

For thoroughness, we'll also take a look at some of the shounen-style chibis in a later chapter. And you'll see that even with those characters, you can use chunkier, adorable types—the kind you see in authentic Japanese manga—to make the action-style chibis more appealing.

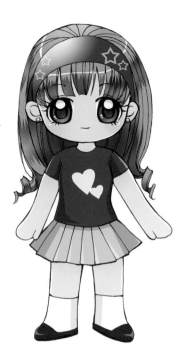

FRONT VIEW

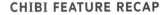

## CHIBI FEATURE RECAP

To recap, here's a list of all the basic chibi proportions. Try to maintain them no matter which way the figure is turned. They don't change from pose to pose.

• Giant head on small body.

• Giant eyes with remaining facial features all small.

• Full head of hair—and lots of it!

• Short, slightly chubby upper body.

• Short arms and legs.

• Sloping shoulders.

• Mitten-type hands or stubby fingers.

• Clunky shoes.

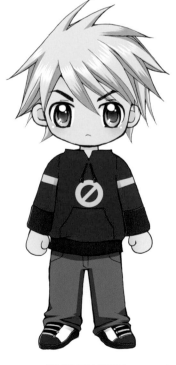

FRONT VIEW

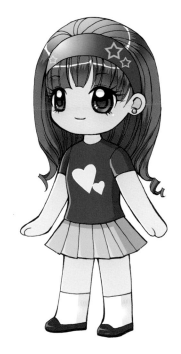
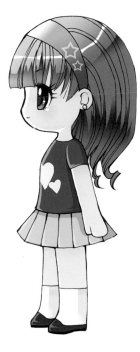

3/4 VIEW                SIDE VIEW                REAR VIEW

3/4 VIEW                SIDE VIEW                REAR VIEW

# CHIBIS AND LIMITED ACTION

In manga, there's a technique that artists use to make the action flow smoothly. They have their figures follow what's called a *line of action*, often sketching in this guideline at the outset of drawing a pose. Then everything is constructed around it, including the head and body. It keeps the poses on target and makes the final drawing stronger. In the drawings on the next few pages, the line of action is indicated in red on the construction steps.

With chibis, *limited action* is the key to drawing funny poses. That's because chibis are short and ultra-compact characters. Although we still begin with the line of action, chibi limbs aren't nearly as flexible as those of regular characters. Chibi limbs in action poses are most often portrayed outstretched, with locked joints at the elbows or knees. They don't move as freely and generally look constricted. This greatly contributes to chibis' adorable and humorous appearance.

Let's compare the stiffer chibi poses to those of more flexible regular manga characters, and you'll see how restricting the flexibility of chibi characters results in cuter, more endearing poses. It's a technique you can definitely use!

## RUNNING

*Can you tell the main difference between the manga pose and the chibi version? Their action lines are similar, except for size, but while the manga arms and legs are both bent and relaxed, the chibi arms and near leg are straight and stiff, giving her a doll-like appearance. Also, the chibi legs take a wider stride, because she can't cover as much ground as the manga girl. It takes the chibi a lot more effort to run, which makes the chibi run funnier. Also, the chibi's hand barely reaches above her eyes, whereas the manga girl's hand easily reaches the top of her head.*

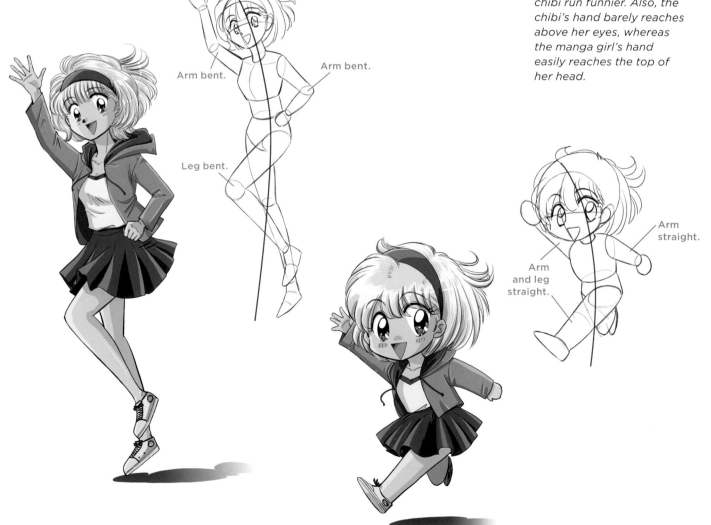

Arm bent.

Arm bent.

Leg bent.

Arm and leg straight.

Arm straight.

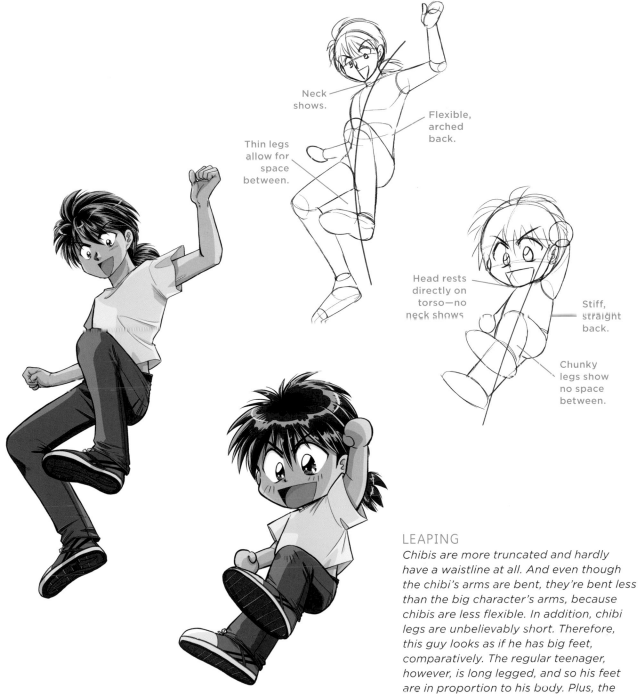

Neck shows.

Flexible, arched back.

Thin legs allow for space between.

Head rests directly on torso—no neck shows

Stiff, straight back.

Chunky legs show no space between.

## LEAPING

*Chibis are more truncated and hardly have a waistline at all. And even though the chibi's arms are bent, they're bent less than the big character's arms, because chibis are less flexible. In addition, chibi legs are unbelievably short. Therefore, this guy looks as if he has big feet, comparatively. The regular teenager, however, is long legged, and so his feet are in proportion to his body. Plus, the chibi's knee can't rise very high, because he's too compact to allow for that.*

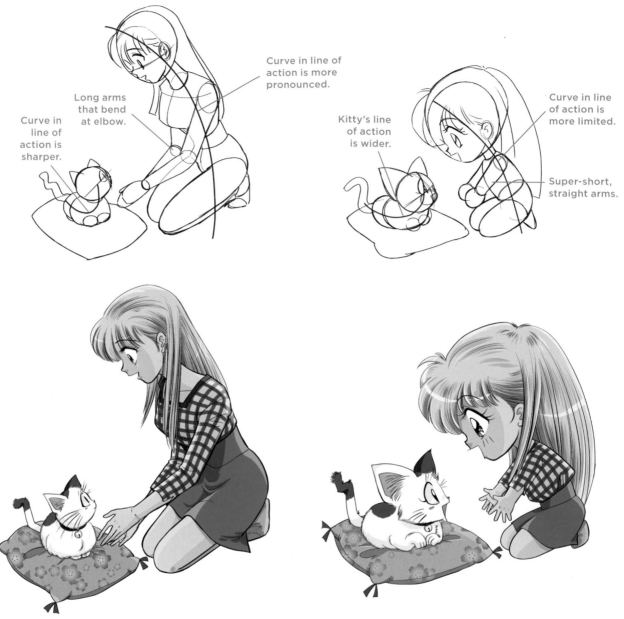

Curve in line of action is sharper.

Long arms that bend at elbow.

Curve in line of action is more pronounced.

Kitty's line of action is wider.

Curve in line of action is more limited.

Super-short, straight arms.

## KNEELING

*Sitting, kneeling, reclining . . . all of these seemingly "inactive" positions still make use of the line of action. Without it, you'd end up with a lifeless pose. The humorous aspect to the kneeling pose is that no matter how far the chibi leans forward, her arms simply aren't long enough to allow her to touch the cat, while the bigger teen can easily pet the feline sitting right where she is. This straining to touch the cat with outstretched arms shows yearning and desire. The little bundle of fur also happens to be a chibi, and it's also conserving action quite well, as most cats do, with a simple line of action.*

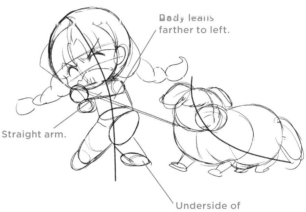

Bent arm.

## TUGGING

*The tinier they are, the more effort chibis are forced to make—even to do the smallest things. While our normal-size teenager only needs to give a little tug on the leash to remind her dog to keep moving, it takes the chibi a full-body commitment to accomplish the same task! The line of action is similar but curves more to the left and the straightened arms of the chibi reveal the huge amount of tugging energy she has to exert—pulling with all of her might. Plus, those special effects are working overtime: sweat, hair strands, flipped-out braids, and blush marks across the face.*

Body leans farther to left.

Straight arm.

Shoe points down.

Underside of shoe shows.

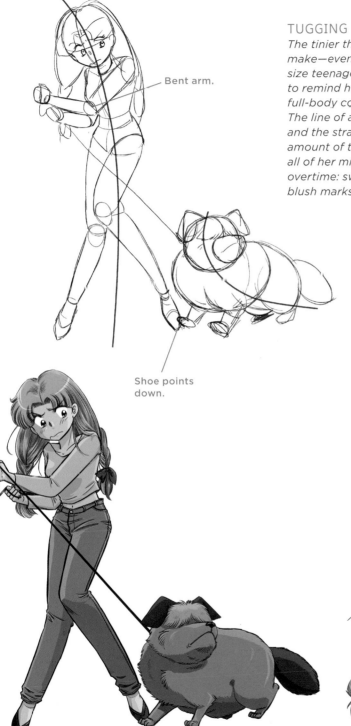

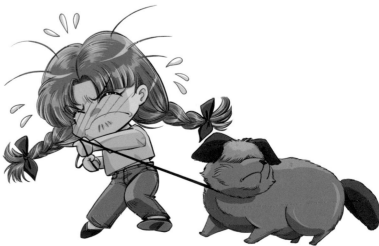

## SUPER-SIMPLE CHIBI HANDS

I don't have to tell you that drawing hands can be a challenge for many artists. But the good news is that drawing chibi hands is easy for *everyone*! In fact, chibi hands are the easiest and most fun hands to draw on the entire planet! That's because chibi hands rarely show the fingers. How is that possible? Well, their small, round hands are mostly drawn like mittens. And in the few instances when individual fingers are shown, they're depicted as short and cute, without any joints, knuckles, or fingernails. Even at their most defined, chibi hands look like puffy ski gloves, which makes them simple enough to draw that even a total beginner can master it. But even though they're so basic, you don't lose any expressiveness. Compare all the normal hand gestures to their chibi versions here to get the idea.

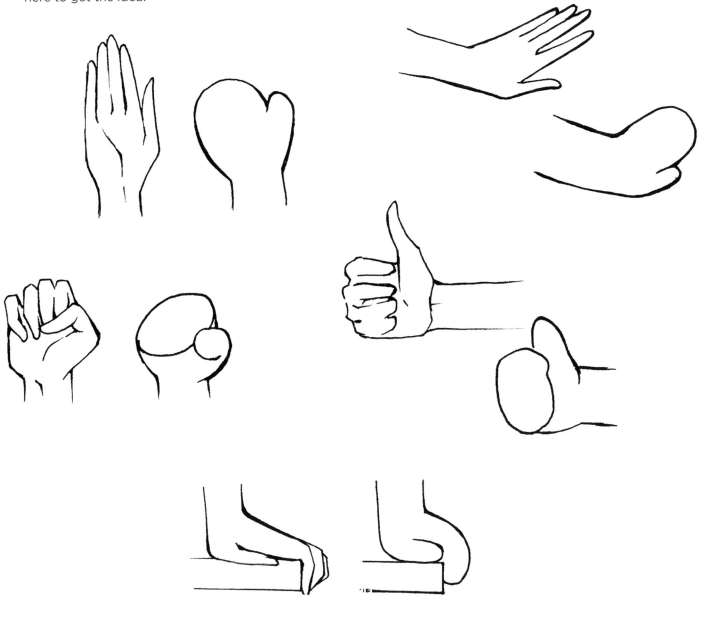

## HAND GESTURES IN USE

*Hand gestures that would otherwise be quite challenging to construct realistically are super-easy to incorporate into chibi poses.*

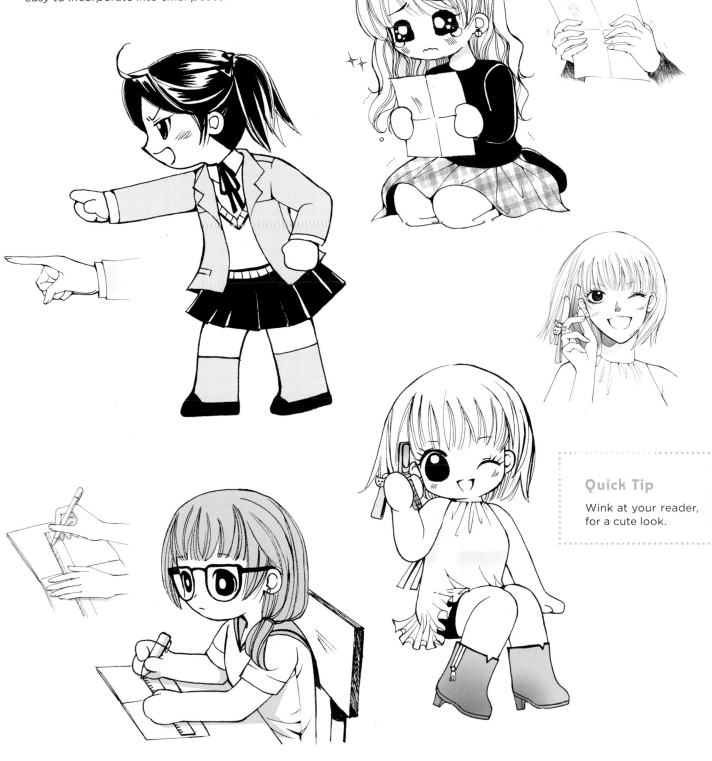

**Quick Tip**

Wink at your reader, for a cute look.

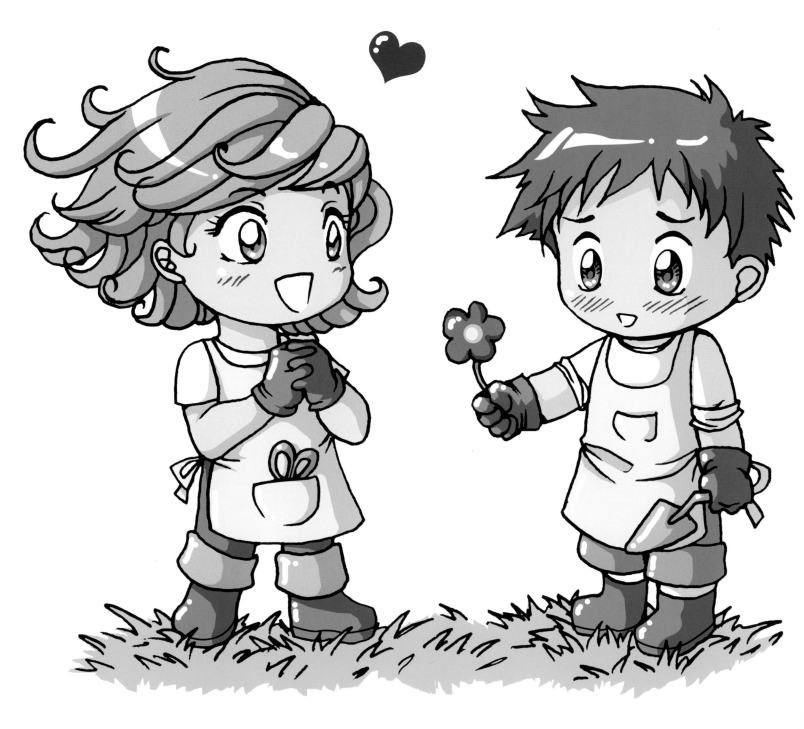

# Chibi Tricks of the Trade

**EVERY ONCE IN A WHILE** you come across a drawing for which there seems to be no ready answer in how-to-draw manga books. That's what this section's all about: the solutions for those minor drawing problems that don't seem so minor when you're wrestling with them alone—and that give your characters a professional touch once you master them. These hints present the ways in which manga artists solve these sticking points. They're easy to do, once you know the secrets.

# MAKING CLOTHING LOOK REAL

The body pulls and tugs against clothing whenever a character moves or bends. This results in folds and creases. Wrinkling at specific points in the fabric is what makes clothing look real and flexible. If nothing wrinkled, it would look like plastic. If you've been hesitant to tackle this part of drawing clothing and costumes, worry no longer. These are *chibi* clothes, so we'll keep it chibi-simple!

## Fabric "Surface Pressure"

You can't go around adding wrinkles everywhere. That would look so random! Fortunately, there's a way to figure out where the clothing should appear smooth and unaffected by wrinkles. The areas where the clothing *presses down* on the body should be *free* of wrinkles and creases (indicated by patches of gray in the drawings on the next few pages). Creases generally radiate outward from those places where the surface of the clothes is in close contact with the surface of the body.

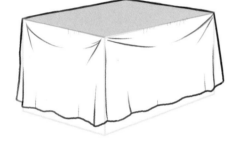

### FLAT SURFACE

*On a table, for example, the top of the tablecloth is free of wrinkles and creases, because it's pressed tightly against the surface of the table underneath it. This concept applies to any flat surface.*

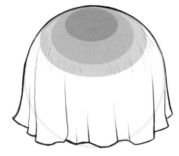

### ROUND SURFACE

*On a round surface (in this case, a sphere), the uppermost rounded area is in closest contact with the cloth on top of it and pulls it smoothly all around. The wrinkles and folds only occur once the cloth falls off from the rounded area.*

### TIGHT SHIRT

*A tight-fitting shirt will show fewer wrinkles than a looser garment.*

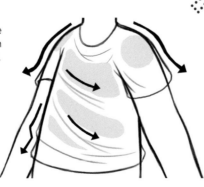

### CREASE DIRECTIONS

Creases that form on the torso are generally drawn diagonally across the body.

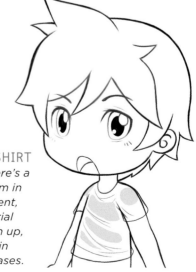

### LOOSE SHIRT

*When there's a lot of room in the garment, the material will bunch up, resulting in more creases.*

## THE SKIRT

*Just because a skirt is short doesn't mean it has no crease marks. A skirt with a band around the waist will have crease marks on the hips. The waistband is drawn on a curve, because it travels around the body and the body is round. It's not drawn across the body as a straight line.*

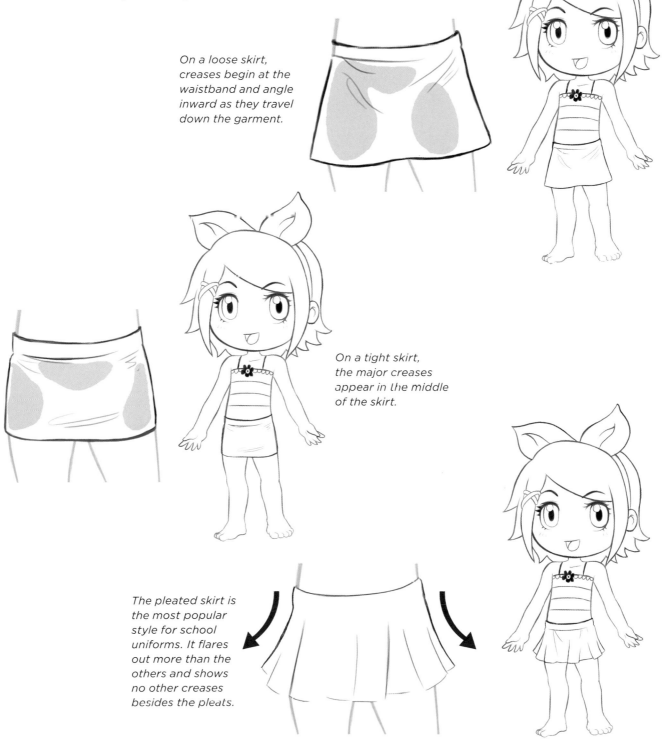

*On a loose skirt, creases begin at the waistband and angle inward as they travel down the garment.*

*On a tight skirt, the major creases appear in the middle of the skirt.*

*The pleated skirt is the most popular style for school uniforms. It flares out more than the others and shows no other creases besides the pleats.*

## Sleeve Folds for Boys

Boy chibis are rough on clothes. They tug and pull them and twist and yank on them. This results in lots of folds and creases. If you know how to make correct folds, you won't have to use as many of them in order for things to look convincing. Too many folds make clothes look old and wrinkled instead of dynamic. Let's see how specific actions result in specific types of folds.

### STRAIGHT ARM
*This fold occurs when the fabric is straight and begins to droop due to gravity. If you don't show this effect, the clothing will look stiff.*

### RIGHT ANGLE
*Bending the arm at a right angle produces a small pocket in the elbow that looks like a little loop.*

### 45-DEGREE ANGLE
*When the fabric is really squeezed, three interlacing lines are used to create the appearance of a tightened, interlacing fold.*

### BENDING WITH PULLING
*When the arm bends and also pulls, a lot of little tugging folds radiate outward from the crook of the elbow or wherever the origin of the fold is (such as the knee).*

## Pants and Seams for Boys

One reason that artists add patterns or designs onto clothing (which we'll get into more fully on the next page) is to fill up the interior areas of the clothes so that they don't look empty or blank, and this, in turn, makes characters appear solid and three-dimensional. This may work well with shirts and tops. But what about pants? You can't very well give your characters pants with stripes or other patterned designs on them, unless they've been accidentally transported here by a time warp from the 1960s. One good solution is to add a seam line to the pants that mirrors the contour of the leg. Let's see how it works.

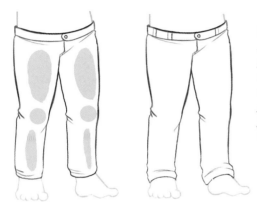

### NO SEAMS

*Just as with the other garments, the areas where the pants press tightly against the body (the gray areas) show no wrinkles. There are enough small bumps and wrinkles, though, to make the form look solid. Still, if you want to make things even more convincing—or if you'd simply like to add more detail—you need to take it one step farther.*

### CONTINUOUS SEAM

*A thin line twists and turns to conform to the wrinkles in the fabric.*

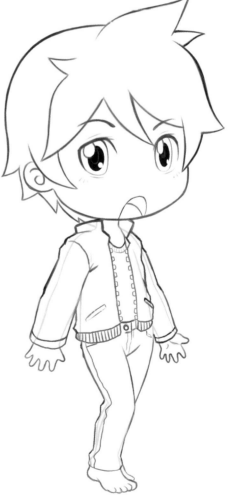

### SEAMS AND WRINKLES

*No matter which type of seam line you use, the lines bunch together at the knee and the ankle just above the foot to indicate the wrinkles and folds in the garment.*

### DOTTED SEAM

*This is seen mostly with jeans and gives a stitched-seam effect.*

## Adding Pattern Step by Step

On small characters, simple designs work best, because they're easier to read than splashy ones—and this is especially true when figures are reduced all the way down to chibi size. If you're not working in color, it's also helpful to alternate your placement of black and white areas with grays to make the garment stand out. Placing white beside white or black beside black blends the tones together and causes the outfit to lose definition.

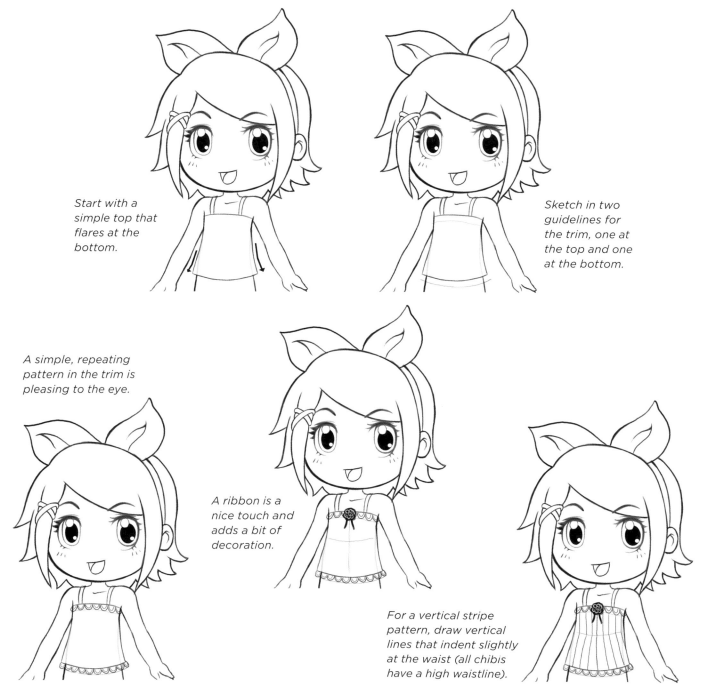

*Start with a simple top that flares at the bottom.*

*Sketch in two guidelines for the trim, one at the top and one at the bottom.*

*A simple, repeating pattern in the trim is pleasing to the eye.*

*A ribbon is a nice touch and adds a bit of decoration.*

*For a vertical stripe pattern, draw vertical lines that indent slightly at the waist (all chibis have a high waistline).*

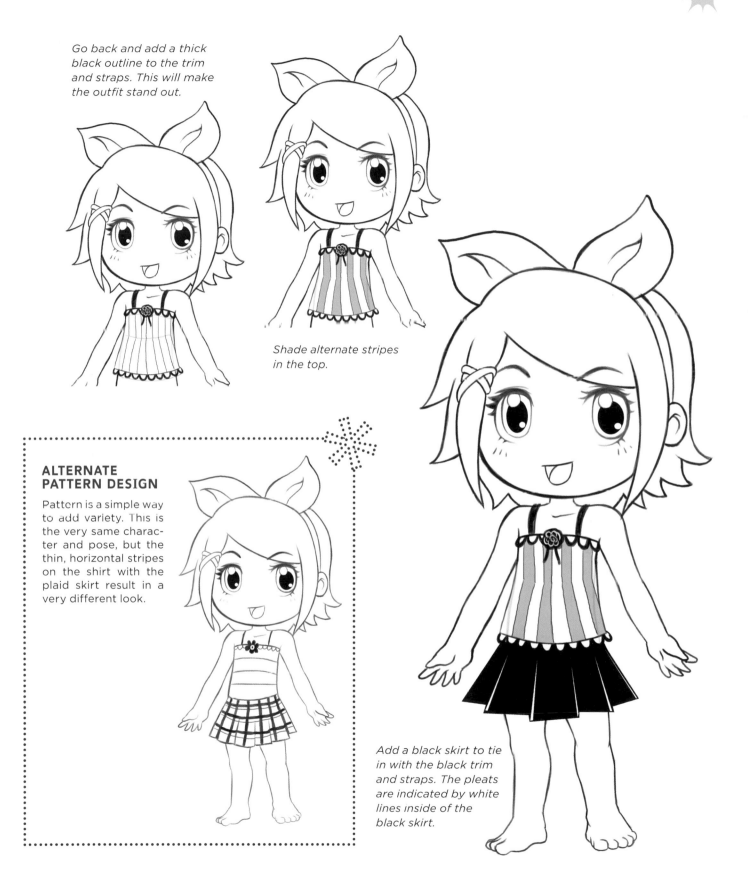

*Go back and add a thick black outline to the trim and straps. This will make the outfit stand out.*

*Shade alternate stripes in the top.*

**ALTERNATE PATTERN DESIGN**

Pattern is a simple way to add variety. This is the very same character and pose, but the thin, horizontal stripes on the shirt with the plaid skirt result in a very different look.

*Add a black skirt to tie in with the black trim and straps. The pleats are indicated by white lines inside of the black skirt.*

# FOOTWEAR

The key word here is *clunky*. The shoes should look somewhat oversized for the character, and even if they have style, they're too big to really be trendy. But that's part of the fun. How hip can a chibi really be? Their feet are too big to make them look slick anyway! Whether they're boots, high heels, or sporty shoes, keep it simple, and trust that your character's truncated proportions will make them funny. The oversized shoes, sneakers, and sandals will help to make the legs appear even shorter—a comical look. Here are a few examples.

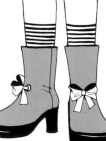

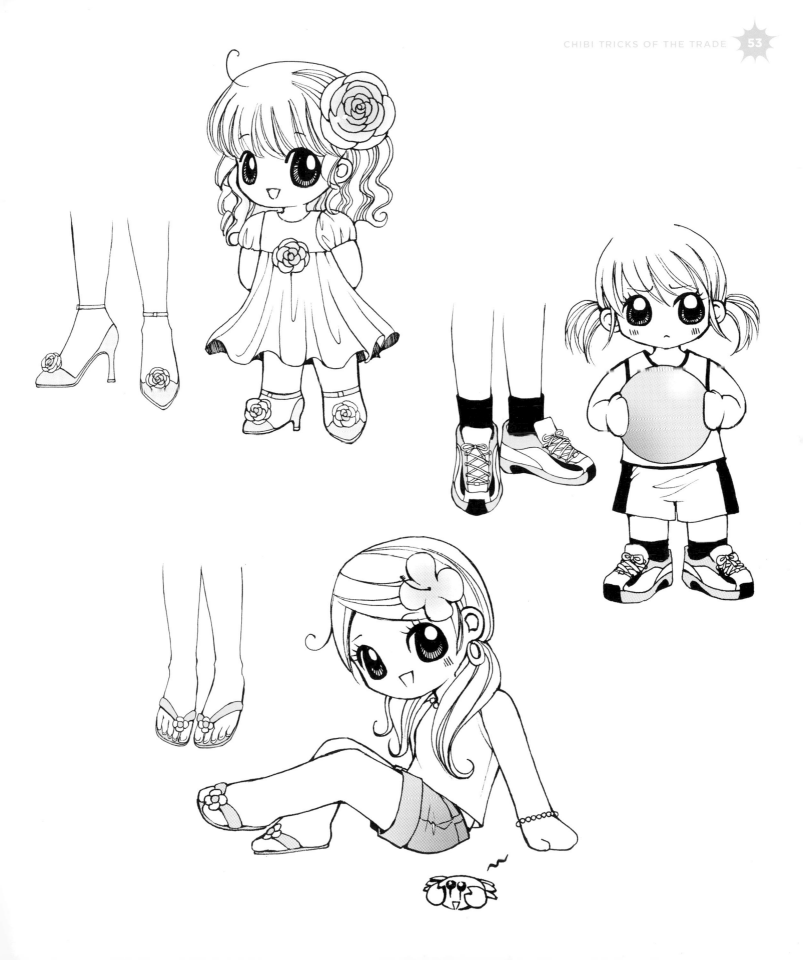

# CHIBI-STYLE PROPS

Props tell a story. For example, a girl who's walking along the street is just walking. But a girl who's walking along the street carrying a purse is shopping. Props also give characters something to hold, something to *do*, so that they're not just standing there with their hands in their pockets. And they also tell us something about the character's world. Does your character own a hat or tiara? Each prop says something different about that person.

When you draw chibis, you have a unique opportunity to "caricature" your props to be ultra-cute—and therefore consistent with everything else in the chibi world. The props should be small but fat, super-simplified, and very round.

These props on the next few pages are fun and easy to draw and can function in so many different scenes and situations that I'm sure you'll find plenty of uses for them. But even if you don't intend to draw all of them right now, use this special section for reference whenever you need it.

## Bags

Don't waste an opportunity to add a cute accessory to your chibi's outfits: Give her a charming purse. You can add an emblem to the bag, such as an animal shape, but keep it simple. You could even turn it into an animal-shape purse, like the one this girl is carrying, if you want to really go for an ultra-adorable look. Keep the colors light and cheery. Or you could add a smiling face, flowers, or hearts. Bags come in all shapes and sizes, so choose a definite style, not just a box with straps.

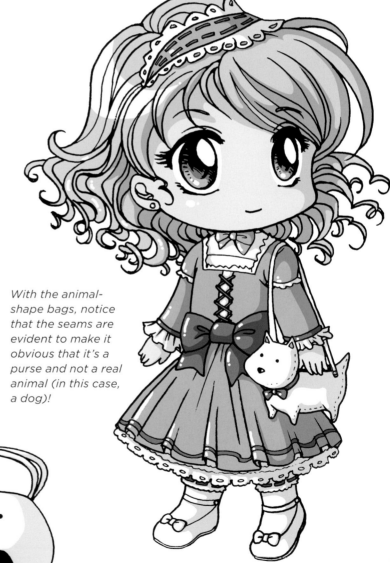

*With the animal-shape bags, notice that the seams are evident to make it obvious that it's a purse and not a real animal (in this case, a dog)!*

PLAIN HORIZONTAL SHAPE

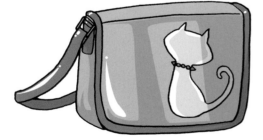

ANIMAL EMBLEM

FACE

## Hair Care and More

These props give a character something to do. For example, she's in the bathroom while her younger brother stands outside yelling at her to hurry up because she's taking too long in there! They're also good props to use in school settings; the smaller items can be quickly removed from her purse and applied furtively when she sees her crush coming toward her down the hallway.

Notice how all the items are small but thick and chunky, for a cute look. Also, using one color is important for the entire group of products; this makes it look like a set.

PERFUME

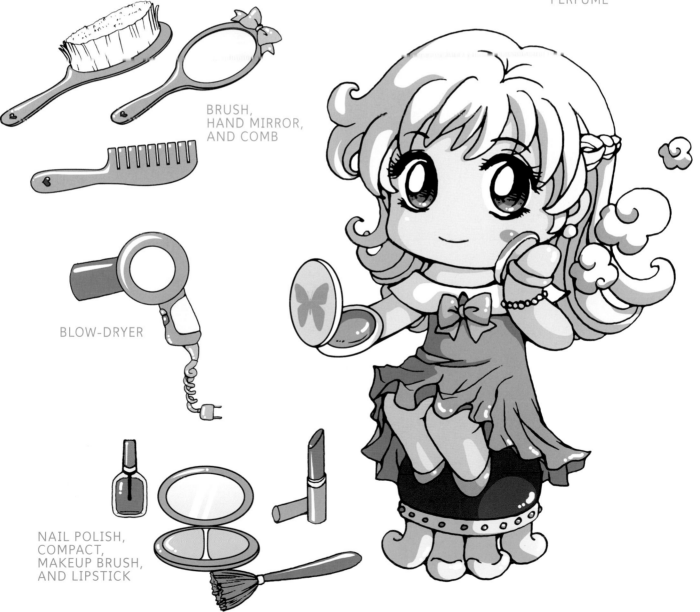

BRUSH,
HAND MIRROR,
AND COMB

BLOW-DRYER

NAIL POLISH,
COMPACT,
MAKEUP BRUSH,
AND LIPSTICK

## Treats and Snack Food

Kids and snacks go together. When you draw snack food, think of the item as a prop, not as food. Nutritionally, it barely registers as food anyway. Design these treats to look zippy and cheerful, like toys. Add all the bells and whistles. In other words, if it's a burger, make it a double-decker. If it's ice cream, make it two or even three scoops. If it's a wedge of pie, show the layers. If it's a slice of pizza, toss in toppings. Show the colorful packaging where you can. When there's no packaging, add some cute and charming dishware that looks as if it came from a dollhouse.

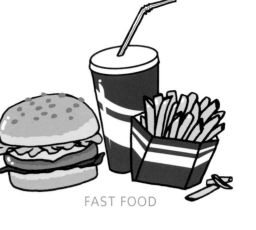

FAST FOOD

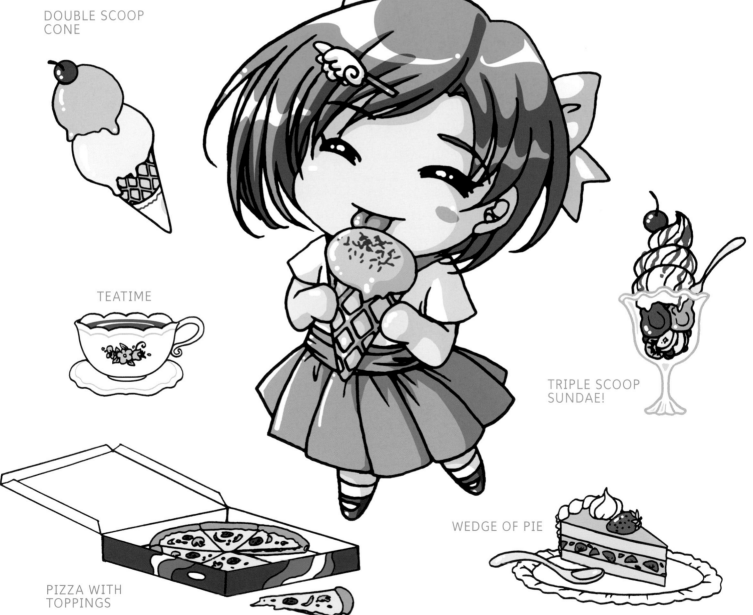

DOUBLE SCOOP
CONE

TEATIME

TRIPLE SCOOP
SUNDAE!

PIZZA WITH
TOPPINGS

WEDGE OF PIE

## Cute Electronics

Many electronics have catchy designs already, so it's not so hard to "chibify" them. It used to be that electronics all looked very futuristic. Now they lean more toward "fashion trendy," which serves our purposes better. Think of them more as outfit accessories than hi-tech gizmos. TVs no longer have "rabbit ear" antennas, but sometimes cartoonists still use them, because they're a universally recognized icon that stands for television. What about screen savers? Those are a great place to add simple—and I repeat, simple—logos, such as faces or animal shapes. Since every young person would rather have a laptop than a regular computer, give one to your character. Heck, it doesn't cost any more to draw a laptop than it does to draw a regular desktop model, and it looks cooler. Most electronic devices come in a variety of different colors. Take advantage of that rather than using silver on all of them. Colors make them look happier and give the props personality.

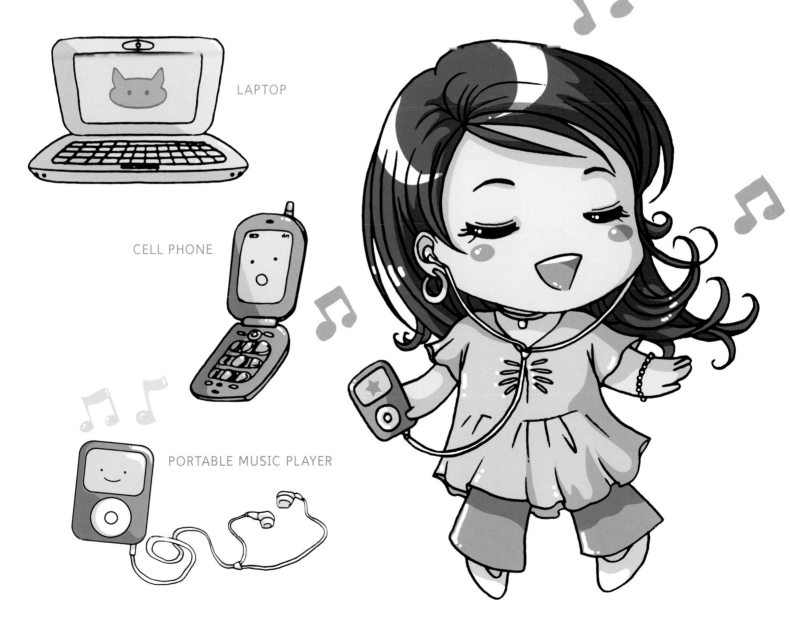

OLD-FASHIONED TV WITH RABBIT EARS

LAPTOP

CELL PHONE

PORTABLE MUSIC PLAYER

# FUNKY FURNITURE

One of the most important aspects of drawing a chibi sitting in any kind of furniture is figuring out where the chibi is relative to the ground. As the chibi sits, her legs should be propped up straight, with her feet just barely off the end of the couch—not even close to touching the floor. She doesn't even take up the space of an entire cushion! The cushions should look plump. This is a cute look that immediately evokes a sympathetic response from the reader.

RETRO COUCH

COMFY OLD-
FASHIONED SOFA

CHAISE LOUNGE
(OR CHAISE LONGUE
IF YOU'RE FANCY)

# FRIENDLY FLOWERS

Flowers are used throughout manga as metaphorical symbols to convey the mood of a scene. Dreamy scenes, love scenes, and happy scenes can all be decorated with flowery backgrounds to enhance and communicate the mood. And, of course, flowers are given as tokens of affection.

Flowers and plants are particularly charming in chibi stories, because in this genre, they take on bouncy, animated personas—like mini-characters. More than plants, they're like a gallery of tiny friends. Often, the center circle of the flower has a simple face with a happy expression. Roses are far and away the most common type of flower used in manga, but many others can also be used. And you can even invent your own types, provided that they look appealing.

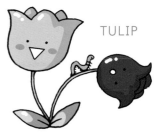

TULIP

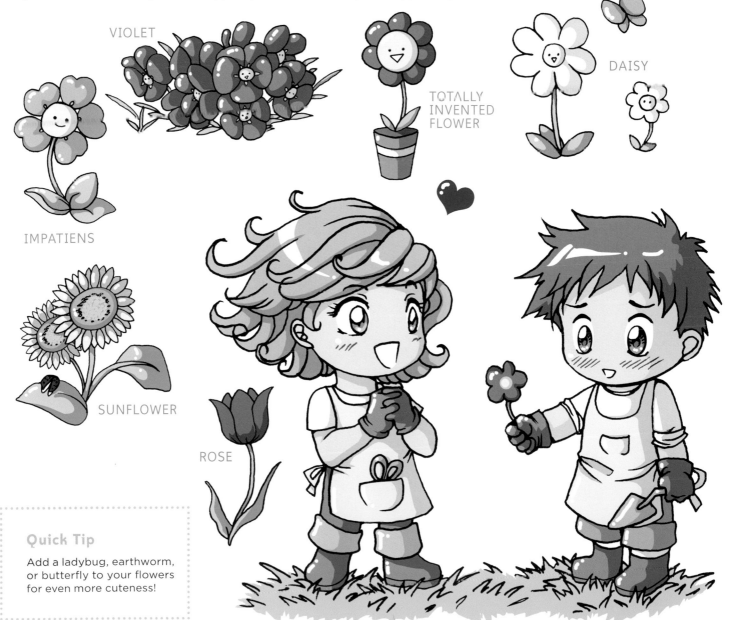

VIOLET

TOTALLY INVENTED FLOWER

DAISY

IMPATIENS

SUNFLOWER

ROSE

**Quick Tip**

Add a ladybug, earthworm, or butterfly to your flowers for even more cuteness!

# CHUNKY MOTOR VEHICLES

Vehicles, especially motorcycles, can be complex machines to draw. But the chibi world is a round and simplified place. In keeping with this theme, you can draw a chassis over the engine, which gives the bike a simplified look and also makes it much easier to draw! Motorcycles are strictly for bad-boy chibis. Most of the time, you'll find chibis on motor scooters, which are plenty fast for these little guys and gals—and are friendlier-looking machines. A single puff of exhaust smoke is a cute scooter touch.

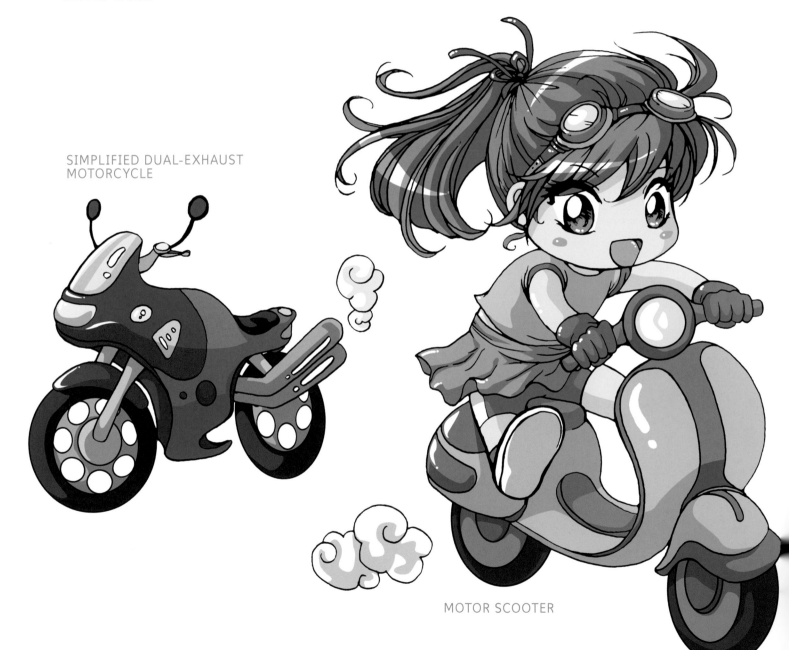

SIMPLIFIED DUAL-EXHAUST MOTORCYCLE

MOTOR SCOOTER

RACE CAR WITH SPOILER

SUBCOMPACT CONVERTIBLE

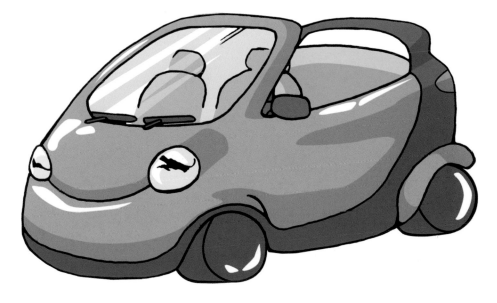

## Quick Tip

If the car's a convertible, having the top open makes it easier to draw the characters inside, and your audience will also be able to see them better.

# The Chibi Cast of Characters

THIS SUPER-SIZE SECTION stars the adorable chibis found in all of manga's most popular genres. It's a virtual buffet of epic—and chibi—proportions! Since just about every character goes chibi at some point (when undergoing extreme stress or emotions), chibis cross all genres. Until now, you may not have been exposed to all of the possible variations of chibi character designs. Once you see an entire assortment, you'll be able to decide which are your favorites to draw. And of course, the step-by-step approach and Quick Tips will give you all the assistance you'll need to get the job done. Since we covered school kids in the first chapter, now we'll get to everything from anthros to magical girls, sci-fi, mecha, occult, and more!

# MAGICAL GIRLS

The magical girl genre is hugely popular in manga. It's actually a subgenre of *shoujo* (girl's comics). Magical girls are usually school-age girls who undergo a magical transformation and become super-idealized teens who wear glamorous costumes and wield amazing powers or possess extraordinary talents. They fight for good (not evil) and often engage in battles to save the world from the forces of darkness. They can often fly and sometimes have cute monster helpers. Some use magical crystals, swords, wands, staffs, or other such devices to help direct their considerable powers. Many times, manga artists use school uniforms as the inspiration for magical girl costumes; other times, their costumes are drawn as from scratch.

Severely foreshortened arm looks very compressed.

Short dress is coupled with long coat.

Fantasy magical girl hair: swirls and curls.

## Quick Tip

Magical girl hair is long and famous for its extended curls and fantastical swirls.

## Sorceress

The wand and cape identify her as a sorceress who can conjure spells and cause magical effects, from shape-shifting to manipulating the forces of nature. Under the billowing coat is a regular schoolgirl outfit. Magical girls are transformed from schoolgirls, so this derivation is consistent with our theme. The star inside the wand's crystal ball is a necessary addition, because it makes the sphere look translucent.

## Dreamy Magical Girl

Some magical girls are more fantasy than fighter. These sweet, super-endearing types are made even more doll-like by the fact that they're chibis. This one clutches her chest in an expression of quiet joy. The ringlets add to her sugary appearance, as do the flounces on the dress and the long gloves. The various dress layers give her a frilly look. Ornate dresses are common on magical girls. Using plant leaves for the wings and hair ties works with the rose theme in the background. (Remember, flowers are always a popular design motif in manga.)

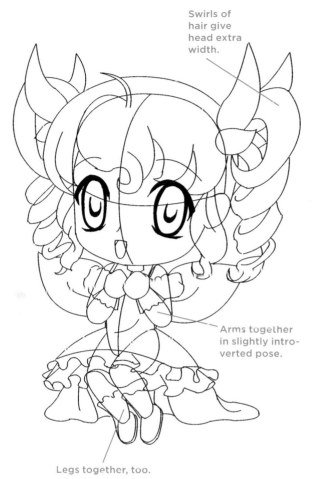

Swirls of hair give head extra width.

Arms together in slightly intro- verted pose.

Legs together, too.

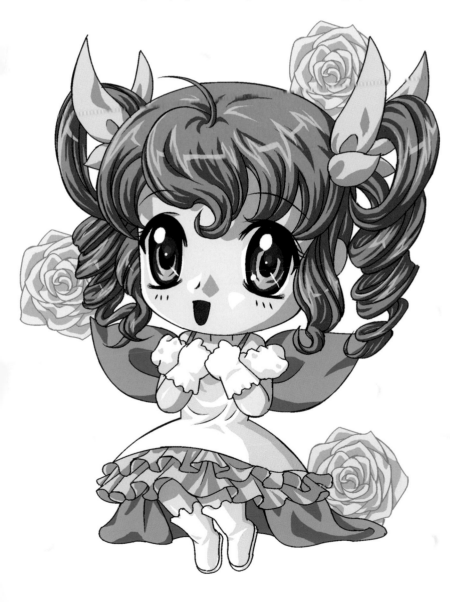

HAIR CURL DETAIL

## Transforming Magical Girl

When a magical girl transforms from an ordinary schoolgirl into an astral version of herself, swirling streams of magic "tornado" around her. Her eyes close, her mouth becomes small, and her head tilts back, enraptured. She floats, weightless, experiencing a peaceful transition into a fantasy heroine. Everything should look like it's being blown in a wind tunnel. The hair and clothes snap about tumultuously in the enchantment. With so much action going on, it works to keep the costume simple until she emerges from her cocoon of magic. You don't want to overload the reader's eye.

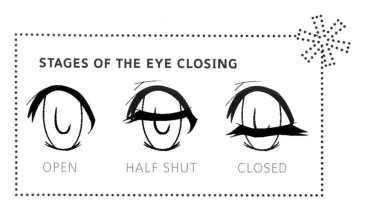

**STAGES OF THE EYE CLOSING**

OPEN          HALF SHUT          CLOSED

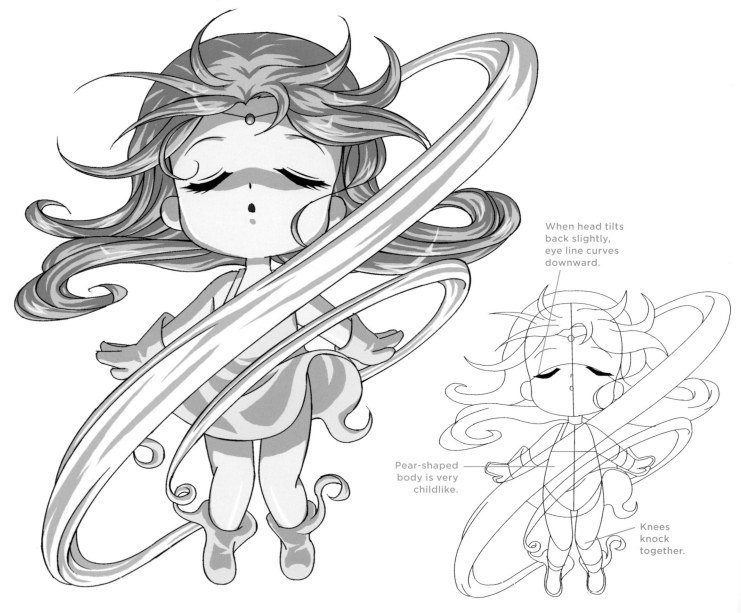

When head tilts back slightly, eye line curves downward.

Pear-shaped body is very childlike.

Knees knock together.

## Sad Magical Girl

Nobody knows loneliness like the fantasy heroine. The weight of the world is on her shoulders. Her magical identity is secret. She can't tell anyone. Her best friends are mad at her because she's not spending enough time with them, and no one is grateful that she's risking her own life every time she battles the bad guys. It's enough to make a girl cry! Sometimes a magical girl will meet a magical boy during her battles—and they will help each other in their quest, and she won't be so sad and lonely anymore.

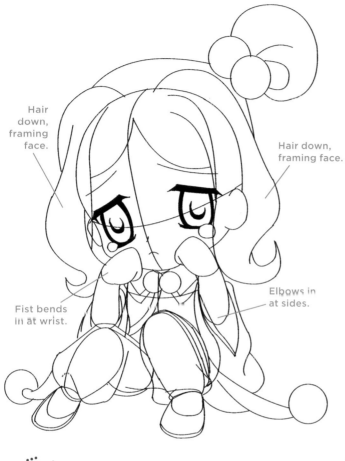

Hair down, framing face.

Hair down, framing face.

Elbows in at sides.

Fist bends in at wrist.

### A NOTE ABOUT THE POSE

Everything about the pose communicates her state of mind: She rubs against the base of her cheeks, and her eyes bubble with a few tears. The body closes up tight into a ball. Note how the top eyelids press down on the eyes.

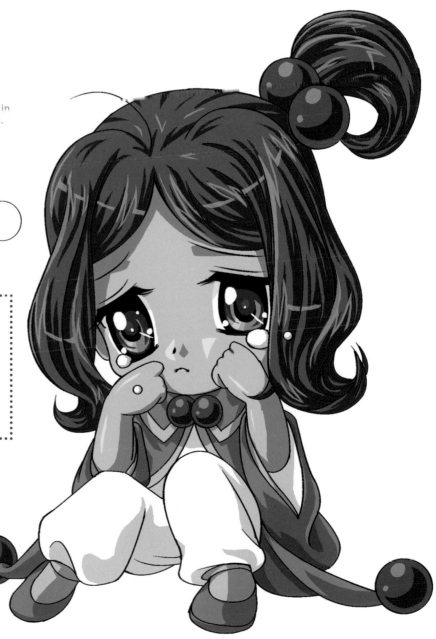

## Winged Magical Girl

Magical girls don't need wings to fly, but winged characters give the appearance that flying is the special skill at which they are particularly adept. And they can use speed to outmaneuver a bigger opponent. You can use wings to design an angel fighter, and for this character type, draw a robe instead of a glamorized schoolgirl outfit. Add to that a wooden staff, and you've got a chibi goddess. The wings don't have to be oversized; larger wings would make her look like an angel (also an interesting type) instead of a magical girl.

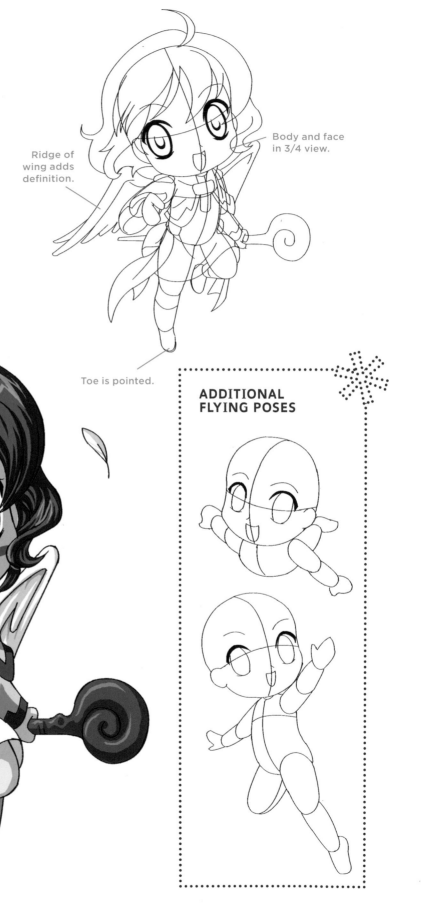

Ridge of wing adds definition.

Body and face in 3/4 view.

Toe is pointed.

**ADDITIONAL FLYING POSES**

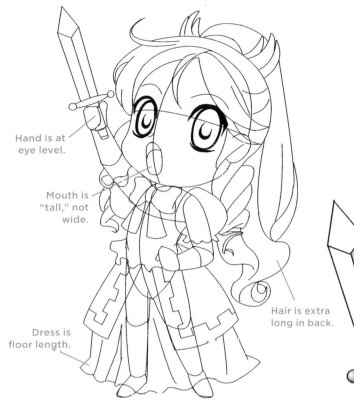

Hand is at eye level.

Mouth is "tall," not wide.

Hair is extra long in back.

Dress is floor length.

## Fighter Princess

A sword, lifted above the head, turns an ordinary girl into a true leader. And to turn the prop into part of a costume, we'll make her a medieval character—a chibi girl knight or even a medieval princess. Princesses in manga are often also fighters. All female characters in the upper classes in the Middle Ages wore long dresses with "poufy" shoulders and elbow-length gloves. They also wore layers upon layers of clothing. And do you know why? Because the castles were freezing cold! Nevertheless, they were very creative with costumes, which were ornate with lots of fancy trimming. And note the headpiece here.

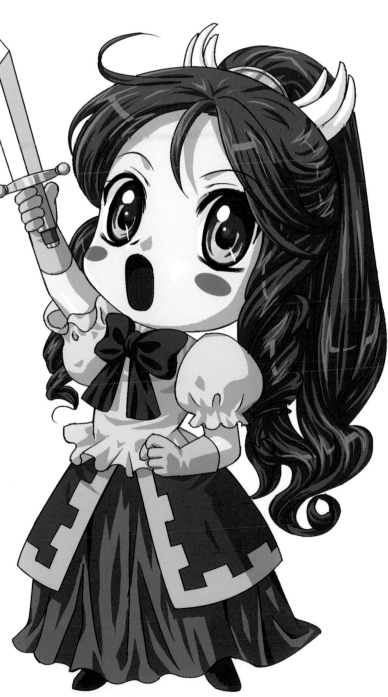

# "EVIL" CHIBIS

Some of the funniest chibis are the ones that are cast in the most villainous roles. It's a wink to the audience, because, really, how bad can a chibi actually be? When creating evil chibis, use the three Cs: character, costume, and color. Character refers to the type—for example, a vampire. The costume must be bold and eye-catching. And the colors most often used for evil characters are the colors associated with night: dark grays, blues, purples, and reds—and sometimes, pale yellows and pale greens.

## Samurai Bad Girl

Bad samurai are just as widespread in manga as good samurai. The bad attitude is funnier on chibi characters, though, because it stuffs so much intensity into such a small package. Note how the upper eyelids press down on her eyes; it's not just the eyebrows that are making the frown. For the pose, the legs face forward but the body twists into a 3/4 turn, coiling up as she pulls her blade from its scabbard. Samurai always have ponytails (even boys). The sandals are worn with split-toe socks, and a loose jacket and billowing pants complete the outfit.

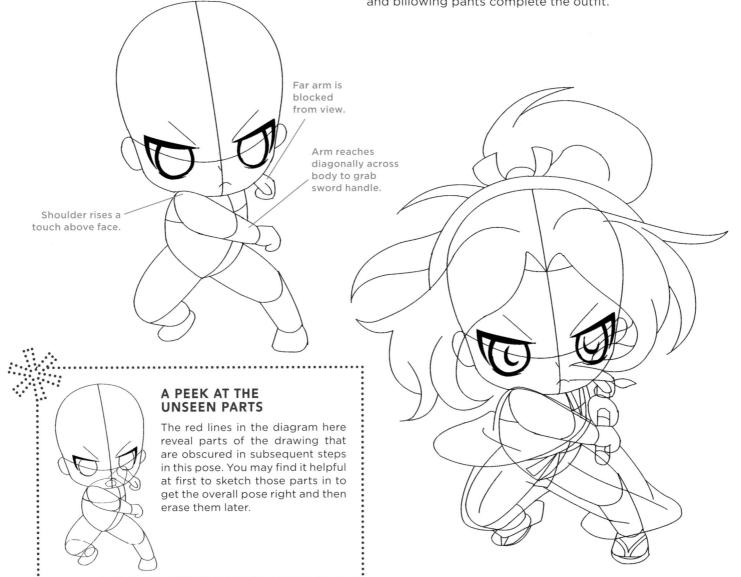

Far arm is blocked from view.

Arm reaches diagonally across body to grab sword handle.

Shoulder rises a touch above face.

### A PEEK AT THE UNSEEN PARTS

The red lines in the diagram here reveal parts of the drawing that are obscured in subsequent steps in this pose. You may find it helpful at first to sketch those parts in to get the overall pose right and then erase them later.

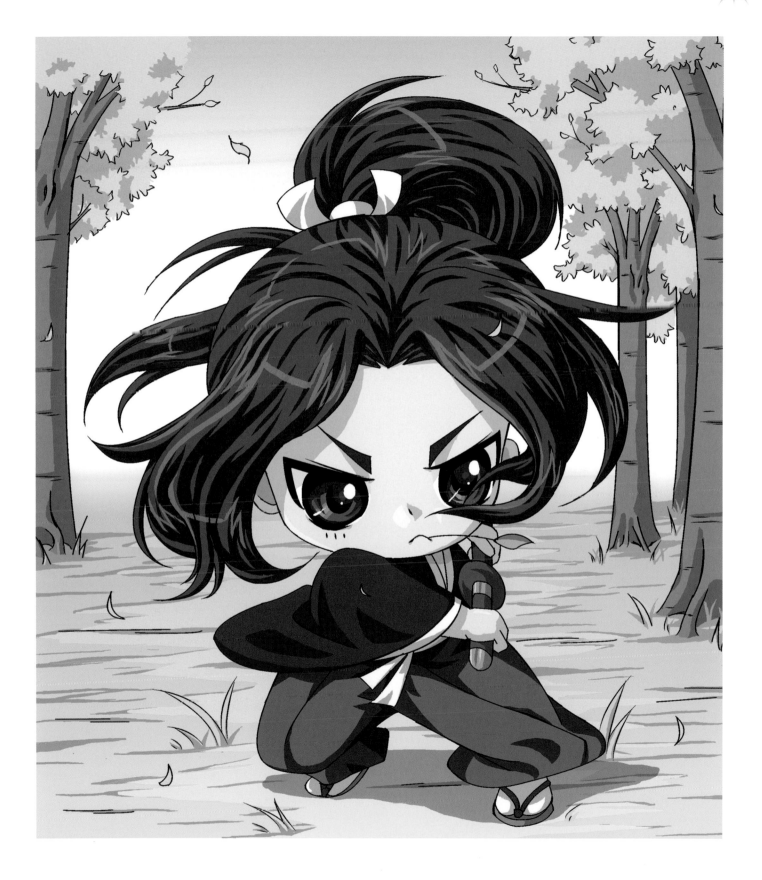

## Vampire Gal

Vampire gals only appear in nighttime scenes. They're almost always drawn with long, flowing hair and wearing a black skirt with high heels. For a more Victorian look, you'll sometimes see a long dress with a tattered hemline. A robe or a cape can also be a featured accessory. This cutie of the occult also has a pair of small bat wings on her back. A single upper fang is optional.

### DRAMATIC SKIRTS

The reason the skirt looks so effectively dramatic here is that it has several different forces working on it at the same time (indicated by the arrows on the diagram here). These cause it to billow out and fold dynamically in the breeze.

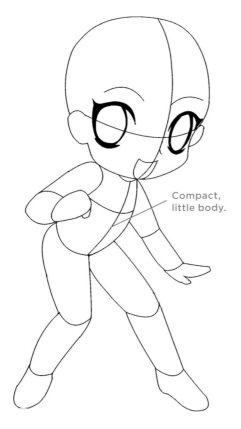

Compact, little body.

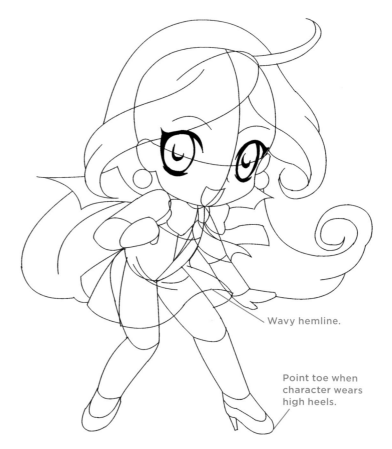

Wavy hemline.

Point toe when character wears high heels.

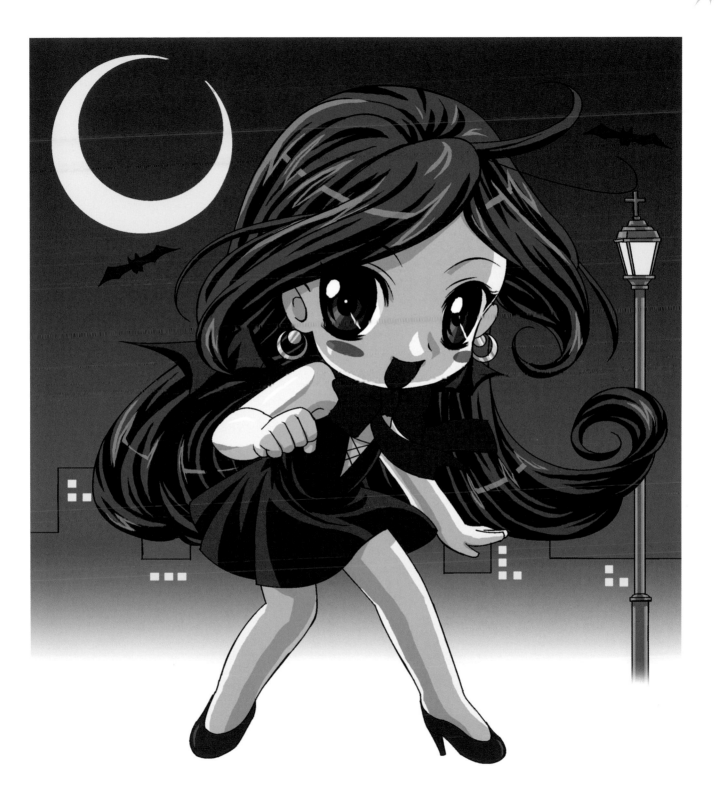

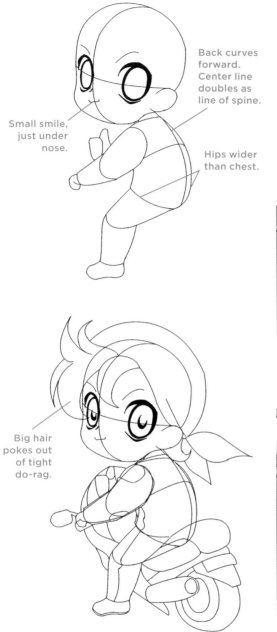

Back curves forward. Center line doubles as line of spine.

Small smile, just under nose.

Hips wider than chest.

Big hair pokes out of tight do-rag.

## Biker Boy

How's this for a semi-bad biker boy? A do-rag with a shock of hair shooting out from underneath and a black leather jacket. The skull-and-bones logo is a great addition. And if that's not bad enough, you can give him a chopper with a low-rider seat and high handlebars (which is a different look from the racing-bike style shown here). Look at his smile and big old eyes. He can't help it—even as the leader of the gang, he's still adorable!

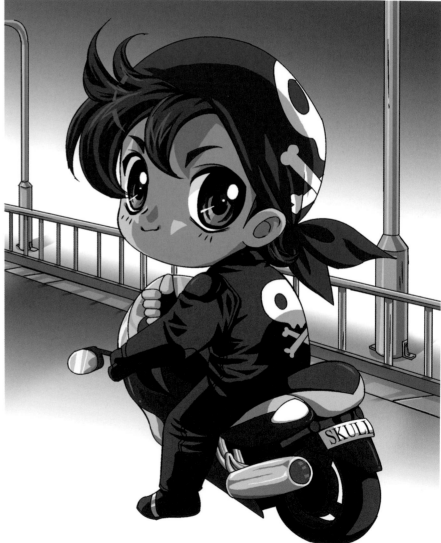

## Sad-Sack Prisoner

This bad boy is cooling his heels in the big house. Although nowadays most prisoners wear orange jumpsuits, the cartoon version still wears the stereotypical black and white, long-sleeved costume with a ball and chain attached to the ankle. It's a funny look, instantly recognizable, and has become a convention in comics of all kinds. When he tries to escape, he has to carry that big, heavy ball with both hands, which results in a funny mad dash.

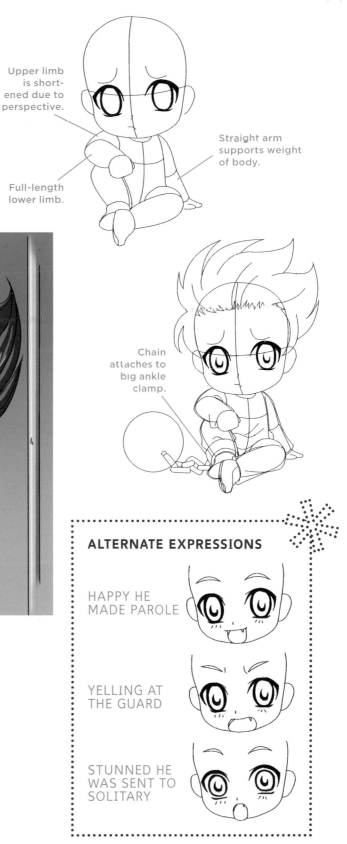

Upper limb is shortened due to perspective.

Straight arm supports weight of body.

Full-length lower limb.

Chain attaches to big ankle clamp.

**ALTERNATE EXPRESSIONS**

HAPPY HE MADE PAROLE

YELLING AT THE GUARD

STUNNED HE WAS SENT TO SOLITARY

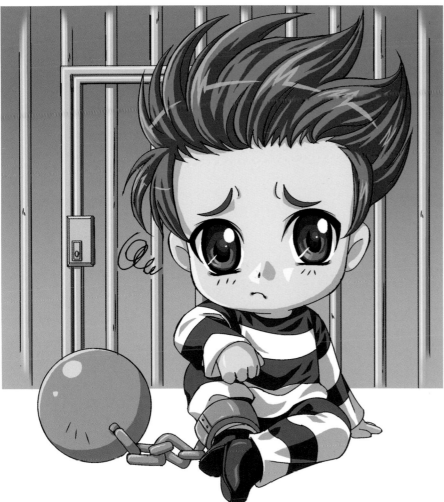

## Goth Boy

Goths love to wear trench coats, boots, and gloves—anything to shield them from the sunlight. The long, androgynous blond hair also adds a dramatic contrast to the character's brilliant black wardrobe. Could that be blood in the glass? It makes us wonder if he is more than merely a goth. . . . But if he were a vampire, then we'd have to eliminate the cross on the bottom of his coat, because vampires are allergic to such symbols. Maybe he's just plain spooky.

Tilt head down slightly.

Point toe on crossed legs.

### ANOTHER PEEK AT THE UNSEEN PARTS

Just as on the drawing in the box on page 70, the red lines here reveal the parts of the body that are obscured in the final pose, where other body parts overlap them. Again, you may find it helpful at first to sketch those parts in to get the overall pose right and then erase them later.

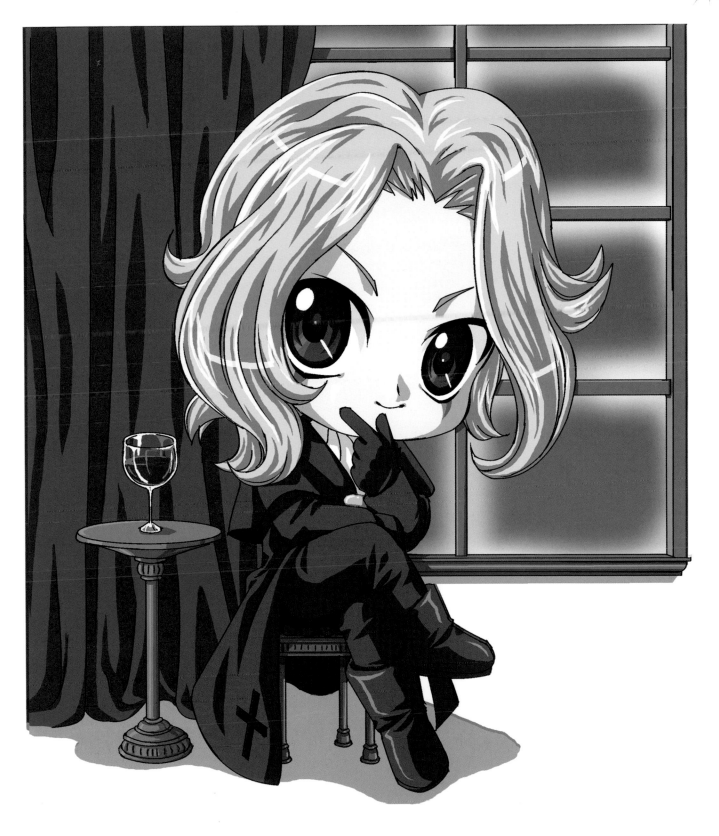

## Mad Scientist

Mad scientists—even budding ones—always wear lab coats and glasses. This one also has braces on his teeth and that wild, crazy-professor-type hair. The mad scientist is usually wickedly ambitious and has elaborate plans to take over the world, as you can see from his maniacal grin—the classic bad-guy expression. Mad scientists are made for chibis, because they're all brain and no body, the perfect chibi proportions.

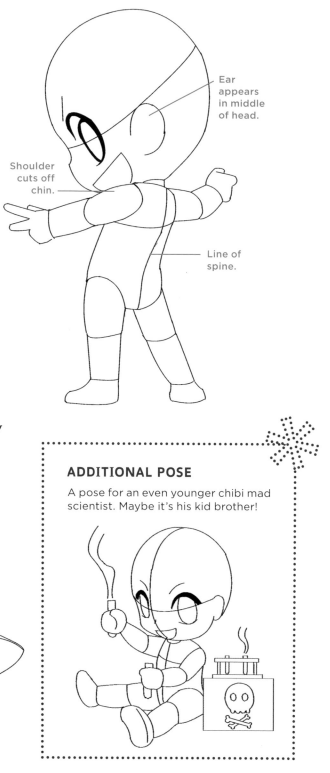

Ear appears in middle of head.

Shoulder cuts off chin.

Line of spine.

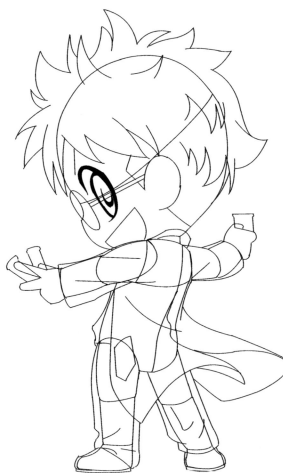

### ADDITIONAL POSE

A pose for an even younger chibi mad scientist. Maybe it's his kid brother!

## DRAWING SOMEONE FROM BEHIND

When drawing someone whose back is toward you, "cheat" the face—in other words, tilt the head toward the reader so that the facial expression is still visible. This is very important in creating a winning pose.

# SCI-FI CHIBIS

Sci-fi means *action*. And characters in this popular genre wear some of the most inventive costumes, often accompanied by gadgetry and weapons. They're cool under pressure and strike dramatic poses. They range from secret agents to space captains and evil warlords who command different quadrants of the galaxy. But the secret is that chibi space commanders and the like, although surely funny, can actually make quite compelling characters. Whenever you have small characters outsized by larger foes, you have the ingredients for good drama, and chibis have that by their very definition. Sci-fi also adds a hard-action element not usually seen with chibis. It's a fresh angle that offers lots of thrills and hi-tech wizardry to the category.

## Laser Boy

Some mecha items can transform an ordinary kid into a sci-fi character. This sci-fi boy is wearing jeans and a pullover shirt. What's the difference between him and any other shounen-style chibi? Shoulder guards, a headpiece, and a handheld laser. That's all it takes to transform a regular boy into a futuristic fighter. The crouching position is the classic "ready" stance, showing that he's prepared for trouble—and trouble is what he's going to get. Downward-tilting eyebrows read as determined.

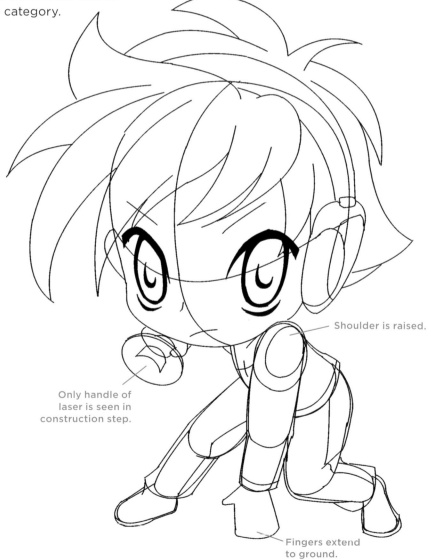

Shoulder is raised.

Only handle of laser is seen in construction step.

Fingers extend to ground.

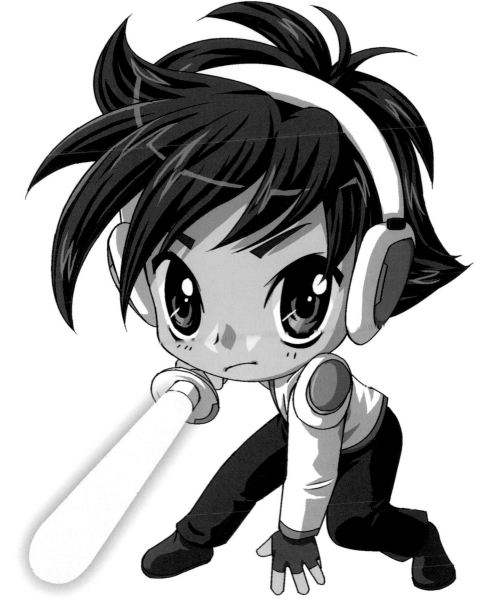

## THE EFFECT OF PERSPECTIVE

Note that the natural shape of the arm tapers from thick at the shoulder to thin at the hand. That's what you see in the center drawing. But when the arm comes straight at us, it's just the reverse: The hand is largest, and the shoulder is smallest. This is what you see in the construction at the far right. This is due to the laws of perspective, which state that things nearer to us appear larger than things farther away.

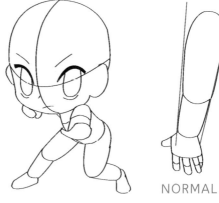

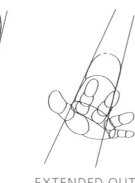

NORMAL          EXTENDED OUT

# Space Alien Cutie

Here's a chibi from another world. Aliens like these have been showing up forever in popular space adventures. They're like guest stars in movies or television shows. You add them to spice up the cast or crew of an adventure story. You don't need to change much to indicate that the character is an alien. In fact, if you make the character too different—for example, by giving it three eyes or tubes coming out of its head—you could lessen its appeal by making it look strangely alien. This one has been given alien ears, a fang, and a tail and then colored pink, but her basic, overall form is still that of a little girl chibi.

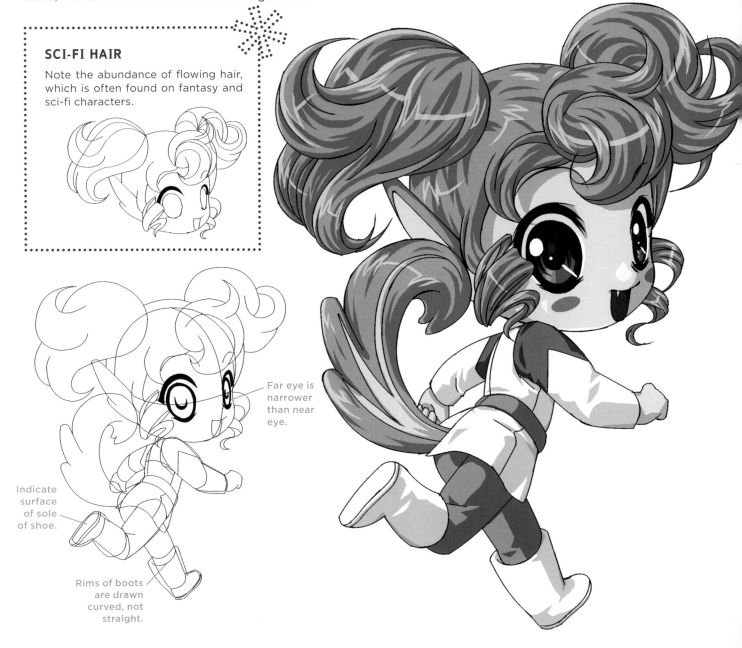

### SCI-FI HAIR

Note the abundance of flowing hair, which is often found on fantasy and sci-fi characters.

Far eye is narrower than near eye.

Indicate surface of sole of shoe.

Rims of boots are drawn curved, not straight.

# Evil Spaceship Commander

The smaller the evil chibi, the bigger his ambitions. These tiny mega-lomaniacs make truly hilarious characters because of the incongruity in the ratio of power to size. Hooded characters are always cloaked in mystery and are often evil, and when you combine that with a cape, well, you've definitely got someone on the wrong side of justice. Adding an eyepiece is another way to remove the humanity, making him part machine. When you have an elaborate costume, such as this, you don't necessarily need a dramatic pose to make an impact. The costume does most of the work for you.

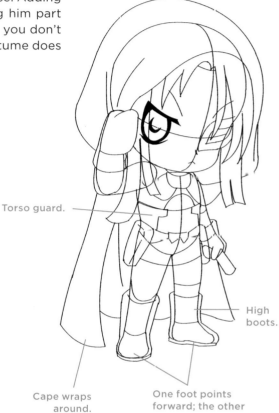

Torso guard.

High boots.

Cape wraps around.

One foot points forward; the other points to the side.

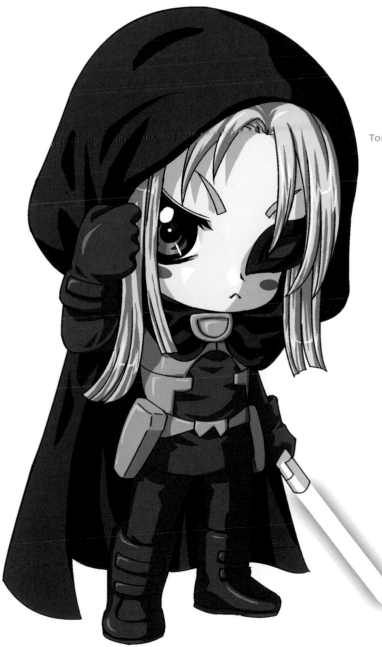

## Quick Tip

Hip guards are a popular item in fantasy and sci-fi manga. They may look like sheaths for daggers, but they're not. They're separate elements.

## Secret Agent

Don't mess with this chibi! She wears black clothes so that she can move stealthily through the night. Firing at two different targets simultaneously indicates that she's fighting more than one opponent at a time, so she must be good!

Hair shows action, too.

Tummy out.

Back arched.

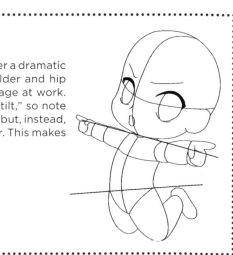

### BODY DYNAMICS

Her leap into the air gives her a dramatic flair and so does her shoulder and hip tilt. That's real body language at work. The red lines call out this "tilt," so note that the lines aren't parallel but, instead, are tilted toward each other. This makes for more body action.

## Rebel Leader

He's one of the loyalists remaining on Earth after the last Great Alien War. While many humans have given up the fight, he's leading the resistance to take his planet back from those slimy green things that have been making colonies out of his former hometown.

This is a mini-version of the typical cyberpunk character we're familiar with from popular action-style anime. The eye patch and trench coat make him seem like an outlaw, but he's really an anti-hero; he's a good guy, but only by the slimmest of margins.

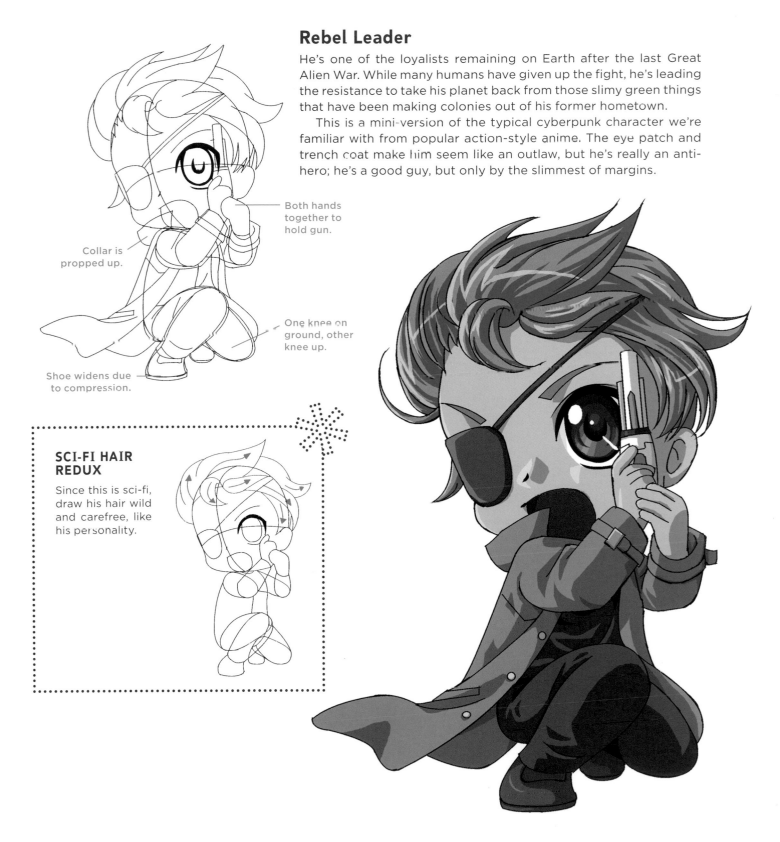

Collar is propped up.

Both hands together to hold gun.

One knee on ground, other knee up.

Shoe widens due to compression.

### SCI-FI HAIR REDUX

Since this is sci-fi, draw his hair wild and carefree, like his personality.

# Cyborg

Just as you have the evil chibi spaceship commander, naturally, you've got to have a good spaceship chibi character, too. This cyborg is it. She's a helpful, loyal, and smart crew member. But she's no shrinking violet; she's also a fighter—and super-strong, because she is a machine. Her arms are weaponized. And note the magical-girl-type leggings, which give her a cute appearance. The one-piece bodysuit is a typical sci-fi costume that can be used on humans as well as cyborg characters.

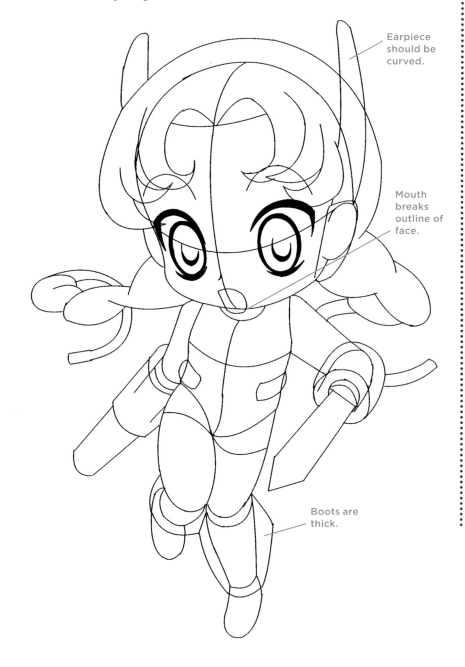

Earpiece should be curved.

Mouth breaks outline of face.

Boots are thick.

## CHIBI PROPORTIONS REFRESHER

The head is huge compared to the body. Measured against the overall height, it spans from the shoulders to the knees, not from the shoulders to the waist. Similarly, the eyes also stretch long and take up a substantial percentage of the length of the head.

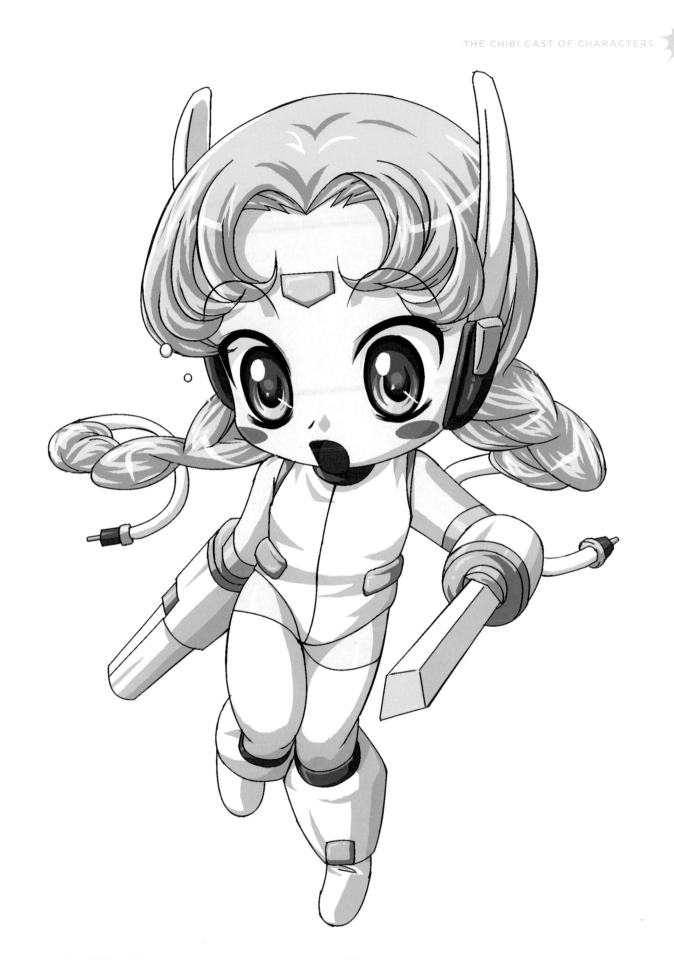

## ANTHROS

Manga anthros are characters that meld human with animal. Playful, mischievous, and curious, anthro chibis are super-popular and tons of fun to draw. Everyone loves manga's famous cat-girls, for example, those adorable human-feline hybrids that walk like people but purr like kittens. You don't have to learn cat anatomy or anything so complicated to create these winning characters; a pair of giant cat ears, a tail, and some markings are usually enough to turn a human chibi into a cat-girl.

In addition, manga artists are always experimenting with what works, and as an artist, you should, too! So manga artists have taken the idea of cat-girls a step farther: They've combined chibis with all sorts of lovable little fuzz balls, including bears, rabbits, and raccoons. Let's take a look at how it's done.

## Basic Cat-Girl Chibi

This cat-girl is a singer, maybe in her own rock band. She has a giant pair of cat ears right where a real cat's ears would go: not on the sides of her head but toward the top. She's petite and feminine and even a bit frilly. Note the little cat collar around her neck. She also wears a ribbon with a bell on her chest and a bow on her tail. But other than that, she's mostly human looking. I said *mostly*. Can you see the one other cat element? It's subtle. Did you spot it? It's her mouth. She has a split upper lip, the way a cat does.

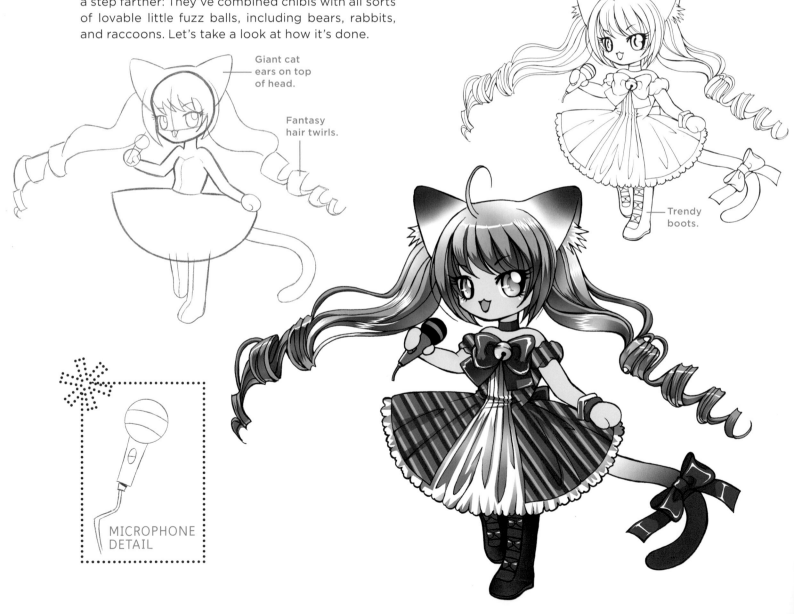

Giant cat ears on top of head.

Fantasy hair twirls.

Trendy boots.

MICROPHONE DETAIL

# Bunny-Girl

Bunnies are very girly and sweet. And so is this character. Big rabbit ears spring from her head, with hair accessories at the bottom of each. A common manga device is to have the character holding a doll in the shape of the anthro on which she is based. So this little chibi carries a stuffed bunny with her. Her coat trim is white and fuzzy, also reminding us of bunnies. Keep her eyes huge, with big shines in them, which looks endearing and innocent. The hair falls all the way down below the waistline. Turn the feet slightly inward for a young-looking stance.

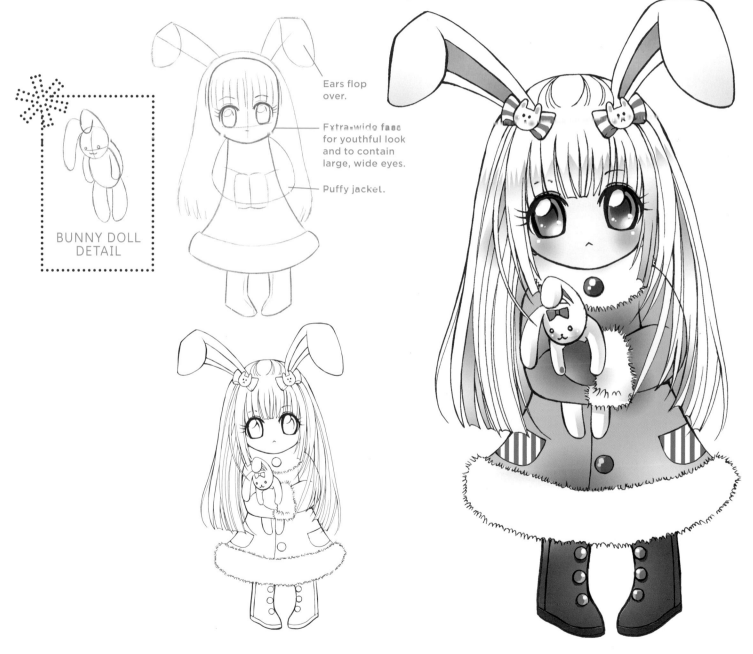

BUNNY DOLL DETAIL

Ears flop over.

Extra-wide face for youthful look and to contain large, wide eyes.

Puffy jacket.

## Tiger-Boy

Personalities of anthro characters often are made to mirror, to some extent, their animal roots. So, a tiger character would most likely be rough and tumble in play—even fearless. Maybe he's the protector of the group. In this way, you allow his animal personality to come to the fore.

This tiger-boy has stripes on his tail. Some artists might go further and add stripes to the arms, too. I wouldn't suggest adding stripes to the face, as that tends to make a character look evil. Note that the tail is shaped in a classic S curve rather than lying flat on the ground, inanimate.

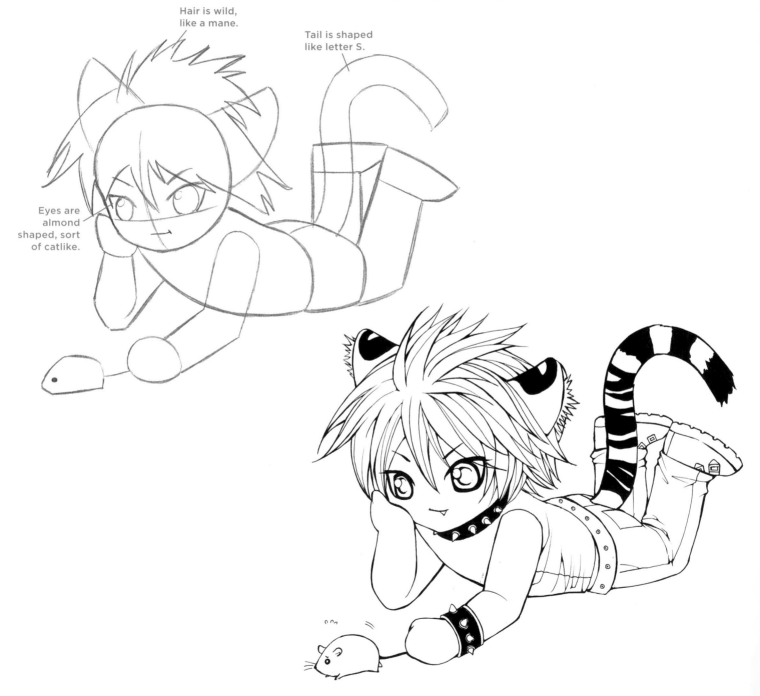

Hair is wild, like a mane.

Tail is shaped like letter S.

Eyes are almond shaped, sort of catlike.

**INDICATING FORM**

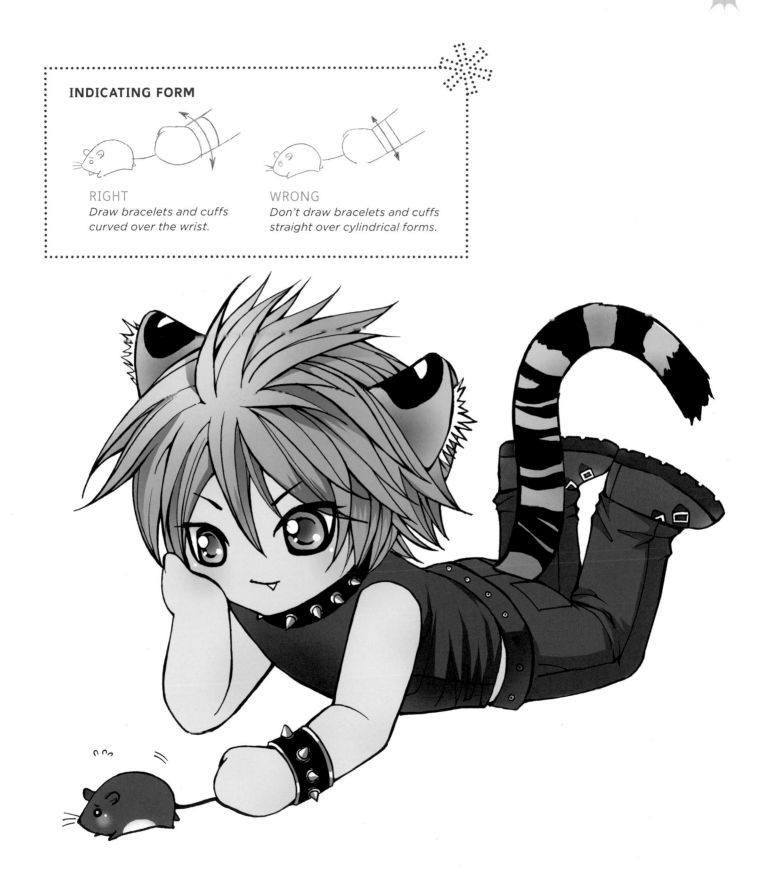

RIGHT
Draw bracelets and cuffs curved over the wrist.

WRONG
Don't draw bracelets and cuffs straight over cylindrical forms.

# Fox-Girl

Coloring is important in creating an identity for your anthro chibis. The fox is known for its rich orange coloring. So not only will this character's ears and tail get the orange treatment but her hair and even her kimono will take on that color theme. Note the white-tipped ears and fluffy tail, which are hallmarks of cartoon foxes.

Although noses are prominent on animals, noses on chibis are not, so we can leave the nose out here. Some artists like to include a few whiskers on their anthro characters. This can work with normal-size cat-girls and other anthros, but chibis are so small and cute that the whiskers tend to "ugly them up" a bit. My personal recommendation is to avoid them with the little guys.

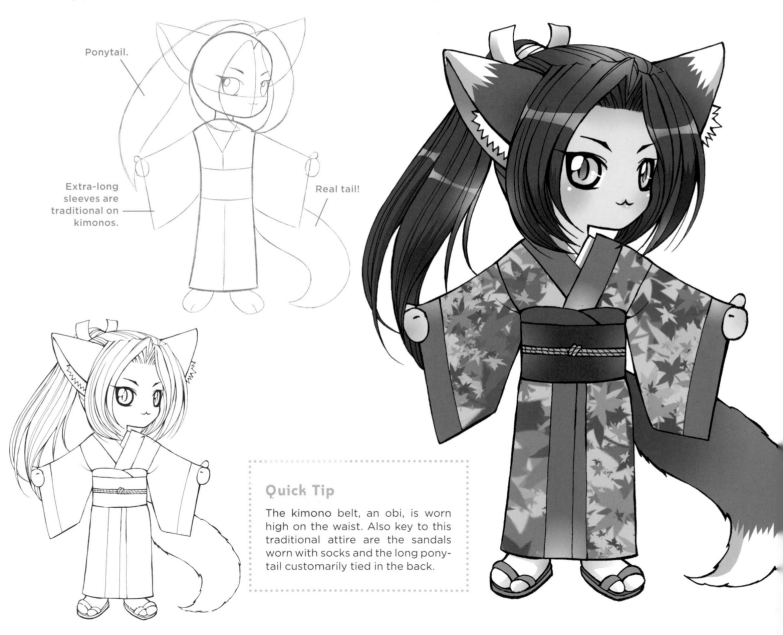

Ponytail.

Extra-long sleeves are traditional on kimonos.

Real tail!

## Quick Tip

The kimono belt, an obi, is worn high on the waist. Also key to this traditional attire are the sandals worn with socks and the long ponytail customarily tied in the back.

# Bear-Girl

There isn't too much you want to change on a chibi girl to make her a bear-girl, because even though bears are thought of as cute, they're also big and fat—and we definitely don't want that for our girl chibi! So, besides bear ears and a tiny tuft of a bear tail, what are we going to give her to reinforce her new identity? Well, how about a humongous teddy bear to lug around with her wherever she goes? In addition, her coloring can also mimic that of a bear, sort of a warm theme that ranges from brown to orange. The color combination of orange and green always works well, so bluish-green eyes are a natural for her. Draw the two of them cheek to cheek, to show affection.

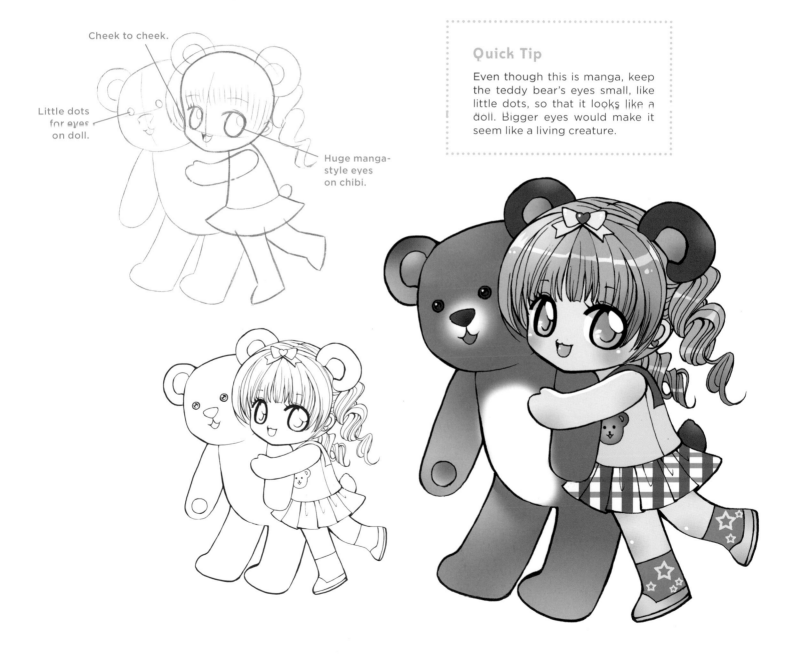

Cheek to cheek.

Little dots for eyes on doll.

Huge manga-style eyes on chibi.

### Quick Tip

Even though this is manga, keep the teddy bear's eyes small, like little dots, so that it looks like a doll. Bigger eyes would make it seem like a living creature.

# Raccoon-Girl

Raccoons are stealthy creatures, like bandits making away with the goods in the middle of the night. The eye mask is perfect for this good-natured rascal. Although real raccoons don't abscond with anything more valuable than a chicken bone left unguarded in a trash can, you can use the raccoon's crafty personality to develop a more ingenious character for your chibi. Perhaps your chibi is a spy or secret agent or even a master jewel thief. Who better than a raccoon-girl (one with sneakiness in her very nature) to play the part? As a nocturnal animal, the chibi raccoon-girl strikes mainly at night.

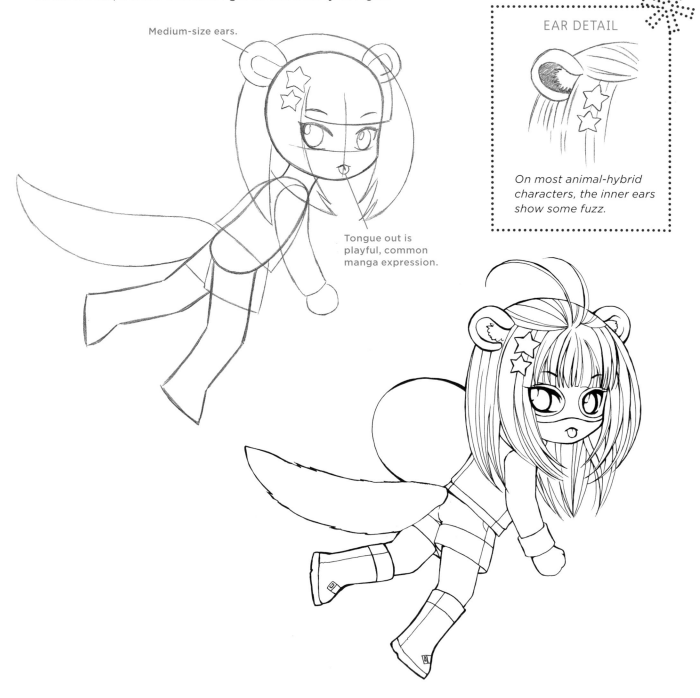

Medium-size ears.

EAR DETAIL

*On most animal-hybrid characters, the inner ears show some fuzz.*

Tongue out is playful, common manga expression.

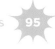

**Quick Tip**

The striped tail is a famous raccoon trait. Make sure to include it on raccoon anthros.

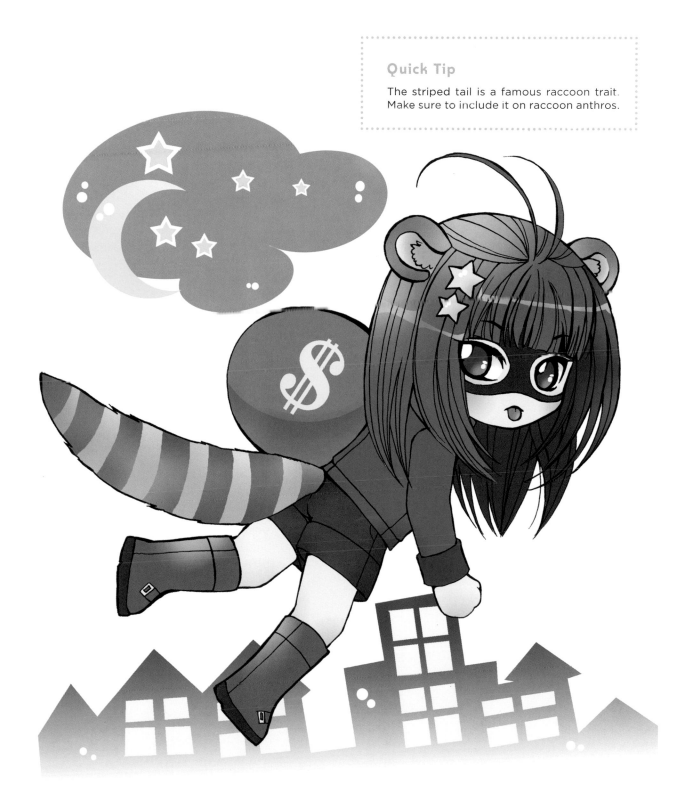

## CHIBI FAIRIES

Fairies are, by definition, tiny. Therefore, chibi fairies must be very, very little, indeed! These enchanted creatures of nature are so light that they weigh less than a feather. You can tell a chibi fairy by its wings, pointed ears, fanciful colors, and swirling or draped clothing. Often, they carry with them musical instruments or a magical staff. Stardust and other special effects oftentimes surround them, adding a glow to their presence. Their expressions are filled with wonder, and they strike elegant poses that are quite appealing to readers everywhere. Fairy chibis are certainly a fan favorite.

## Musical Fairy

Fairies are usually depicted playing such instruments as harps, flutes, mandolins, and lutes. The harp has a heavenly look, which goes well with a long, strapless gown. But be careful not to give your character feathered wings, as that would turn her into an angel (which she's not, as evidenced by her pointy, elfin ears). The wings are, instead, of the delicate, translucent, butterfly variety. The tiara on her head may even indicate that she's royalty, a fairy princess. The fairy princess is a sympathetic character, often portrayed as lonely and awaiting her prince. Sometimes she's held hostage by evil usurpers of the throne.

Gently sloping shoulders.

Large, round near eye, narrow far eye.

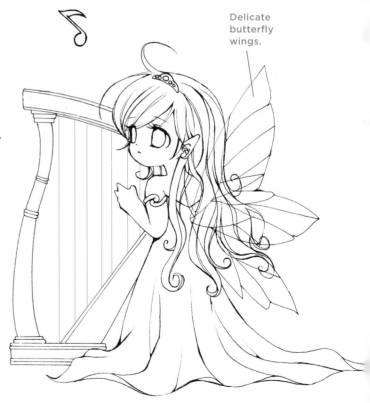

Delicate butterfly wings.

## OVERLAP IN THE 3/4 REAR VIEW

Note that the upper arm overlaps the forearm from this angle, blocking parts of it from view. The upper arm also overlaps the side of the body and upper back.

## Snow Fairy

Fairies can usher in the seasons, and one of the most popular seasonal fairies is the snow fairy. With snowflakes gathering all around him, he descends over the meadow, spreading a cold layer of frost that will envelop the ground for the long winter months ahead. He strikes the classic fairy flying pose: arms outstretched and legs tucked beneath. Notice that the legs are foreshortened, meaning that you cannot see the calves but only the upper legs and then the feet. The knees block our view of the calves. This helps to streamline the pose. If the legs went straight down, the pose would take an odd right angle at the waist. This way, the coat provides the flowing line of action. Note: Deep blue is the color of cold and ice.

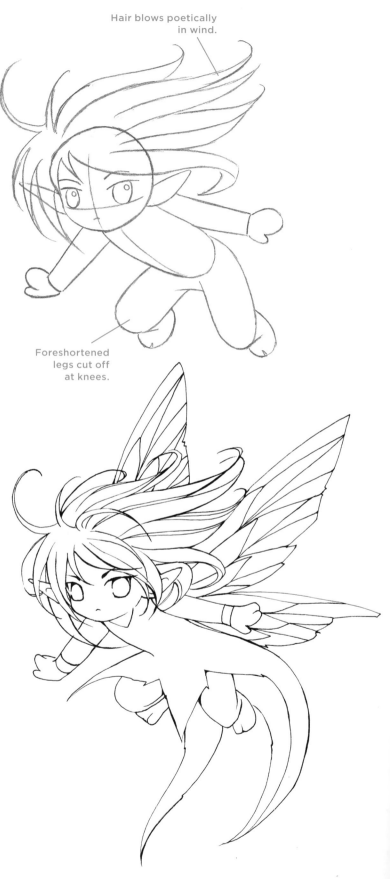

Hair blows poetically in wind.

Foreshortened legs cut off at knees.

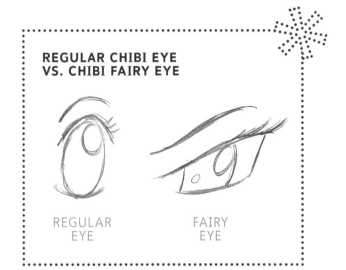

**REGULAR CHIBI EYE VS. CHIBI FAIRY EYE**

REGULAR EYE

FAIRY EYE

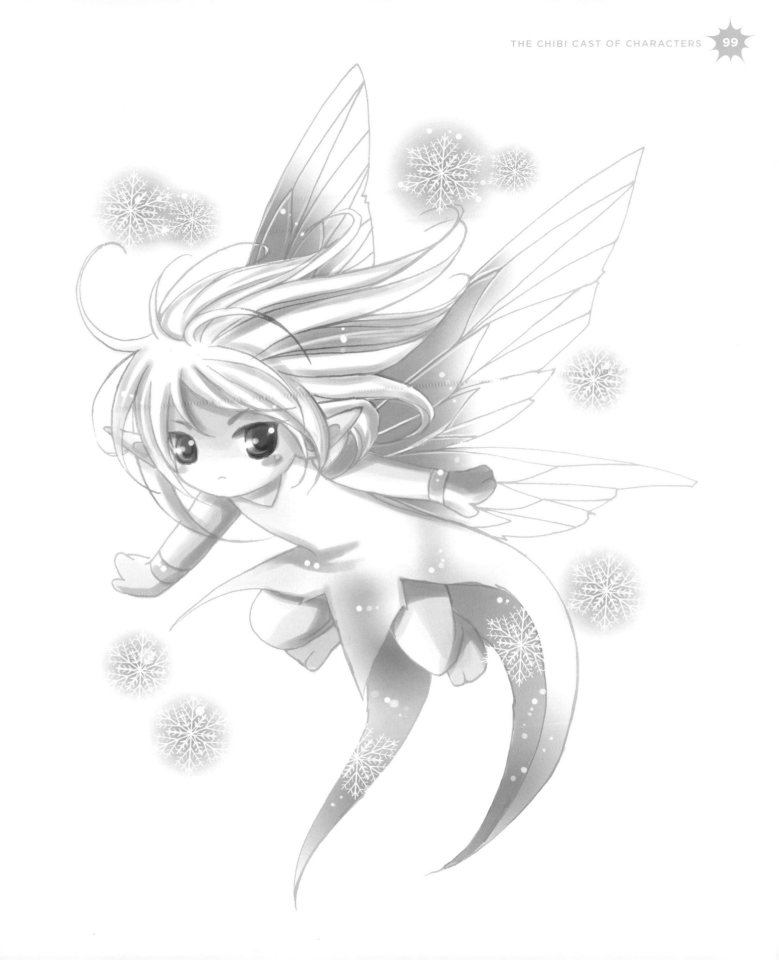

## Water Fairy

Wings turn what would otherwise be a mermaid into a water fairy. Regular mermaids have no wings. But winged water fairies have the ability to fly for short distances above the water and to swim below it. The aqua color, with green highlights, gives her the look of a water being. Jewels, seashells, and beads adorn her, and she is quite pretty. Her hair mimics wind-swept hair, as it drifts romantically along the water currents. Notice the thin veins in the wings, which add elegance; without that touch, the wings would look too robust, like sci-fi appendages. Note also how graceful she looks, with her entire body forming an S curve.

**IT'S ALL IN THE DETAILS!**

Don't overlook the little things. Here, the head tilts back slightly, for a coy look. It's just the touch to finish off the pose.

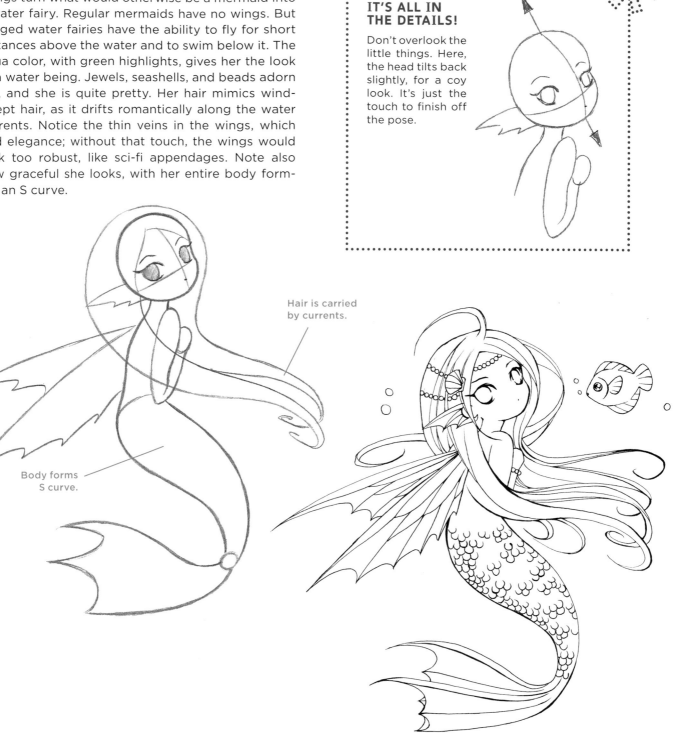

Hair is carried by currents.

Body forms S curve.

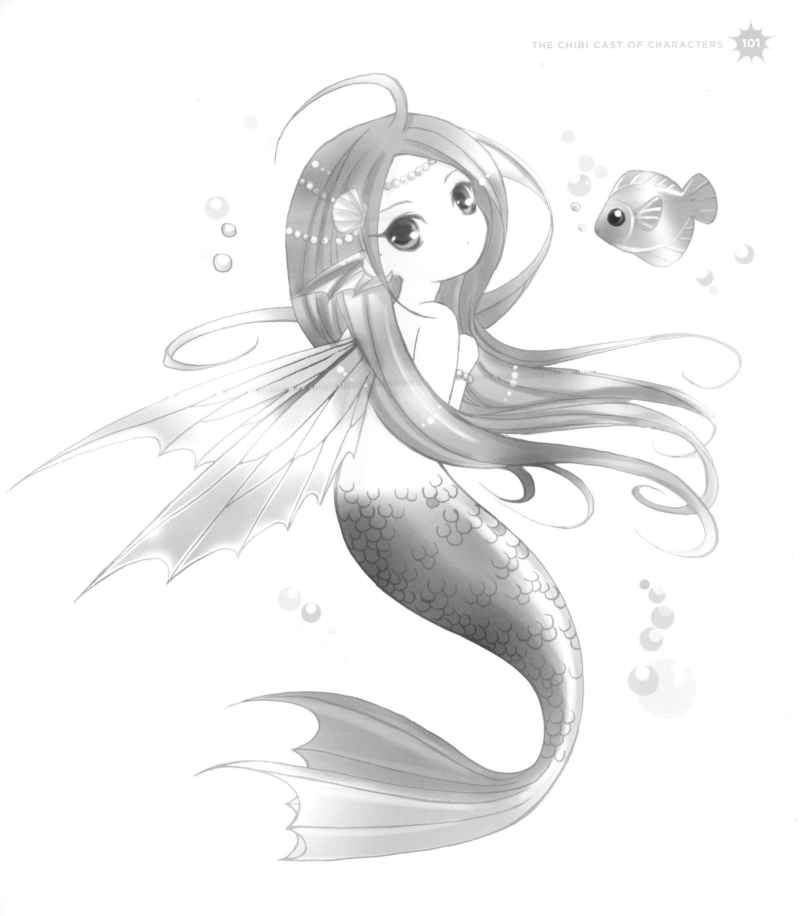

## Cat-Girl Fairy

Cat-girls are so popular that they turn up everywhere, even in fairy stories! Since your cat-girl must have cat ears, the fairy ears will have to be eliminated. The only thing overtly fairyish on her are the double set of gossamer wings. But in keeping with our fairy theme, she also has a flowing outfit and flowing hair. Rather than something beige, which would be more earthly and reminiscent of a cat, the magenta color is straight out of fantasyland. Her cat buddy is also not a realistically drawn cat but a fanciful interpretation, which works to make it look like an enchanted feline—perfect for a fairy's companion.

Giant cat paw.

Cat's bell matches bell detail on dress.

**THE INS & OUTS OF THE HEMLINE**

Indicate the undersides of the ruffles to create the form of the fabric folds.

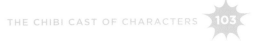

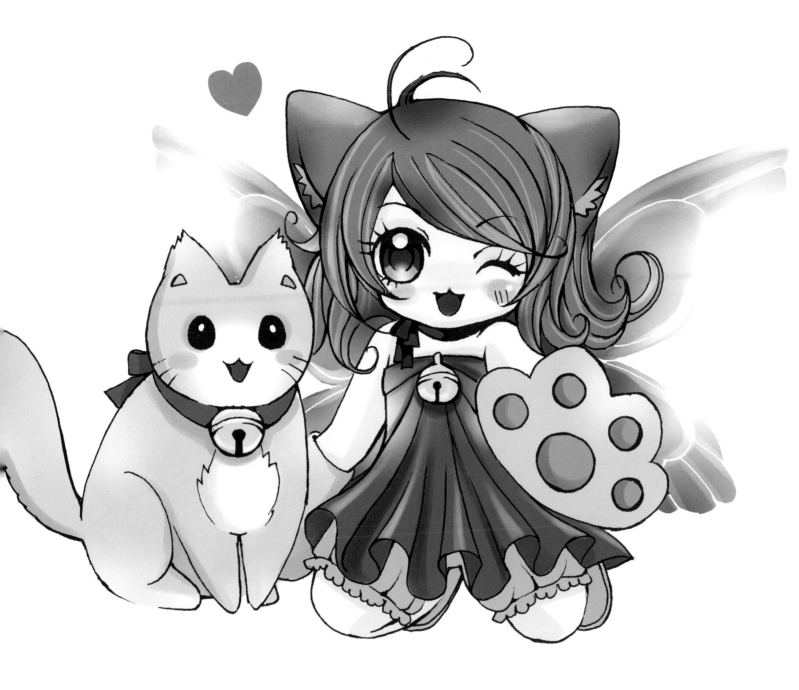

# HUMOROUS CHIBI COUPLES

Once you know how to draw individual chibis, you can put two characters together. We want chibis to interact to create humorous situations. The key to illustrating humor is to show two characters working as a team but each having a very different experience.

Also pay attention to staging: Be sure to draw your couples close together—probably closer than first feels natural to you. Don't worry that it might look cramped. Most beginners make the mistake of staging their characters too far apart, not too close together.

## THE UNEXPECTED KISS
*The look on his face is priceless. It could have been drawn with a happy reaction instead, but that wouldn't have been as funny. The stunned blush is a perfect response. And her expression also works well. She's oblivious, totally unaware of the emotional havoc her one little peck on the cheek has caused. Two people, one kiss, but two totally different reactions. That's the key to humor.*

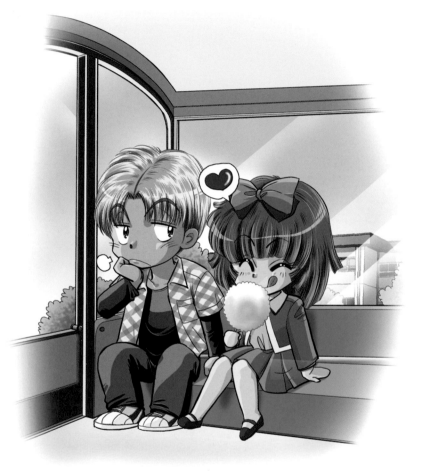

## THE CRUSH
*It's all about positioning here. There may be a ton of empty seats on the bus, but she has zeroed in on her guy! She's just happy to be there, sitting next to him with nothing to say, just blowing gum bubbles while he's bored out of his wits.*

## SKYDIVING
*The fun! The thrills! The sheer terror!!! Here are two people doing the same thing but having two totally different experiences—again, that's a perfect setup for humor.*

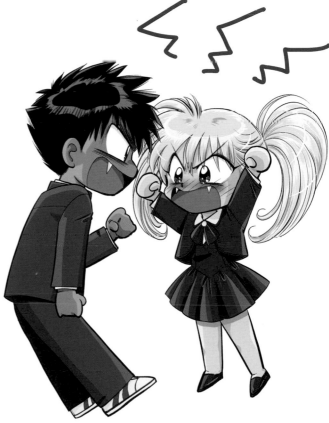

## SLURPING
*Symmetry doesn't work as well in dramatic situations as it does in humorous ones. Things that are dramatic are often drawn to look edgy, off balance, sharp, angled, or high in contrast. But comedy is often symmetrical, and this picture shows how effective a symmetrical setup can be.*

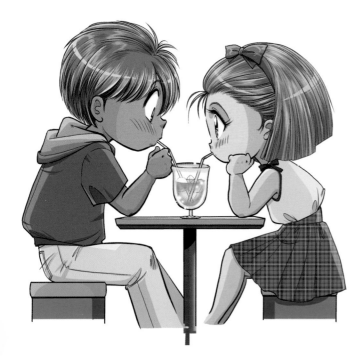

## OH, YEAH? YEAH!
*Aren't chibi arguments fun? Two little powder kegs going at each other with explosive tempers. Actually, this is exactly what happens to normal-size characters in manga stories when they go ballistic during arguments they "turn chibi."*

## SLEDDING

*This is a classic setup, with one character engrossed in the action, while the other character breaks for a moment with a wink to the reader. Manga is the most effective visual art at using this type of reality break. With other styles of cartoons and comics, the result of a "nod" to the reader can be jarring. But with manga, it helps bring the audience into the story and closer to the characters.*

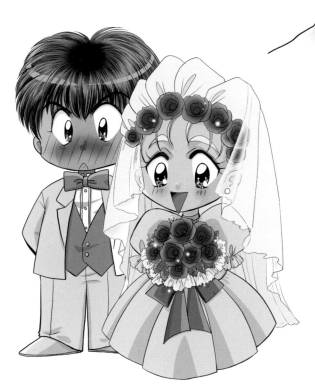

## WHOOPS!

*The best point at which to illustrate a comedic moment like this one is just as everything is about to go wrong but it's too late to do anything about it. Humor is funniest at the moment of anticipation.*

## WHAT HAVE I DONE?

*Again, it's the classic comedy setup when two characters are sharing the same moment but having two entirely different emotions—and only the reader is in on the gag! In a scene like this one, it's important that both characters look straight ahead. If they were to look at each other, they would see what the other is thinking, the situation would be revealed, and the moment would be over.*

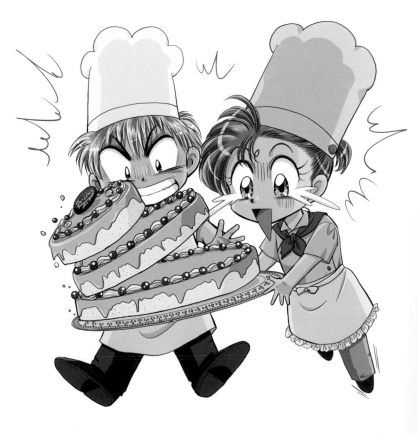

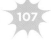

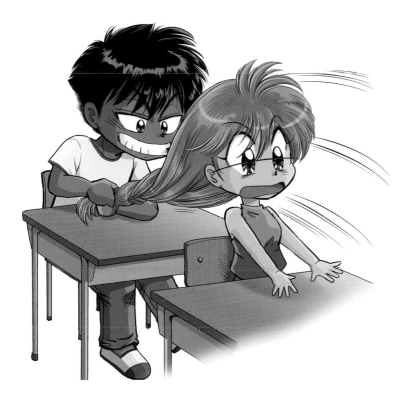

## HEY, CUT IT OUT!

*Open her eyes in a surprised look rather than a look of pain. Pain that's made to look silly can be funny, but if something looks like it really hurts, your reader is going to think you're heartless for poking fun at it.*

## LOOK OUT!

*This is a typical moment when characters "chibi-out" (transform from regular manga characters into chibis). The extreme emotion that triggered the event would be a fear of whatever is after them. Notice the gushers streaming from the girl's eyes.*

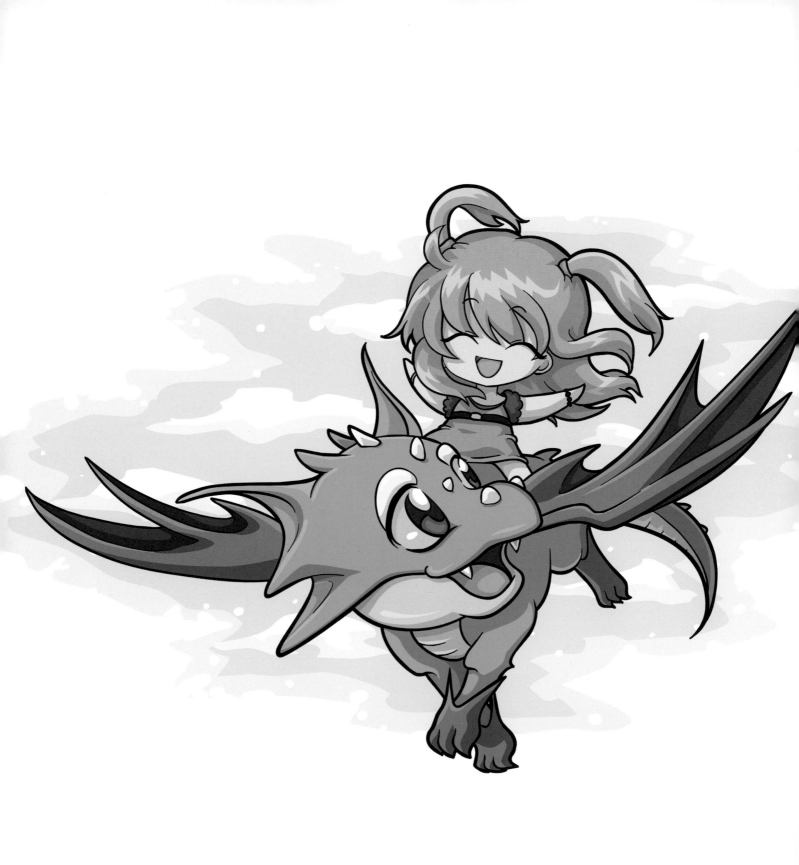

# Mini-Monsters

SOME OF THE MOST INVENTIVE CHIBIS are found in the realm of the cute mini-monsters. This is where your imagination becomes your primary tool. As you get creative in coming up with various types of creatures, try to maintain chibi proportions, which for the most part are based on simplified shapes and chubby little bodies. Although many adorable manga monsters come solely from the imagination, many are also based on dinosaurs, mammals, birds, and even sea life. Most are engaging, but even the evil ones are never drawn to appear overly serious, therefore "winking" at the reader and never truly threatening—no blood dripping from giant fangs or razor-sharp claws. Keep it witty and tongue-in-cheek.

# LITTLE CUTIES

Tiny, cute monsters have the same proportions as human chibis: huge heads on top of little bodies. This one's head is half the length of its entire size. The facial features have been pushed down about as far as they can go, which mimics the placement of the features on a baby. (Like this little chibi monster, babies also have wide eyes and small mouths.) Instead of ears, there are oversized "ear-pieces" on each side of the head; they remind me of Japanese-style hair buns. As for the hands and feet, don't add fingers and toes. These would only make the monster appear too human. And never use a human flesh tone for the skin color, either. That would make the reader self-conscious that the monster isn't wearing any clothes. It's best to avoid the issue entirely by being fantastical with the choice of color.

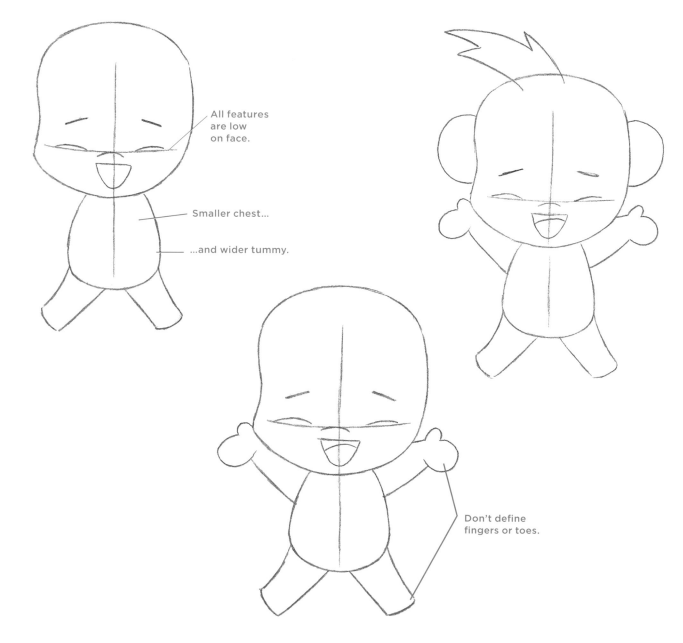

All features are low on face.

Smaller chest...

...and wider tummy.

Don't define fingers or toes.

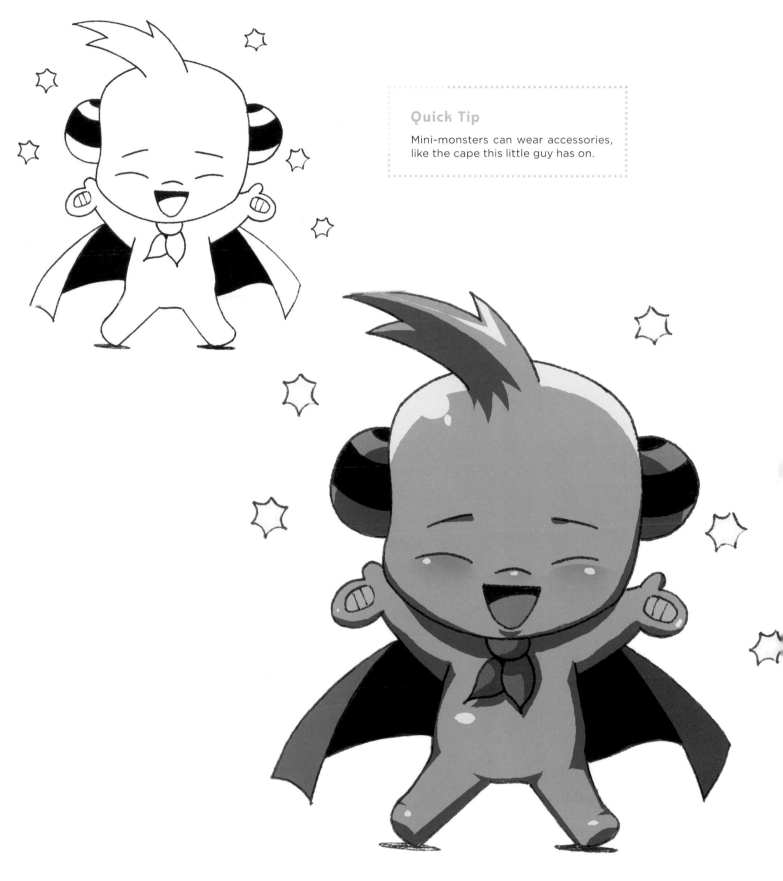

**Quick Tip**

Mini-monsters can wear accessories,
like the cape this little guy has on.

# MONSTERS WITH HORNS

Horns and spiny protuberances are popular additions to manga mini-monsters. Although there are no hard-and-fast rules, horns tend to be used most often on creatures that resemble reptiles. Note the striations across the belly, reminiscent of an alligator. This little guy has a slightly squarer face than the little cutie on the previous page, but he's still pretty round overall. The eyes are small circles, or what's commonly referred to as "button eyes." They're very cute and often have more than one shine in them. The V motif on the forehead is seen frequently in manga on everything from chibis to mecha characters. Tying in to the horn idea, the fingernails and toenails have the look of hard calcifications, making them appear clawlike.

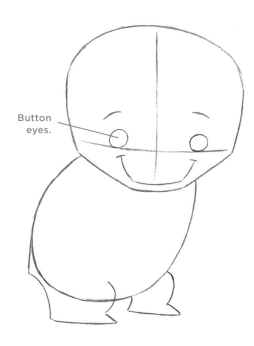

Button eyes.

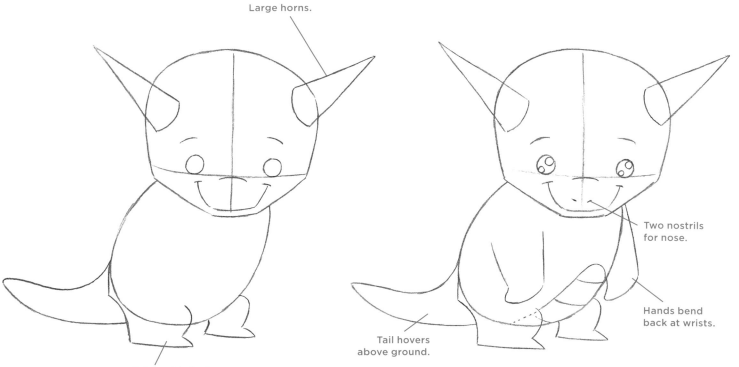

Large horns.

Thick, wide feet.

Two nostrils for nose.

Tail hovers above ground.

Hands bend back at wrists.

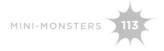

**Quick Tip**

Don't be shy about it; little monsters can have big horns!

# MAGICAL MONSTERS

These pleasing little characters are typically plump, four-legged animals that sit upright on their hind legs. The hind legs are tucked in pretty tightly and therefore bunch up, giving them a chubby look. The sloping shoulders connote dearness. In addition, this monster sports true fantasy-style markings: zigzag stripes on the body and head. The ears are also whimsical in shape, and the eyes are big, with huge shines in them that reflect the light from the magical orb.

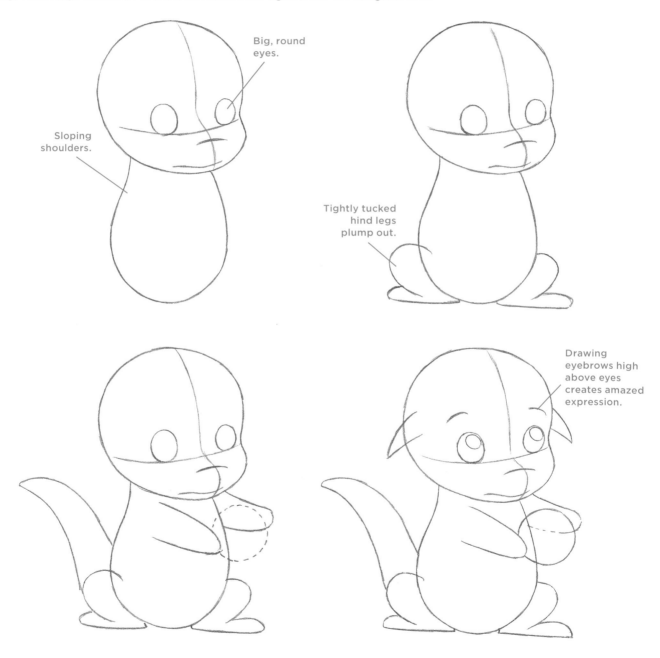

Big, round eyes.

Sloping shoulders.

Tightly tucked hind legs plump out.

Drawing eyebrows high above eyes creates amazed expression.

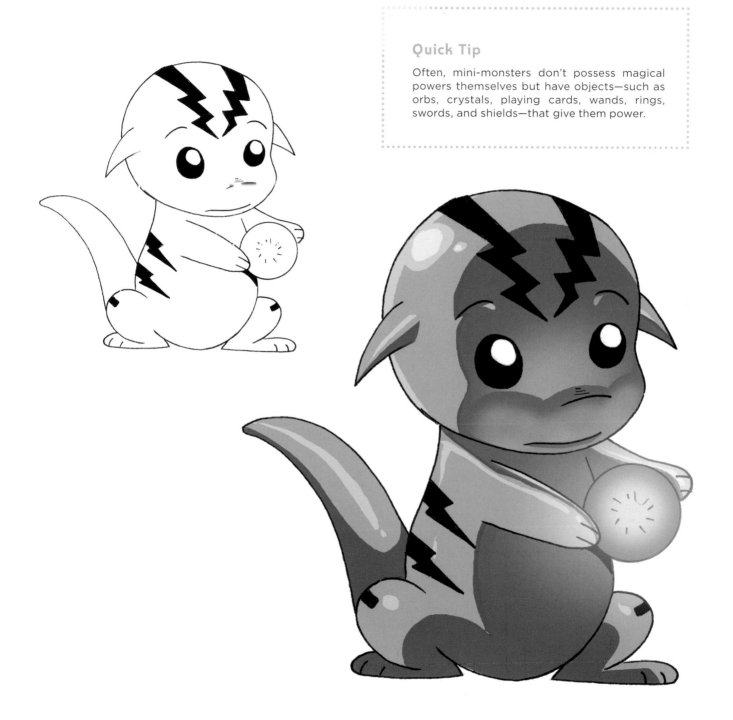

### Quick Tip

Often, mini-monsters don't possess magical powers themselves but have objects—such as orbs, crystals, playing cards, wands, rings, swords, and shields—that give them power.

# EVEN MORE MINIS!

## HIPPO

*As you've no doubt noticed, many chibi mini-monsters are anthropomorphic in the sense that they stand upright on two legs, like humans. You can—and should—do that even with this hippo. And if you stopped there, you'd be left with an ordinary hippo cartoon, so the eyes should be adjusted to be manga-style. A few more inventions are also included here: a long, "unhippolike" tail; spikes on the back; and dorsal fins on the head.*

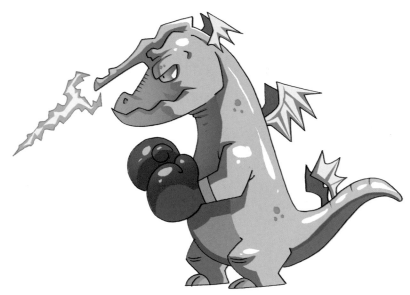

## DINOSAUR-STYLE MINI-MONSTER

*No group of chibi mini-monsters would be complete without at least one super-powered, predatory dinosaur. This type is ubiquitous in the world of mini-monsters. They terrify the smaller chibi monsters and may actually possess some pretty powerful magical abilities, but readers find them funny because they're such tiny bullies. The boxing gloves are a common, humorous motif in manga. And they're funny here because this is a T. rex–style monster, and the T. rex was known to have puny, useless arms. So what are a couple of boxing gloves going to do for him? Note that the predator type of mini-monster has a different eye than the cute type: The pupil is a mere pinpoint surrounded by the whites of the eye rather than a large and glistening manga pupil.*

## ANXIOUS MONSTER

*Some monsters are worriers. They make you want to just pick them up and reassure them. This type is usually partnered up with a human pal who's a playmate of the little monster. Sometimes the little monster can be a pain in the neck—too needy, or too curious at the wrong times, but always adorable. Some of them are so shy they disappear whenever anyone else except their pal is around, so it's like having an invisible friend.*

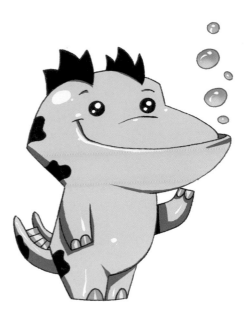

## MINI-MONSTER PETS

*Some adorable pets happen to also be chibi monsters. This cutie's gigantic eyes make her look timid. A lightning bolt marking always denotes an enchanted origin, as does the coloring, which cues us in that this is not an ordinary pet. Of course, we can't leave those triangular cat ears alone—they're too tempting for us manga artists! So we'll turn them into something special, like geometric cones, to make them look less realistic. The head shape is tweaked to be rectangular and super-large.*

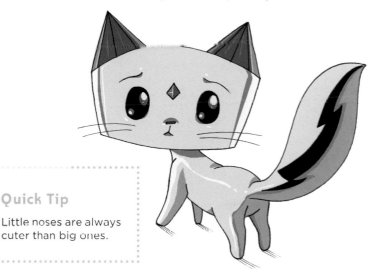

## BURPING MONSTER

*You've got to excuse him. He forgets his manners whenever he gets a little tummy trouble. Many mini-monsters are cautiously friendly, playful tykes, like this one. In addition to his indigestion dilemma, he has a unique double set of dorsal fins on top of his head and a double set of tails fused together. Irregular spots decorate his chubby body. Make sure that the back of his head sticks out from his body, in the same way that his jaw sticks out.*

**Quick Tip**

Little noses are always cuter than big ones.

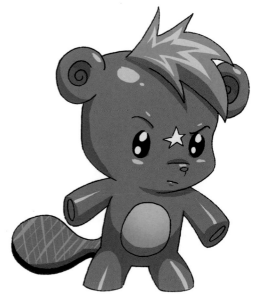

## PLUSHY MONSTER

*Many of the most beloved mini-monsters look somewhat like children's plush toys. The trick is to make them look determined and fighting mad while still squeezable and cute. This one's design has been borrowed from a teddy bear. Instead of tapering the limbs at the hands and feet, they actually get wider, as they often do on teddy bears. Of course, this is not a teddy bear but something different. So you want to accentuate that difference. Instead of the small button eyes that you'd expect on a teddy bear, he has large, oval, glistening shoujo-style eyes. A huge tuft of spiked hair works to bring him into the manga genre. And notice the little star on his forehead: Facial emblems and markings are common on fantasy characters. Last, the tail is from a completely different animal: the beaver. This reinvents his look and is also, and not coincidentally, the tail of another cute animal. Giving him the tail of a reptile, for example, would look too weird.*

## CHIBI MONSTERS AND THEIR PEOPLE

Some monsters have zippy personalities and are hard to control, while others are docile and friendly. Some are too playful, never giving their human friends a break, while others exhibit special powers that can charm and protect their people. Whatever the dynamic, the mini-pal is very attached to the chibi.

Eye contact is an important element in building the team relationship. The characters don't have to look at each other's eyes in every drawing, but usually it's a good idea to have at least one of them looking at the other as a gesture of acknowledgment. Otherwise, it appears that you have two unrelated individuals in the scene.

## Silly Songbird

This little bird has the power of music. It can hypnotize a chibi simply by chirping a lullaby. Unfortunately, it also puts itself to sleep that way! Note the scale of the monster as compared to the chibi. This is a typical, medium-size chibi monster. Generally speaking, the smaller the chibi monster, the faster it moves. But that's not to say you can't invent your own fast-moving, fat chibi monster. Still, as you'll see, the fat ones are funnier if they are depicted as lumbering, and good-natured but lazy. For the cute mini-monsters, plump is the way to go.

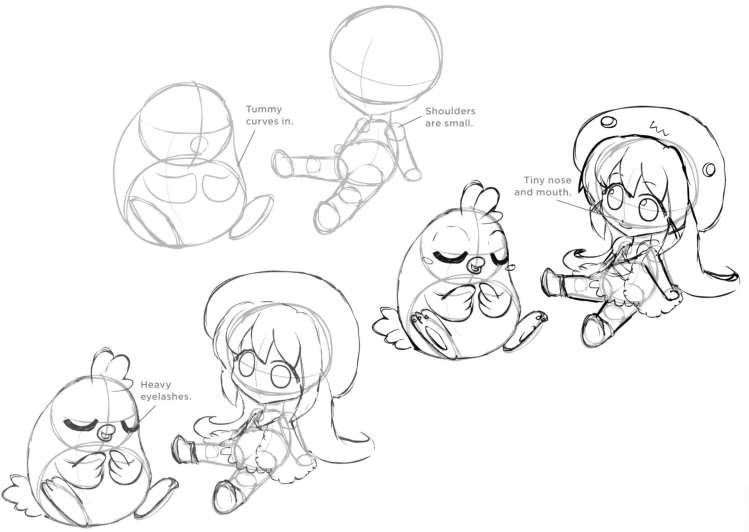

Tummy curves in.

Shoulders are small.

Tiny nose and mouth.

Heavy eyelashes.

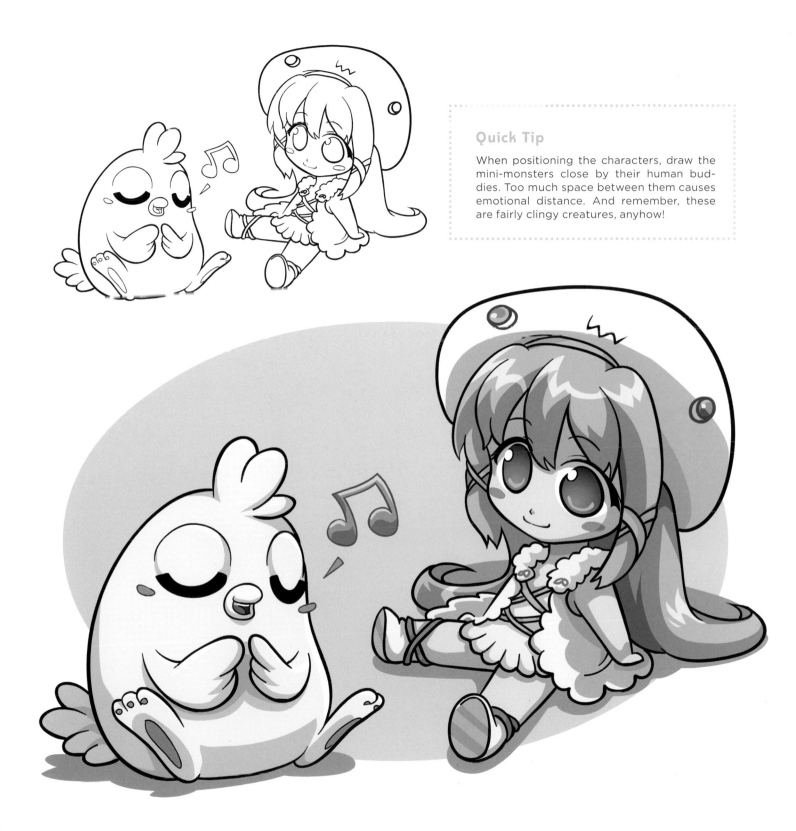

## Quick Tip

When positioning the characters, draw the mini-monsters close by their human buddies. Too much space between them causes emotional distance. And remember, these are fairly clingy creatures, anyhow!

## Flying Companion

Trying to keep up with a small flying chibi will have you out of breath in no time! These little companions flit about playfully, having fun with their human pals. The chibi monster can be a basic shape, and this one is built on as basic a shape as you can have: the circle. The giant eyes and split lip give it a cute, animal-like face. The squiggly things and tail give it a fantasy look.

Note the pose of the human chibi. The extended foot (the push-off foot, here) is planted at an angle, instead of straight down, in order to show action. The arms and elbows are out from the sides of the body. And the hair, too, gets into the act, bouncing around and adding to the sense of motion. (Note how the arms and legs both taper down to small hands and feet.)

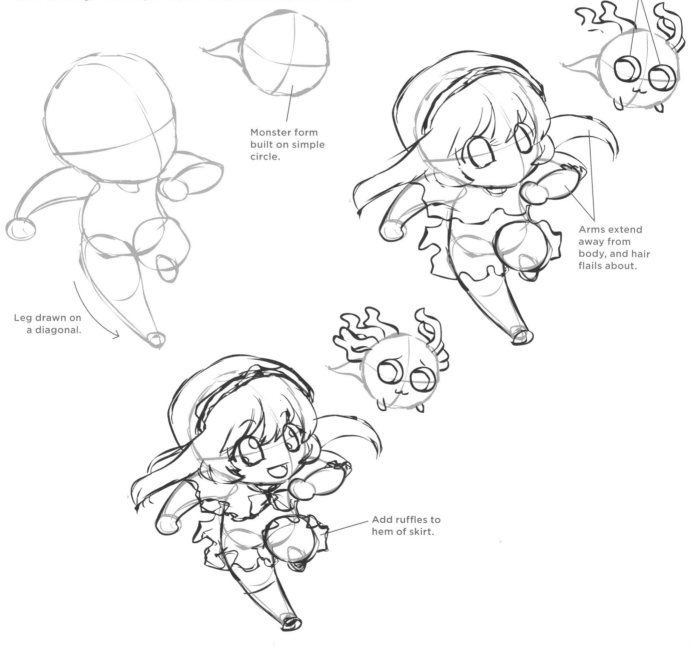

Monster form built on simple circle.

Huge eyes take up most of face.

Arms extend away from body, and hair flails about.

Leg drawn on a diagonal.

Add ruffles to hem of skirt.

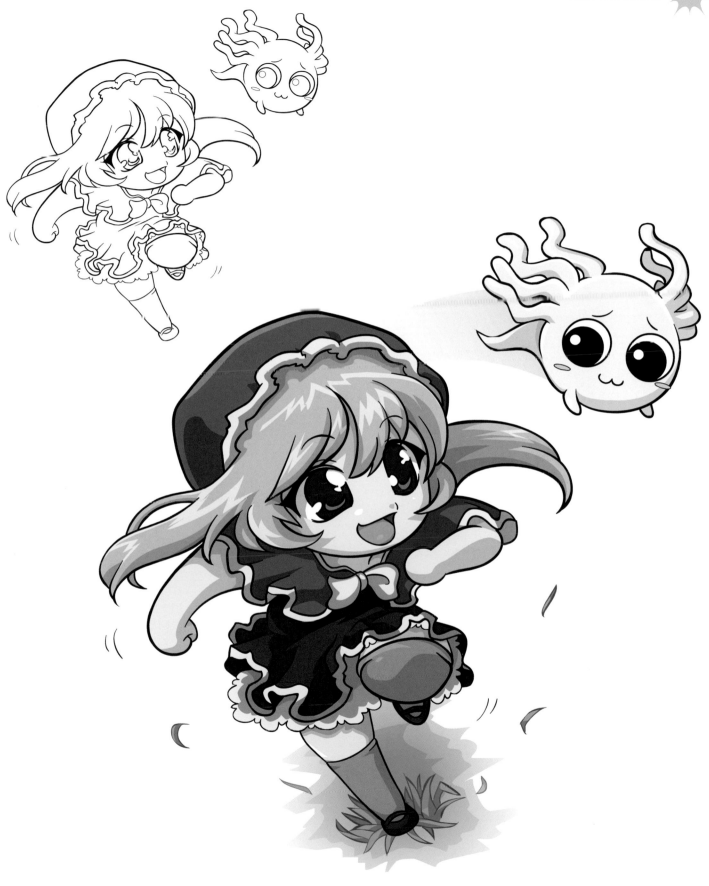

## "Big" Flying Companion

Mini-monsters provide the ultimate wish-fulfillment fantasy: the ability to fly. Hopping on the back of a favorite monster soon takes you above the clouds on a spectacular journey to faraway lands with the promise of new adventures. Winged monsters need a wingspan wide enough to give the illusion of good gliding capabilities. Therefore, drawings of these characters will be more horizontal, since the wings stretch out horizontally across the page. You'll need to position your figures in the middle of the page so that neither of the wings gets cut off by the edge of the paper.

It works best to draw the monster first; this gives you a platform on which to draw the sitting girl. Keep her body simple. After all, some of it will be cut off by the creature's head, anyway. Simplicity is also good because, visually speaking, we don't want the chibi to compete with that great flying monster. The flyer is the star; the girl remains static and symmetrical, while the flying monster is posed more dynamically, with one leg crossing over the other and the head tilting back to catch a glimpse of his cargo.

Wide wingspan.

Large head.

Both ponytails blow in same direction.

One leg crosses over the other.

Foot and tail peek out.

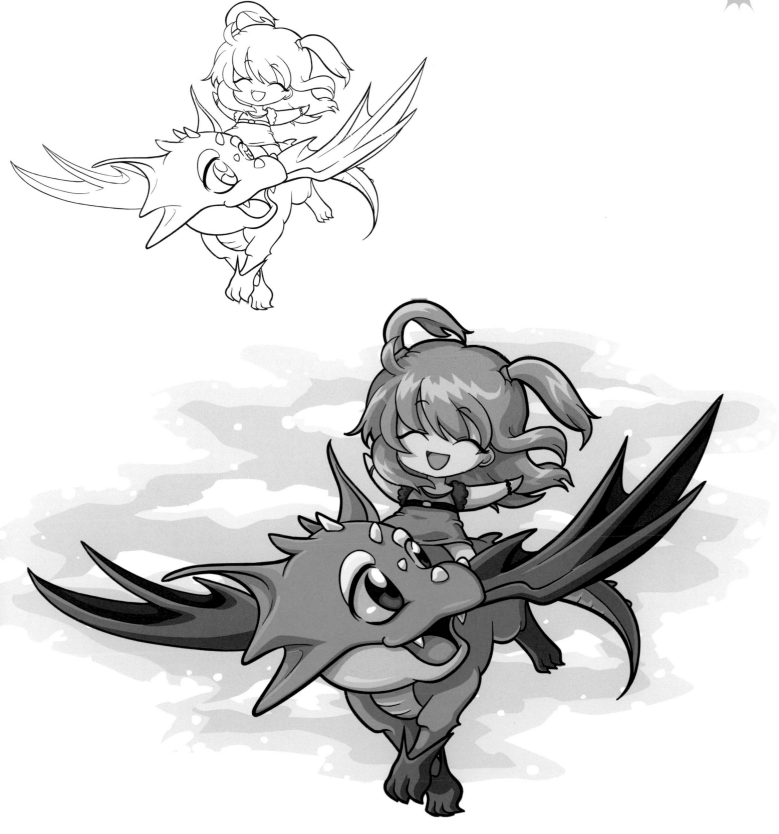

## Hyperactive Fur Ball

The tinier they are, the faster they bop around! It's no use trying to calm down these playful little creatures. They are a bundle of energy and are going to bounce around—ricocheting off walls, ceilings, and floors—until you're all worn out and your place is upside down. Then, while you clean up, they'll be snoozing. The horns are purely decorative; these little fur balls couldn't hurt anybody. Notice the monster's closed eyes. This represents extreme joy. Then notice the chibi's wide-open eyes, representing extreme distress!

Hair starts off in buns.

Hair buns ruffle and start to fall out.

Add ram-style horns.

Fur ball bends at "waist."

Speed lines indicate chibi is moving.

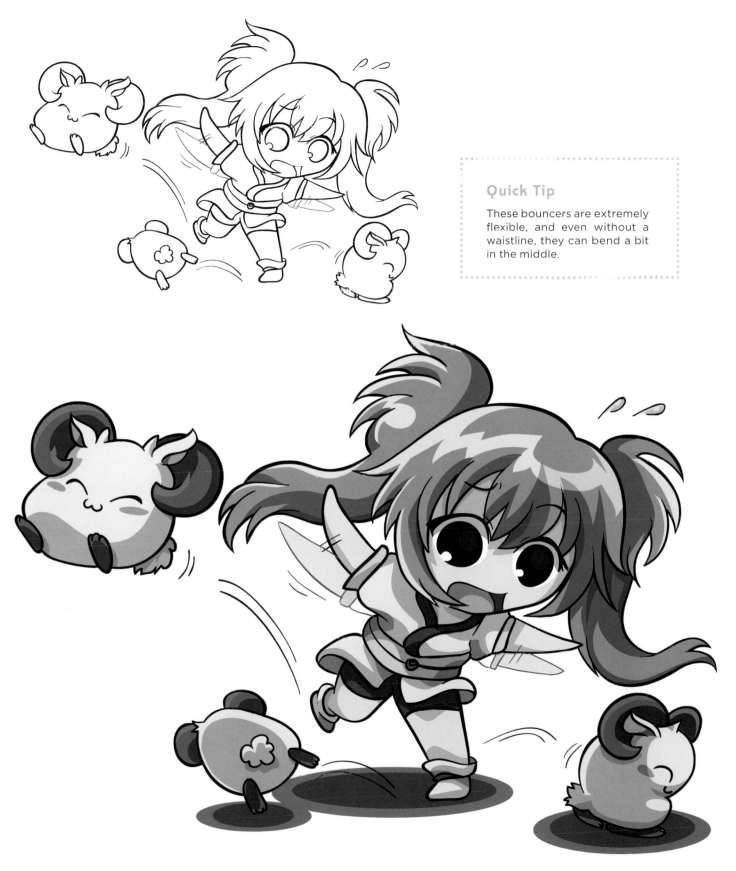

**Quick Tip**

These bouncers are extremely flexible, and even without a waistline, they can bend a bit in the middle.

## Scaredy-Cat

This kitty is going to turn his chibi into a scratching post if he's not careful. The ears are elongated, reminiscent of a fox. And notice the cat's eyes; they've gotten so wide with fear that the boundaries between them are gone and they're now melded together into one. If you look closely, you'll also see little motion lines in the whites of the eyes, surrounding the pupils in the final, color image.

In contrast to this, the boy has one eyebrow up and the other down, which is the classic expression for consternation. His hair is a mess, adding to the sense of confusion. He's also swimming in those clothes that are too big for him. But then again, everything is too big for him—he's a chibi!

Foreleg tapers down to tiny paw.

Tail wraps around chibi's face.

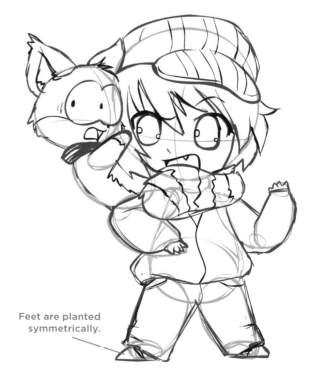

Feet are planted symmetrically.

## Quick Tip

Since the main performance in this gag falls to the cat, the boy should be left relatively inactive and static, so as not to compete with the cat's outrageous pose.

## Sushi Swiper

Mini-monsters are notorious for mischief. And look at the result of this monster's brazen pilfering: He sends his chibi friend into a rage! His eyes go blank inside his glasses, blush streaks go down his cheek, and a shock effect emanates from the side of his head. Meanwhile, the little monster, who really could stand to skip a meal, is happily darting away from the scene of the crime without giving it a second thought. Keep the monster's mouth small, which is necessary for a cute look.

And remember what we said about the importance of drawing comedy team members close together? At first, it may appear as if these two characters are far apart, but in reality, the monster's foot is almost touching the table. So they're actually in close proximity to each other. It's only an illusion that they're far apart.

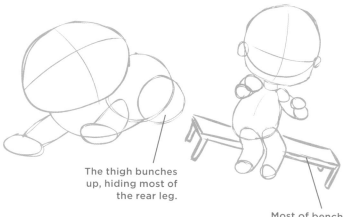

The thigh bunches up, hiding most of the rear leg.

Most of bench will be hidden by table.

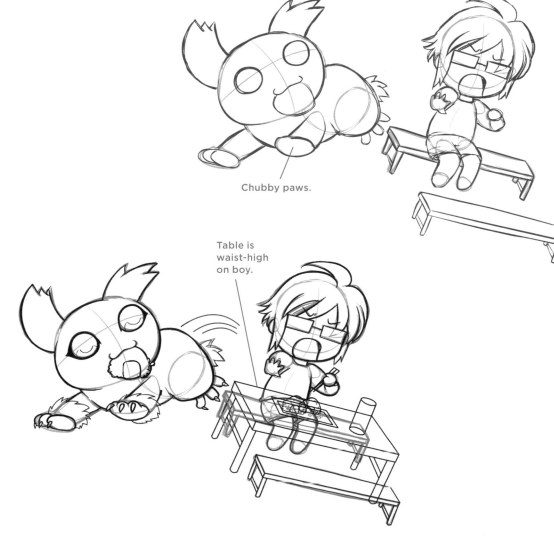

Chubby paws.

Table is waist-high on boy.

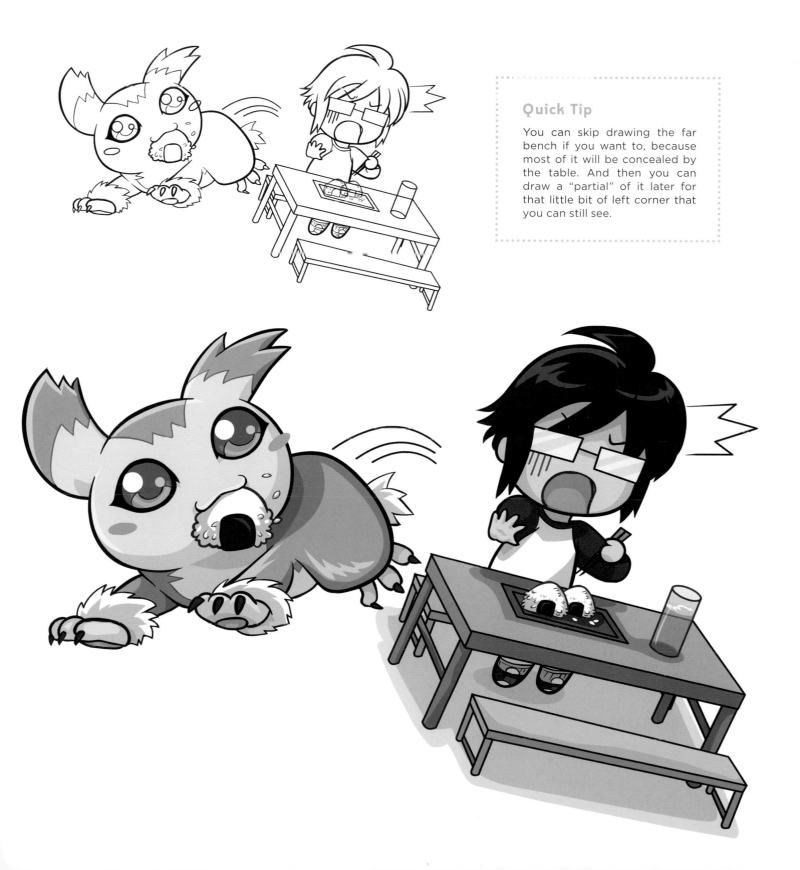

**Quick Tip**

You can skip drawing the far bench if you want to, because most of it will be concealed by the table. And then you can draw a "partial" of it later for that little bit of left corner that you can still see.

## Protective Monster

Brave little tyke. This monster summons all his powers to protect his chibi friend (a cat-girl) from evildoers. His mouth opens wide and lets out a rush of wind, which can overpower the "baddest" of bad guys. Leave it to those tiny ones to pack a punch with their magical powers.

This mini-monster is a plant hybrid, a popular type of creature. He has button eyes and only a dot for a nose. His arms and legs are short and cute as they are, so there's no need to add fingers or toes.

The cat-girl's ears are drawn horizontally. She also has a big head of hair, which can hide the origin of the ears—something you have to contend with when drawing any cat-girl. Her knees and hands are together in this timid pose, as she hides behind her protector-friend.

Body turns away fearfully from danger.

Body leans forward to assert authority.

Ears point sideways.

Arms and legs are too short for fingers and toes.

Both shoulders are out in front of body.

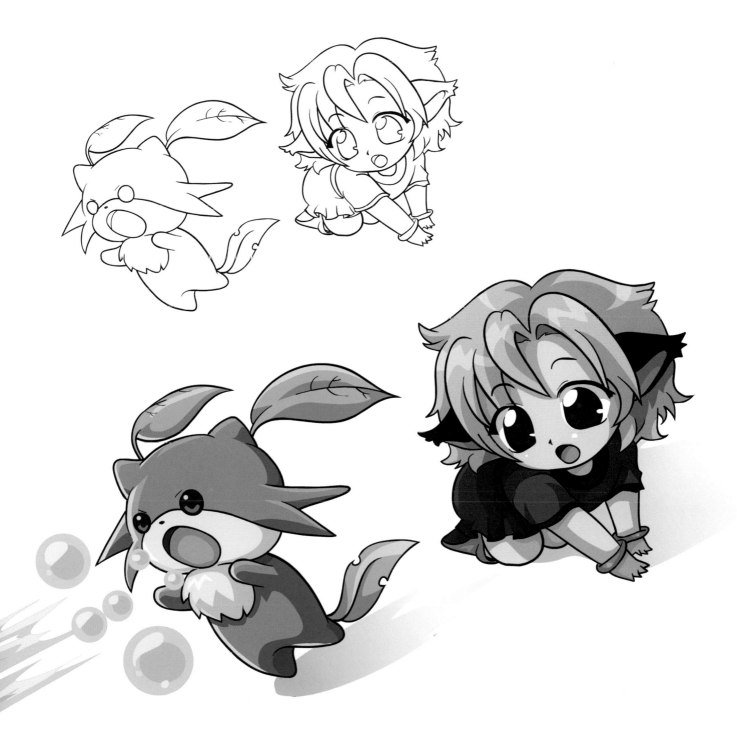

## Sleepy Sidekick

This sleepy monster and his chibi are obviously working on two different schedules. The sweat drop by the little girl's head indicates maximum effort as she tries to roust this guy from his delicious slumber. Opposing intentions make comedy work. The chibi is cast as a type A personality, while the monster is a type B personality. Make that a type C!

These are about the upper limits of how big you can make your mini-monster before it starts to overpower its little chibi friend and look, well, like a real monster. (You can make some bad-guy monsters a lot bigger, but then they'll look less "chibi-ish.") This guy, the size of an overstuffed sofa, is still within the size range of a chibi monster. And, again, notice the contrast: Big nose, little eyes. Big body, little legs. Contrast is humorous.

Monster body built on two ovals.

Very short, plump limbs.

Front knee bends deeply.

Back leg is straighter.

Monster's tail extends past girl.

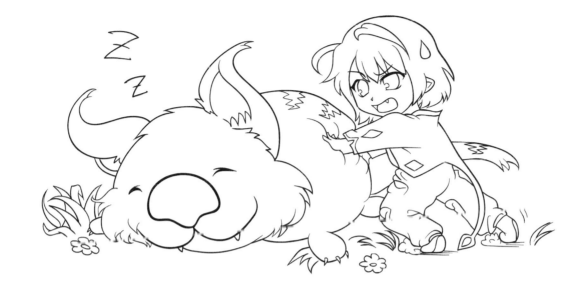

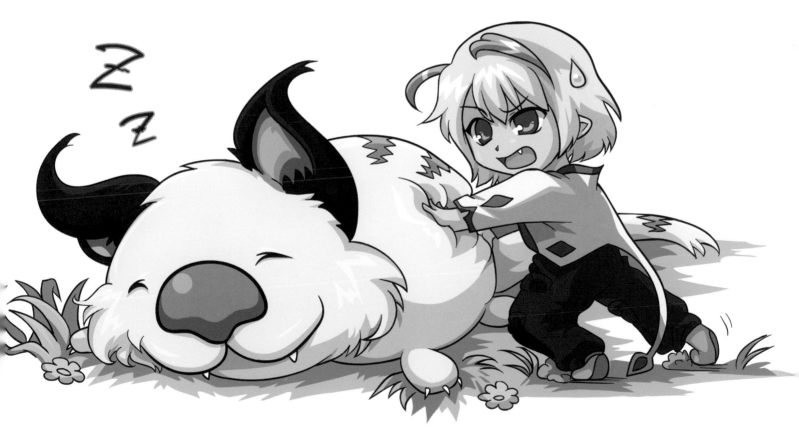

# Chibi Animals

BY TURNING AN ANIMAL INTO A CHIBI, you can make any species cute and irresistible. But it takes more than merely making them look like youngsters to create the infinite cuteness associated with being "chibified." The proportions also need to be exaggerated in the famous Japanese style. For example, the chibi head must be very round and twice its normal size. The eyes should be huge and placed wide apart. The body gets more compact, the limbs get shorter, and the neck is almost eliminated. Often, an anthropomorphic pose is struck, too. Yet, these animals are not *anthros* (human-animal hybrids). No, they're still officially quadrupeds, even when standing up on hind legs. They're sweet critters, whether they're domestic pets or farm or wild animals. And if the animal is little, like a rabbit, you can draw it bigger so that it looks chubby and has more presence on the page; if it's big, like a cow, draw it somewhat smaller so that it looks like a miniature version of itself. In other words, no matter what their stature in real life, chibi animals all end up roughly the same size, give or take.

# DOMESTIC PETS
## Dogs and Pups

The head of the dog is based on a circle. Onto that we add some mass for the cheeks. How's that for easy? Vary the shape of the ears to change the look of the "breed." You don't have to be completely accurate here. You can take some liberties—as long as everything's cute! The same goes for the markings. The body is shaped like an elongated oval, a very simple form. No neck is necessary.

Puppies always have short tails and small noses. Although the paws are oversized on real pups, keep the convention of drawing small "hands" and "feet" on all chibis, both human and animal.

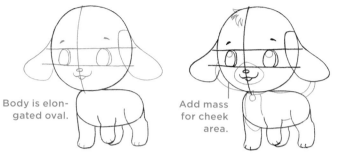

Head starts as circle.

Body is elongated oval.

Add mass for cheek area.

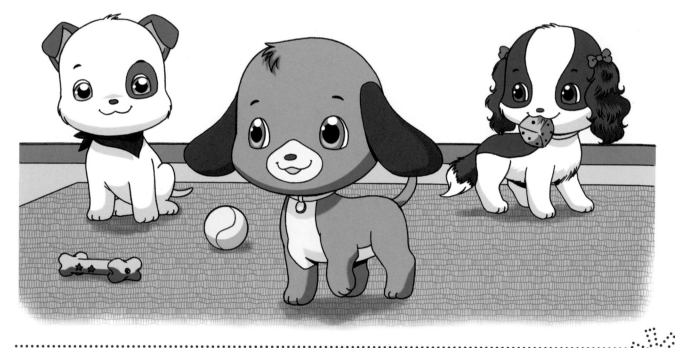

### EARS & MARKING VARIATIONS

FORWARD EARS/WHITE FACE MASK

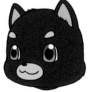

PERKY EARS/"ROTTIE" MARKINGS

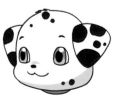

FLOPPY EARS/ DALMATIAN SPOTS

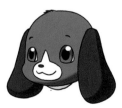

PENDULUM EARS/WHITE MUZZLE

SHAGGY EARS/ GOLDEN COLORING

# Cats and Kittens

Kittens should always give the impression of being soft. Starting with the head, draw a large circle. But then, specific to the feline, give it pointy, furry cheeks. The nose is just a tiny pink dot. And unlike with the dog, draw all cat ears the same way: as little triangles. Notice, too, the split upper lip. Mainly, it's the markings and, to a lesser extent, the type of tail that make each cat character look like an individual.

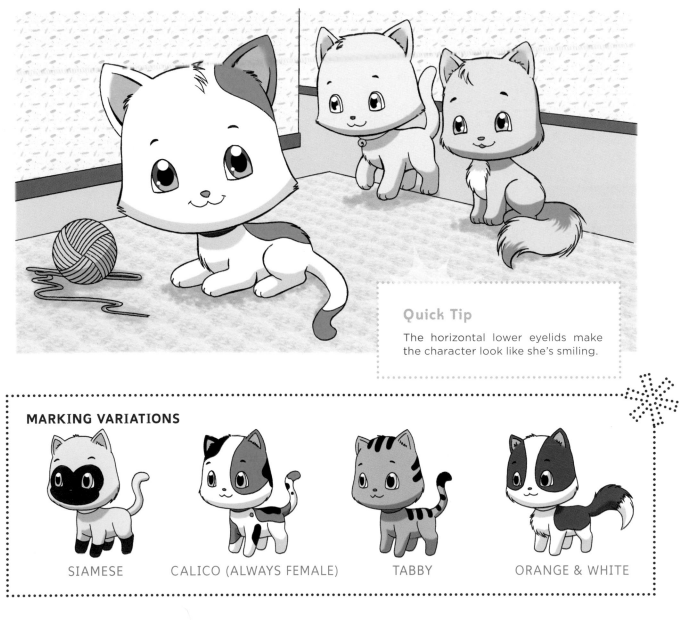

Triangular ears.

Circular head foundation.

Pointed cheek fur.

Small, split lip.

## Quick Tip

The horizontal lower eyelids make the character look like she's smiling.

**MARKING VARIATIONS**

SIAMESE

CALICO (ALWAYS FEMALE)

TABBY

ORANGE & WHITE

# CRITTERS SMALL AND "LARGE"
## Bouncing Bunnies

Bunnies exhibit a variety of hues and markings. They also have chubby cheeks with ruffled fur. The head construction is similar to that of the beaver on page 140, but leave out the buckteeth and change the small ears to long, floppy ones. The buckteeth and whiskers that we see on mature rabbits are unnecessary on chibi bunnies, so leave them off. The nose can be pink or black, but pink tends to look cuter. As for the body, the plump thighs give the bottom a chubby look, which makes the bunnies cuter—if that's even possible. The tail is a bushy fuzz ball. And notice that tuft of fur at the chest, which makes chibi bunnies look soft and squeezable. Like a scarf that blows in the wind, the ears react to movement and add to the sense of motion.

As bunny runs forward, ears drag behind.

Feet come over arms.

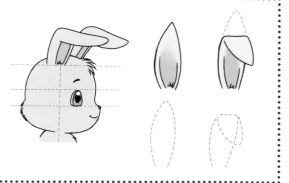

### Quick Tip

When a bunny runs, show all four feet off the ground at the same time.

### EAR & FACE DETAILS

When the ears flop over, reference how big they are in the straightened position to get the correct length in the bent position. The profile lets you see the bent ears in place and also affords a good look at the relationships of the features: The nose and the bottom of the eye are at the same level, and the distance from the top of the eye to the base of the ear matches the distance from the bottom of the eye to the bottom of the head. Note, too, that the base of the ear is placed a little below the line of the top of the skull.

## Mischievous Raccoons

Here's a bright-eyed troublemaker whom everyone loves. Raccoons are often portrayed with the personality of hyperactive boys who get into everything. They can run on all fours or in a human posture. The lower mouth section is narrow and horizontal. The ears are pointed, like cat ears. The markings, especially the eye mask and rings around the fluffy tail, are famous and should not be adjusted. They make the raccoon unique. Any attempt to change these hallmarks will make the animal less recognizable. The hands and feet are darkened—also a well-known raccoon trait.

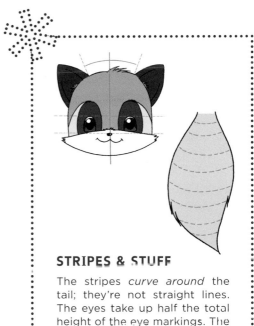

### STRIPES & STUFF

The stripes *curve around* the tail; they're not straight lines. The eyes take up half the total height of the eye markings. The ears begin where the skull starts to curve downward around the sides of the head.

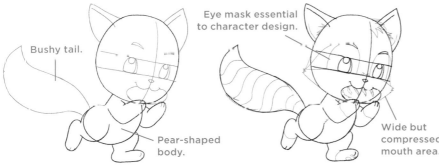

Bushy tail.

Pear-shaped body.

Eye mask essential to character design.

Wide but compressed mouth area.

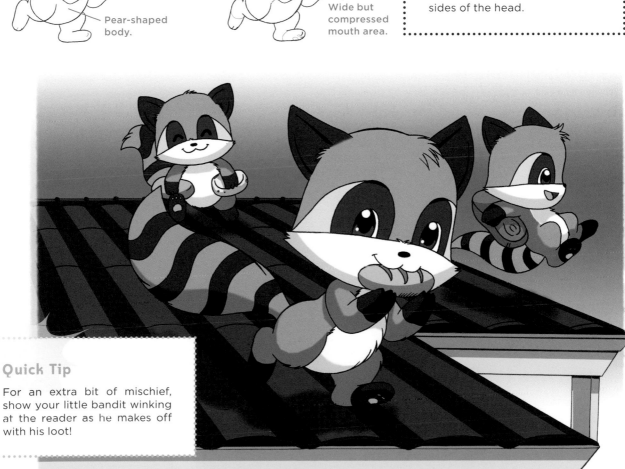

### Quick Tip

For an extra bit of mischief, show your little bandit winking at the reader as he makes off with his loot!

## Lovable Beavers

The hallmarks of this hard-working animal are its buckteeth, wide cheeks, small rounded ears, and, of course, its long, flattened tail. The beaver, in reality, has a small head on top of a large body; however, you should take artistic license and reverse this so that the chibi version has a huge head on top of a small body. This makes it a cuter character. Give him fat cheeks, and ruffle the fur to emphasize the fact that he chews a lot. You can give the beaver a single bucktooth or two, but two is the more popular way to go. Beavers are colored tan or dark brown.

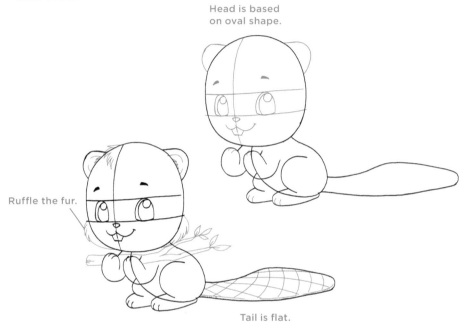

Head is based on oval shape.

Ruffle the fur.

Tail is flat.

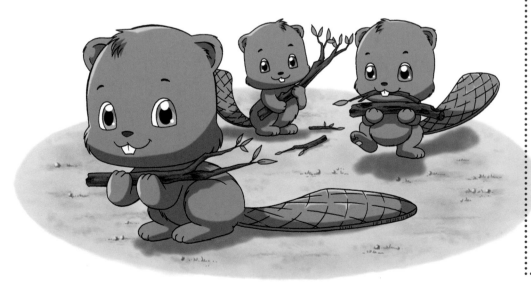

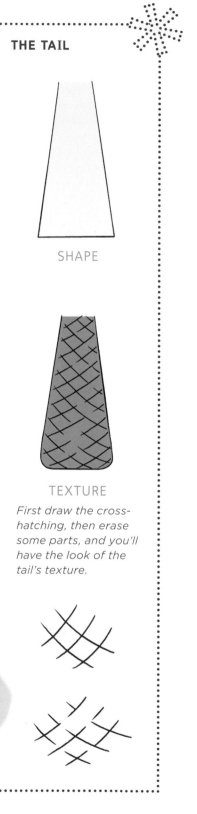

**THE TAIL**

SHAPE

TEXTURE

*First draw the cross-hatching, then erase some parts, and you'll have the look of the tail's texture.*

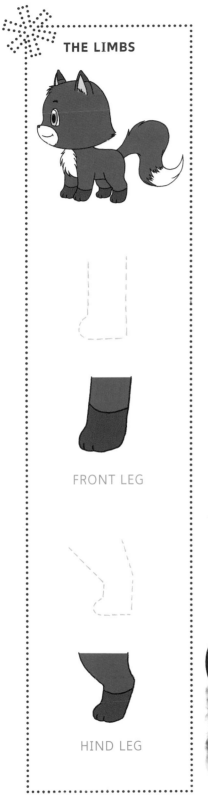

**THE LIMBS**

FRONT LEG

HIND LEG

## Playful Foxes

Foxes are small. They are smaller than dogs and even smaller than mangy old coyotes. They have beautiful, fluffy coats that are rich in color. Their faces are pointed. But chibis are always round, so you have to adjust the face somewhat. Shorten the snout, but keep the sides of the face pointy to maintain the original foxlike quality of the animal. The tail gets even bushier. And although in real life the tip of the tail is sometimes dark, in cartoons it's always depicted with a white tip. The paws remain dark, just as they are on real foxes. That should be enough to "chibi it up" and still have the character read as a fox.

Long, pointy ears.

Giant, bushy tail.

White tip on tail.

Extra-wide, ruffled cheeks.

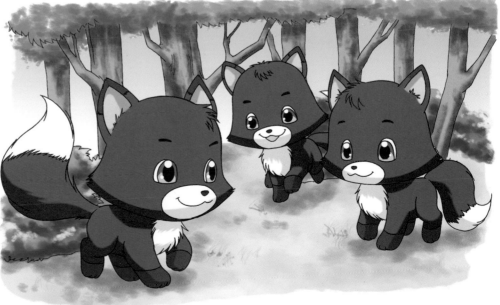

## Cute Cows

The ears stick out diagonally from the head, but the horns are directly on top. Keep the horns small—only bulls have large horns. The muzzle is an oval shape. Dainty little nostrils keep the character looking feminine, as do the eyelashes. These little chibis have an exaggerated hoof size, but don't draw the legs too thick. Thicker legs would result in too sturdy and strong a look for a cute character. Ruffle some fur just above the hooves. You can play with the markings, as some cows have large, splotchy spots and others have none. The tail is long and thin, with a dollop of fur at the end.

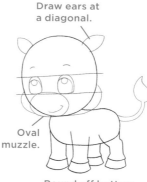

Draw ears at a diagonal.

Oval muzzle.

Round off bottom of hooves.

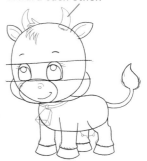

Horns curve inward toward each other.

### THE HEAD & HOOVES

The bottom of the eye rests on the same guideline as the top of the muzzle. The forehead is almost two eye lengths tall, and the ears start at that point. The horns are between the ears and more upright. The hooves are round, not straight. And you can clearly see this when they're raised off the ground and you look at the underside.

## Cuddly Bear Cubs

Bears are often portrayed in humorous sitting poses, because real bears actually do sit like this! This is one of the easiest animal poses to sketch, because it mirrors a human sitting position. Everything about this character is round and fuzzy. And this roundness pulls at the reader's heartstrings. The chibi version has a very basic head construction: an oval for a body, small ears, a split lip, and a stubby tail. And that's all there is to him. Give him a try.

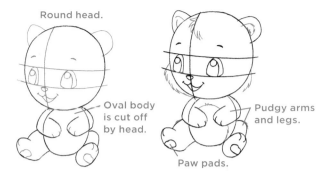

Round head.

Oval body is cut off by head.

Pudgy arms and legs.

Paw pads.

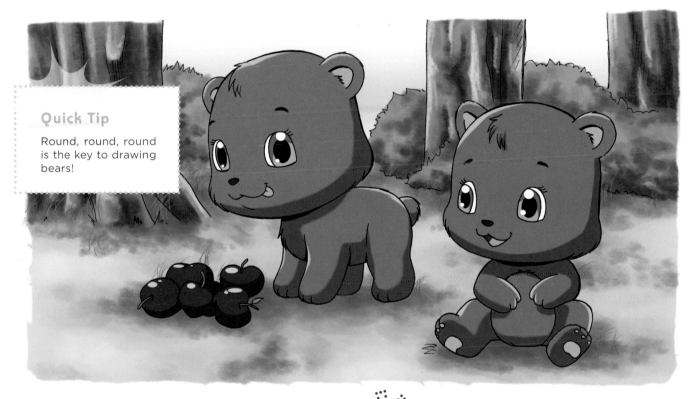

**Quick Tip**

Round, round, round is the key to drawing bears!

### BASIC HEAD CONSTRUCTION

The nose and the bottom of the eyes rest on the same line. The eyebrows and the bottom of the ears are at the same level. The space between the top of the eyes and the bottom of the ears is the same length as the eye itself. As with the raccoon, the ears fall where the top of the skull starts to curve strongly down the sides of the head.

### MORE BEAR TYPES

PANDA BEAR

*These are the classic markings for the famous panda, perhaps the world's most beloved exotic animal.*

POLAR BEAR

*The face is a little pointier than the regular brown bear, and the ears are even a little smaller.*

## SEA LIFE
### Precious Penguins

Real penguins have super-small heads on long bodies. But to create chibi penguins, use the proportions of babies. That means oversized heads on tiny bodies. That also means that the facial features mimic those of children: big eyes and a tiny mouth—or beak, in this case. There is no neck; the head rests directly on the shoulders. The body is quite plump, with shortened flippers for arms (real penguins have long flippers). You can vary the markings, so long as the main stretch of the body and the center of the face remain white.

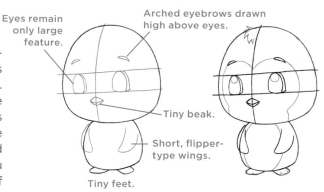

Eyes remain only large feature.

Arched eyebrows drawn high above eyes.

Tiny beak.

Short, flipper-type wings.

Tiny feet.

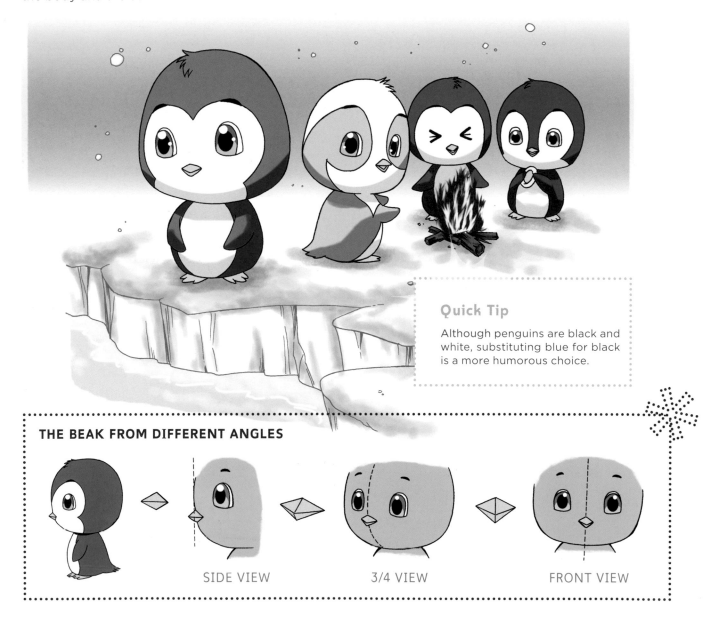

### Quick Tip

Although penguins are black and white, substituting blue for black is a more humorous choice.

**THE BEAK FROM DIFFERENT ANGLES**

SIDE VIEW          3/4 VIEW          FRONT VIEW

# Dancing Sharks

Even sharks can turn chibi! When on land, it's cartoon-trendy to draw fish standing up on their tail fins. Built like a bodybuilder, the shark is narrow at the waist but big around the chest. The snout protrudes, and sharp teeth show at all times. The eyes are almond shaped, not perfectly round. Round eyes are the province of harmless animals, and even though sharks are playful, we can't get away from the fact that they're predators—and the almond-shaped eyes signify that. As far as markings, sharks are two-toned: white around the mouth and belly, grayish-blue everywhere else.

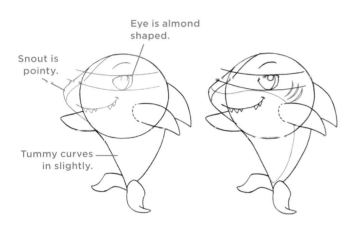

Eye is almond shaped.

Snout is pointy.

Tummy curves in slightly.

## THE DORSAL FIN

The dorsal fin attaches to the center line, which runs down the middle of the back.

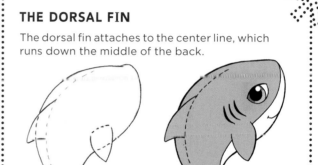

# EXOTICS
## Tiger Cub

Although the tiger cub has lots of stripes, it's best to limit the amount on the face, or you'll make the character look cluttered and unappealing. Notice that the stripes have been left off the areas around the eyes, nose, and mouth. Tigers are generally drawn a little shaggy, so ruffle the fur around the ears, on the top and sides of the head, just over the nose, and on the chest. Note that the nose isn't a circle or an oval but dips slightly in the middle. This happens on other large cats, such as lions, too. For the markings, tigers have three colors of fur: orange, black, and white.

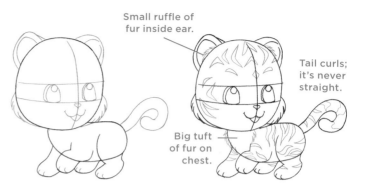

Small ruffle of fur inside ear.

Tail curls; it's never straight.

Big tuft of fur on chest.

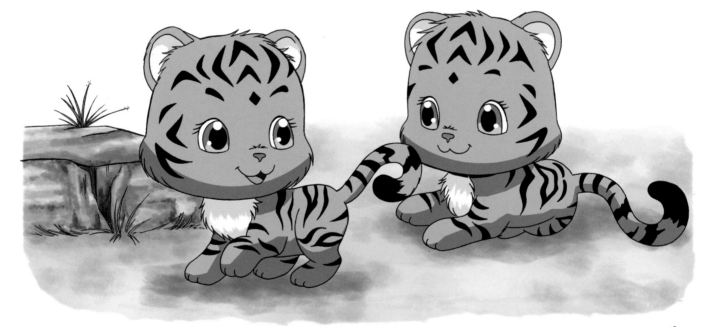

---

**DRAWING A TIGER STRIPE IN FOUR EASY STEPS**

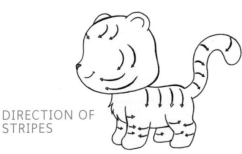

DIRECTION OF STRIPES

*The stripes bow out in the center and are narrow at the ends. They can be solid black or have an open area in the center where the tiger's orange coloring shows through—and they can even remain open at one end. It's good to mix 'em up for variety.*

## Outback Kangaroo

Everyone knows that kangaroos have pouches. But something else they have, which you may not be aware of, is a long and strong tail. It's quite thick at its base, where it attaches to the back. Also, kangaroos have long ears, which are miniaturized on the chibi versions but are still significant. Their posture has them always leaning slightly forward. In this natural resting position, the knees rise up high on the body, almost up to the chest. They're pudgy-cute, with little arms that are almost useless and extra-long feet that lie flat on the ground.

**BASIC HEAD CONSTRUCTION**

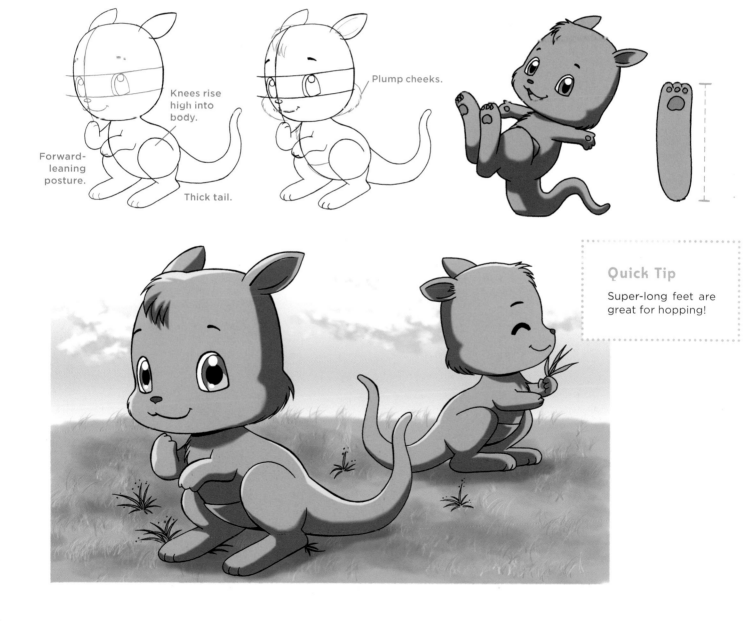

Knees rise high into body.

Plump cheeks.

Forward-leaning posture.

Thick tail.

**Quick Tip**

Super-long feet are great for hopping!

# Shounen: Action-Style Chibis

THE SHOUJO CHARACTERS we've been looking at are cute, pretty, dreamy, and fantastical. They can also be quite silly and humorous. But they're not the only type of chibis that are popular. *Shounen* manga, with which you are also probably familiar due to such anime shows as *Dragon Ball Z* and graphic novels such as *Naruto* and *Bleach*, provides another influence. This style is based on action-adventure characters who can also appear in the chibi genre, and when they do, they're exciting, because they're flamboyant and action-oriented. And even though they tend to leap around and get into fights, their ridiculously compact builds prevent them from doing any serious damage. So they're humorous, as well.

# SHOUJO VS. SHOUNEN

Although shoujo leans more toward girl audiences and shounen more toward boy audiences, the chibi characters of both genres are similar in stature in that they're diminutive and without developed musculature. Shounen boys may be energetic, but they shouldn't look as if they've been pumping iron. In fact, they're a little lacking in physical stature, putting them at a disadvantage when they come in contact with any bad guys.

Their costumes are charged and dynamic. Fighting chibis often don brightly colored clothes and strike heroic poses, mimicking the full-grown heroes of the regular shounen genre. Of course, you can only try to look dramatic in a pose for so long when you're just two feet tall before it starts to look funny—and that's exactly what we're counting on!

**SHOUJO STYLE**
*Shoujo-style hair is romantic and flowing. Even the clothing folds form soft curves.*

**SHOUNEN STYLE**
*In general, shounen hairstyles are often spiked, which is what you'd think of as classic manga hair. And even the fabric folds are more jagged and angular than what you see in the shoujo style. Note the bolder colors, too.*

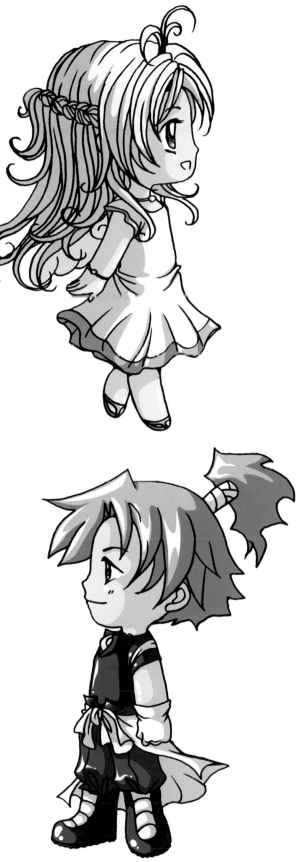

# THE ASIAN INFLUENCE

Many intense-looking shounen chibi fellows wear Asian-style fighting costumes. The Asian theme is no surprise in manga, given that manga originated in Japan and then found its way to South Korea and China, as well. Let's take a look at two popular characters who wear getups with that distinctively Asian flair.

## Traditional Martial Artist

This one's a popular classic: the long jacket with golden details. The style identifies him as one from a royal order. Sometimes, characters dressed with this type of jacket are also cast as sci-fi commanders. The one giveaway here that he's not that type? The slippers. They convey that he's clearly a martial artist. A sci-fi commander would wear boots instead.

The super-spiky hair is pure shounen. Blue may seem like an odd choice for hair color, but it's used to make the character look more fantastic. The purple and gold on the uniform are a good color combination that complement each other. Try it on other costumes, too.

Weight on balls of feet, heels off ground.

Waist-high knees.

Rounded shoulders.

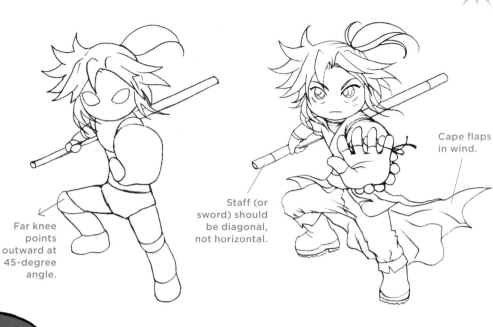

Near hand is greatly exaggerated.

Far knee points outward at 45-degree angle.

Staff (or sword) should be diagonal, not horizontal.

Cape flaps in wind.

## Teen Samurai

Teen warriors are a big part of the manga craze. Rebellious and undisciplined, they shun tradition, choosing instead to wear street clothes rather than the time-honored *hakama* (the billowing skirtlike pants of formal samurai). But they can still fight like nobody's business. Like the pose? He's just daring you to make the first move.

Even though this chibi is drawn as a nontraditional samurai, it's still important to give him some identifiers so that the reader recognizes that he belongs to the clan of the warrior. This requires three things: ponytail, traditional weapon (long sword or staff), and cape or half-cape wrapped around the waist. Often, the cape is tattered.

# FIGHT SCENE SPECIAL EFFECTS

Chibi characters are so lively that they add great fun to fight scenes, making them exciting and humorous at the same time. But here's the conundrum: How are we going to draw action with these tiny characters? They're too compact to move with a lot of grace. What do we do? Simple, really. Instead of relying on long, flowing lines of action, we rely on special-effects techniques to show movement. These effects are very splashy and trick the eye into thinking that a lot more motion is taking place than actually is.

## BLURS AND STREAKS

*The blur is a famous technique that you'll see in a lot of action scenes in shounen-style manga. It's when an object is moving so fast that it actually loses form and blurs, along with its colors. It's as if you were taking a photo of something and accidentally jiggled your camera just as you were clicking off a frame. In this example, it's the kicker's foot that's in a total blur and trails off into speed lines. No doubt about it, that foot is m-o-v-i-n-g!*

*The streak is the energized speed line used to show the effect of the blurred action. It's used to show a character's trail as he moves. In this case, it's the yellow element and shows the arc the opponent follows as he falls backward after being kicked. Although that figure is drawn without much flex in his body, the streak itself is curved and provides the line of action.*

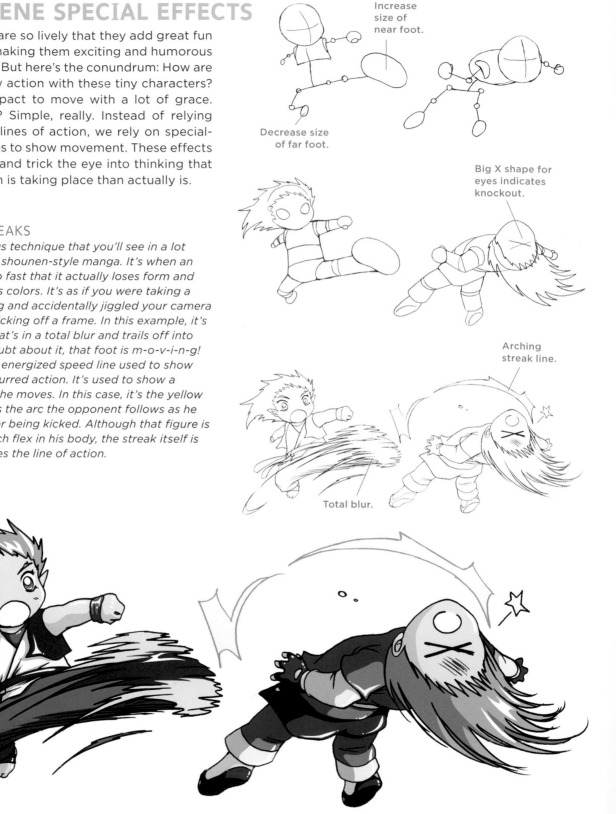

Increase size of near foot.

Decrease size of far foot.

Big X shape for eyes indicates knockout.

Arching streak line.

Total blur.

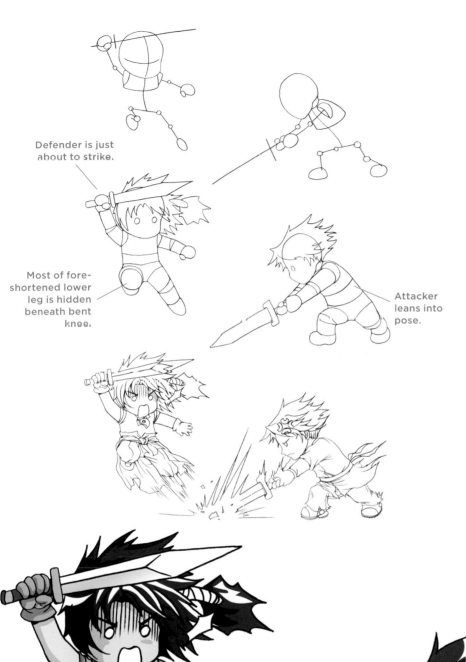

Defender is just about to strike.

Most of fore-shortened lower leg is hidden beneath bent knee.

Attacker leans into pose.

## SPEED LINES AND IMPACT BURSTS

*This scene has been infused with special effects to make it come alive. As the attacker misses his target, his sword smashes into the ground and sparks a jagged impact burst. If you look closely, you'll see that even his gloves and the handle of his sword, which are also moving fast, have blurred during the motion.*

*Meanwhile, the opponent leaps out of the way, causing speed lines to trail his cape and feet. His lower foot also blurs and turns into a bunch of speed lines. Being provoked by the attack, the defender goes completely chibi! His expression becomes a special effect, too: His eyes turn into tiny dots, and blush marks streak down his forehead. Now you've made him mad!*

## ENERGY FIELD

*The energy field is one of my favorite special effects. This classic helps to define a character's abilities. It also just plain looks cool. The cocoon of light surrounding the character should look like it's crackling, with sharp, uneven edges. This type of energy field indicates that this is a super-powered character and not just someone who happens to be emotionally charged up at the moment. Perhaps he has the power of super-strength. Maybe it's the power of flight. Or it could be the power to shoot beams of energy at opponents. Either way, the force comes from within him.*

Hair trails back due to motion.

Head tilts back.

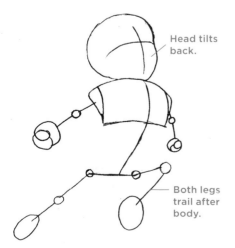

Both legs trail after body.

Jagged edges on flames.

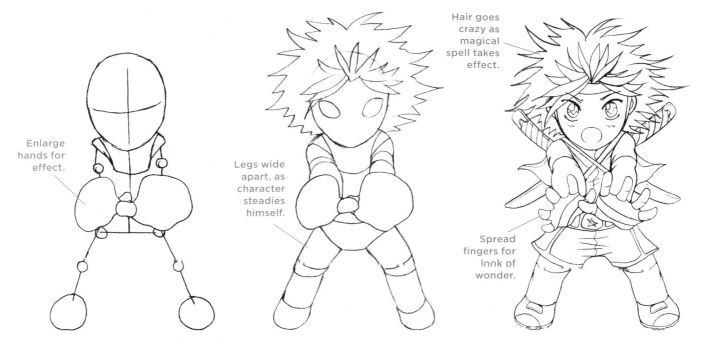

Enlarge hands for effect.

Legs wide apart, as character steadies himself.

Hair goes crazy as magical spell takes effect.

Spread fingers for look of wonder.

## THE POWER TO CREATE

*A character will sometimes discover, quite by accident, that he has magical powers and, in so finding, realize that he's actually of special lineage—for example, he's a sorcerer, a vampire, a shaman, an animal spirit, and so on. In this way, the special effect tells a story about the character. You can see this playing out in the surprised expression on this character's face as he discovers his magical abilities for the first time. This surprise adds a layer of depth to the scene, more so than if the character simply gave the standard evil smile.*

*According to convention, if he were to touch the sphere while it was still in the process of forming, he would break the spell and the thing would disappear. This conceit has the added benefit of looking good visually, because it conveys the sense that the object is floating as a result of the power emanating from his hands.*

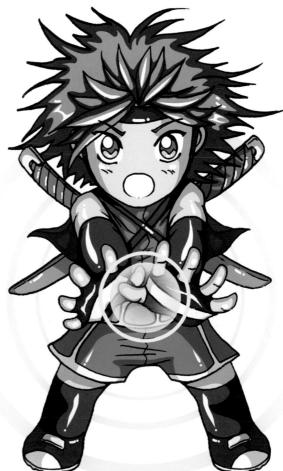

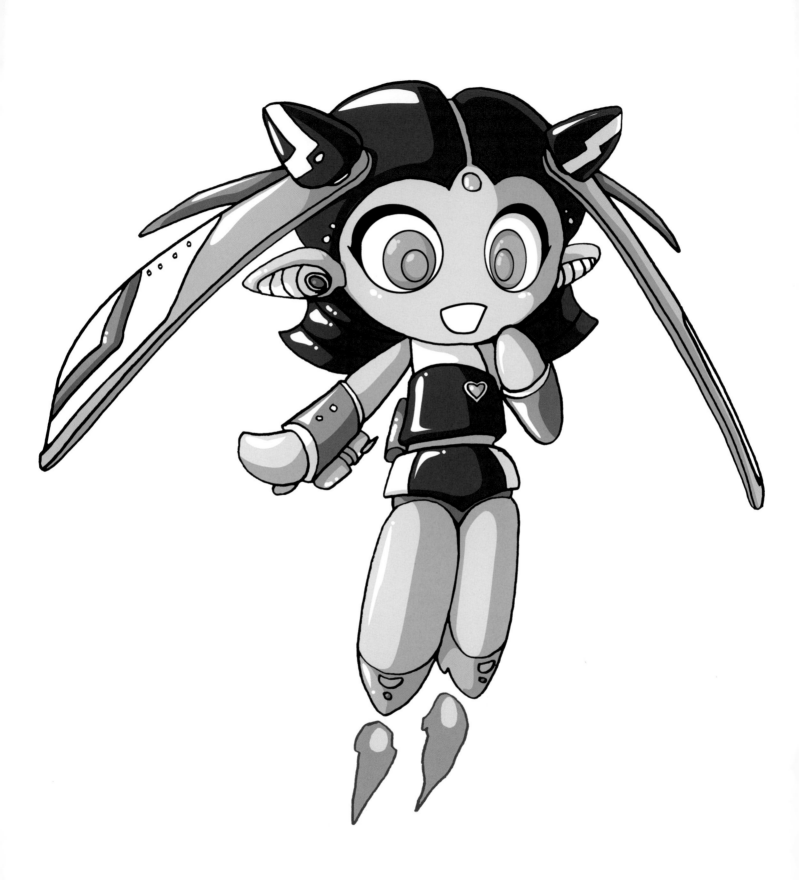

# Chibi Robots

ROBOTS ARE OFTEN CAST as "helper" characters who serve as faithful assistants to their human companions. Usually, robots are sort of faceless figures. But in the unique world of chibis, awesome mecha fighting units shrink down to miniature size and become round and adorable. Chibi robots have lots of personality and are very self-possessed characters. What they lack in size, they more than make up for in enthusiasm. In fact, the smaller they are, the more seriously they seem to take themselves, resulting in hilarious character designs!

Some robots are meek sidekicks, cute and lovable. Others are of the "big buddy" variety. Some mechanical friends are fearless defenders, but others are nefarious and diabolical, evil destroyers with only the worst intentions. Do I sense a battle brewing?

# CLASSIC TELEPROMPTER ROBOT

This is an all-time robot classic. What makes it a standard is that it has a screen for a face. This gives the artist the ability to easily show the character's expression. Since the screen is the focus of the entire character (as the spot where the face is drawn), everything else is minimized so as not to compete with it. A single antenna is important, as it avoids the look of a television set. The baseball cap indicates that it's a boy robot. His overall shape could have been drawn as a square or a rectangle, but round is cuddlier. In general, since chibi robots are drawn fat and squat, any intricate architectural, 3-D mecha designs would be wasted on these little fellows. Like this guy, they're more round than they are boxlike.

Simple circle for body.

Simple screen face.

Very short legs, like on human chibis.

Blocks instead of shoes.

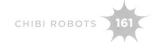

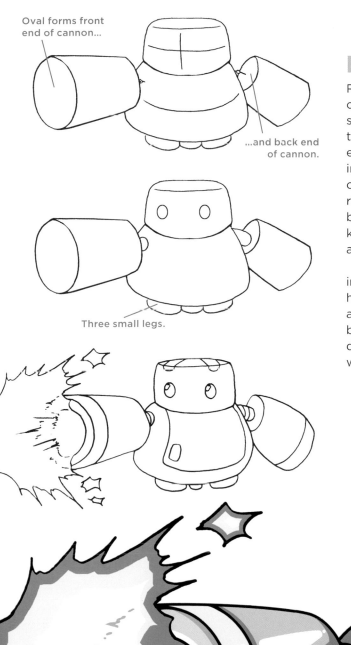

Oval forms front
end of cannon...

...and back end
of cannon.

Three small legs.

# MINI-CANNON

Really tiny robots with lots of firepower are a funny character type. We don't expect so much explosiveness from such small containers! But the thing that makes them so humorous is the nonchalant expressions on their faces. The arms are large cylinders that are actually cannons—a standard item on mecha units big and small. Note the outsize blast right at the opening of the cannon. You need a big blast here to make an impression. Then a few sparkling embers shooting off the edges of the blast are added for emphasis.

This robot is wide around the waist, with almost imperceptible legs and no neck. In other words, he's husky. And like our previous robot, that extra weight adds a "dear" quality to the character. So do the two big eyes. Notice that a minimum of gadgets and doodads is used on the character; if the basic concept works, you don't need to fancy it up.

# SHOUJO ROCKET GIRL

Here's a shoujo-style chibi robot. Remember, shoujo manga is the genre geared toward female readers, so she's totally cutesy, with a chibi-style face. Her arms and legs, however, are drawn in discrete sections so as to look mechanical. And if you look closely, you'll see that her hair is actually a helmet.

Rockets fired from the feet are popular for manga robots, so this gives her the ring of authenticity. And although she can't have the flowing hair of a magical girl, those long, aqua-colored flares off the top of the head serve a similar design function while still reminding the audience that she's made of metal. Note that she also has mitten-type hands, typical of chibi characters.

Legs are separate, large mechanical sections— because they're really rockets!

Flare attachments mimic hair buns.

Hair is short or medium length (not long, since it's made of metal and is a helmet).

Dual blasts from rocket legs.

# EVIL ROBOT

Run for the hills! Here comes a two-foot-tall terror! Seriously, I love tiny evil robots. I mean, who are they trying to scare? The fun of these character types is that they take themselves so ultra-seriously.

This one is weaponized like crazy. And its eye slits are as demonic as they come. With one hand a giant clamp and the other an industrial-strength buzz saw, this tyke means business! His hunched shoulders give him a lurching posture, and the shortened arms also convey a brutelike build. Add to that a "stomach face" (that mouthlike area in the center of the body) and you've got one mean machine. The colors here also convey a wicked, devilish flair, all being in the warm, red family: purple, orange, and red. The only color that's not is the neutral gray, which is used throughout to add visual balance.

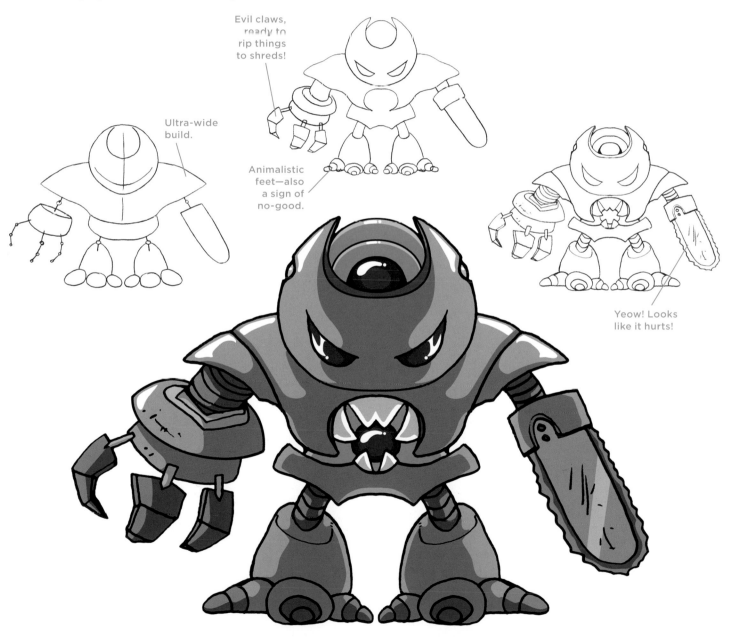

Evil claws, ready to rip things to shreds!

Ultra-wide build.

Animalistic feet—also a sign of no-good.

Yeow! Looks like it hurts!

## MECHA DRILL

As we've seen, arms are often weapons on robots. But contrary to popular belief, they don't all have to fire rockets to be cool looking. The buzz saw on the previous page proved that, and they can also be drills, clamps, claws, magnets, and projectile hooks, to name just a few. The drill hands on this character are based on cone shapes and have spiral lines wrapped around them to indicate the spiral drill-bit texture.

As this heavy robot runs, the dirt beneath his feet shoots up, giving the impression that he's making quite a thud with each step. We'll get more to characters in action in the next chapter, but for now, let's also examine the use of perspective that makes this running pose work so well: The torso (chest) overlaps the hips so that the hips are almost hidden from view. This is classic foreshortening at work. In keeping with this principle, the near drill hand is drawn much larger than the far one. And the near leg is drawn much larger than the far one, too. You need to exaggerate things like this if you want the character to really look like it's running at you.

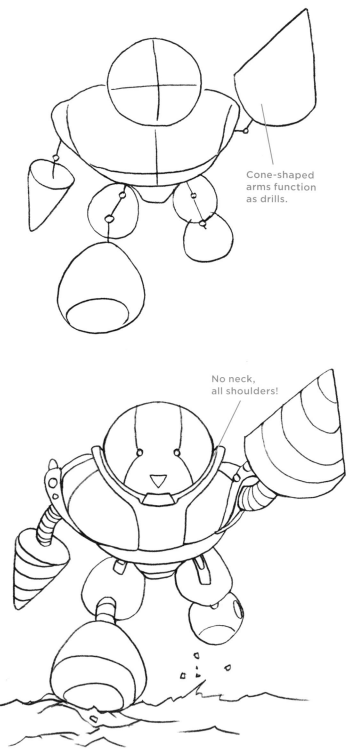

Cone-shaped arms function as drills.

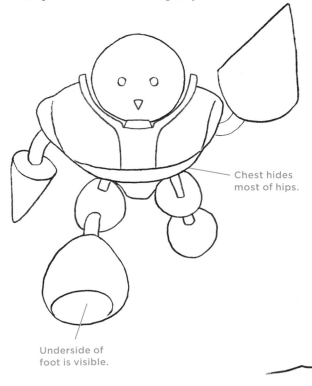

Chest hides most of hips.

Underside of foot is visible.

No neck, all shoulders!

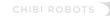

## ROBOT IN FLIGHT

This is the classic "head first" flying pose, which has the character coming right at the reader. The effect of extreme perspective is seen on the body, especially on the arms and legs.

# Animation: Chibis in Motion

**ANIMATION IS A LOT OF FUN** to draw, but it's also helpful to nonanimators, such as *mangaka* (manga artists), comic book artists, and cartoonists. That's because you can see, via animation, all of the various stages of an action that are available for you to draw as individual, still poses.

# THE BASIC WALK

We'll start with the basic walk, but for all the actions in this chapter, you should scan the images with your eyes from left to right, slowly. These are all six-image sequences. Every one of them, except for the punch, is a loop, meaning that it starts at drawing 1, progresses through drawing 6, then begins again at drawing 1—so that the action is a continuous cycle. The beauty in this approach is that you can see that there are six basic mini-action steps that take place in all of these classic motions, and you can choose any of these steps as a basis from which to draw a pose.

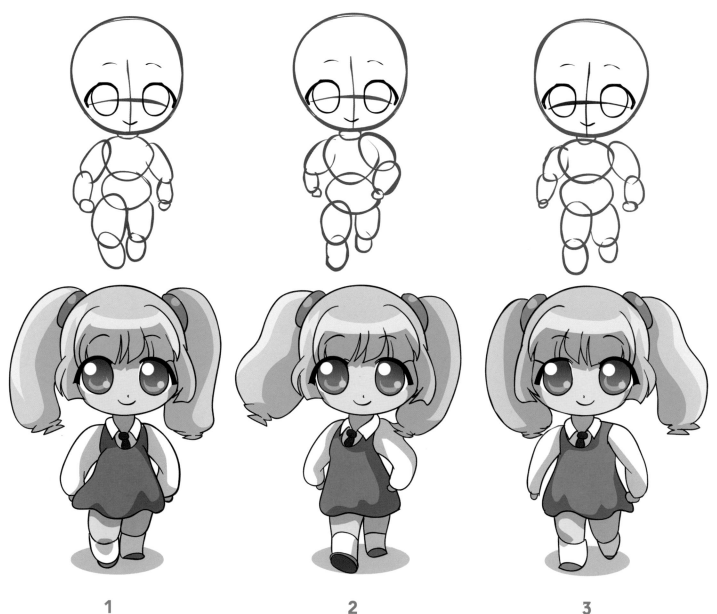

1                                    2                                    3

## Front View

The front walk shows the character facing forward, toward the reader, rather than in profile. For the front walk to work, you've got to give the torso a little twist in poses 2 and 4. These are called the *extremes*, or *key drawings*. That means that they're the most pronounced actions in the sequence. The others—1, 3, 5, and 6—are called *in-betweens*. They fill in the motion that's bookended by the extremes.

Too often, the only poses used by artists to represent movement are the extremes, with the in-betweens being neglected. As a result, everyone's poses start to look the same. Extremes are great, but the other ones are useful, as well, and add variety. Instead of taking a big step forward, the in-between poses show a character as she's just about to take a big step or as she has just taken a big step. They're subtler poses.

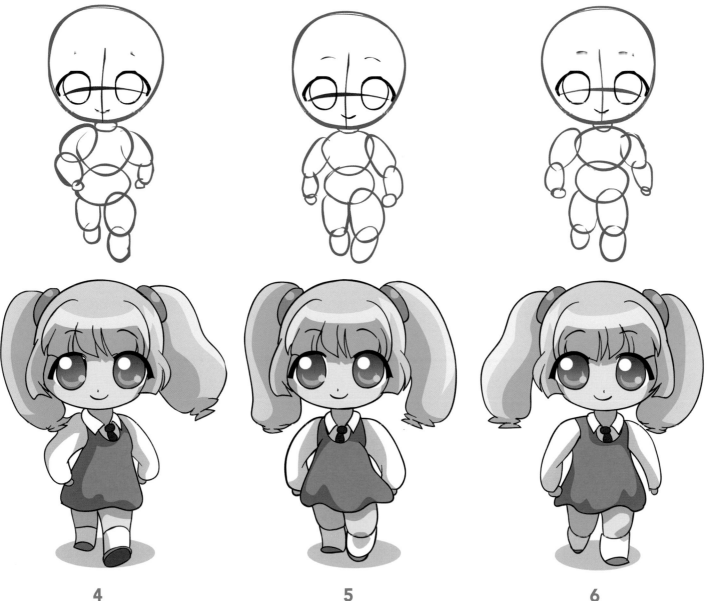

4          5          6

## Side View

The extremes here are poses 1 and 4, which are the most commonly represented in the side view of the walk. Another popular stage in the action, however, is the leg crossover, which occurs in drawing 3. This shows motion in the middle of the action. The more tentative poses, which are good for cute and cautious characters, are poses 2, 5, and 6. Note also how she tends to sink down on steps 2 and 5, after the foot has already made contact with the ground. And since she's walking, and not rushing quickly, her hair doesn't have to blow back (compare to the side view of the run on page 176).

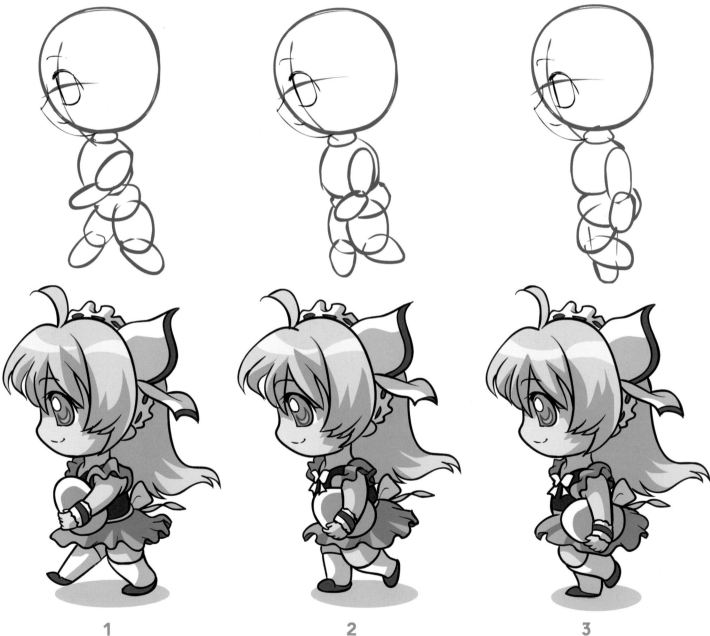

1                                    2                                    3

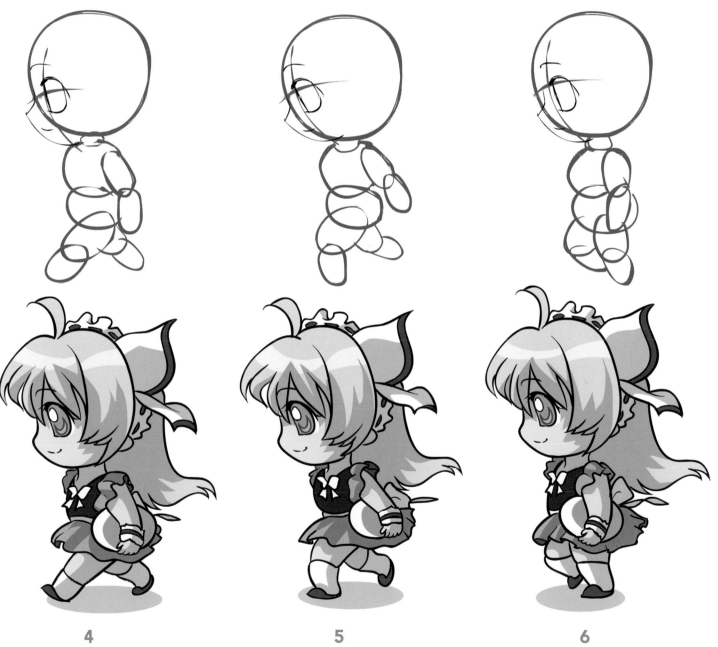

4                              5                              6

# THE FUNNY WALK

Here's a funnier version of the walk. It's a more determined walk by a very impatient little chibi who has just about had it up to here with people calling her Shorty. Notice how her elbows stay up, but the arms swing wide, side to side, in a comical motion.

Unlike the basic walk, where the extended leg straightens, the legs in this funny walk remain bent at the knees throughout the sequence, even on the extremes (drawings 3 and 6). To make her humorous attitude more emphatic, both shoulders face directly

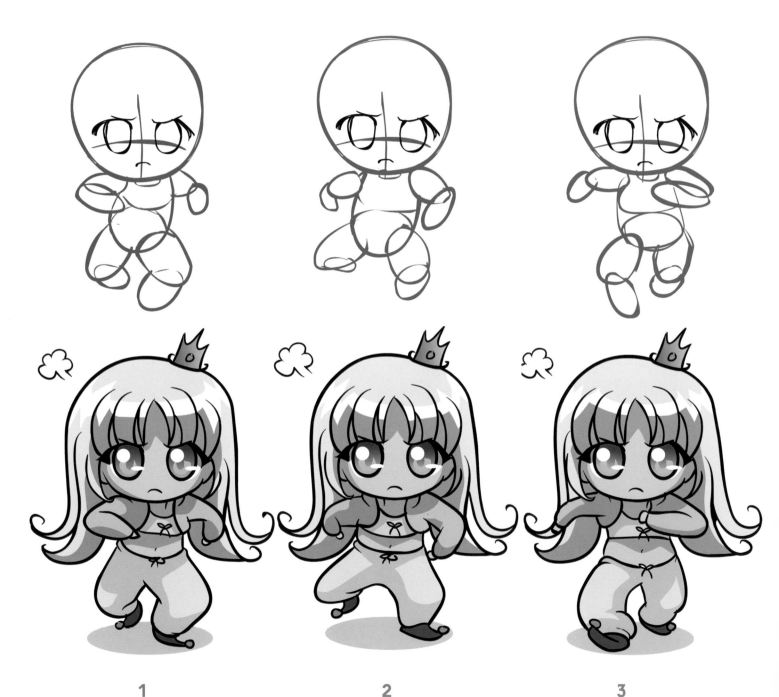

1                                       2                                       3

forward the entire time and don't rotate as they do in the basic walk. Notice how the foot looks smaller as it recedes into the background but is drawn bigger as it comes toward the reader.

4                              5                              6

# THE RUN

The run, unlike the walk, has the character leaning forward throughout the movement. The legs and the arms show a wider range of motion during the run, and the hair and clothes flap in the breeze.

## Front View

This teeny toughie will give us a good look at one of the main drawing principles used in the front view of the run: foreshortening. It's really in evidence in poses 1 and 4 (both are extremes), where the knee is pulled up to the highest level it reaches, is exaggerated in size, and blocks the view of any other

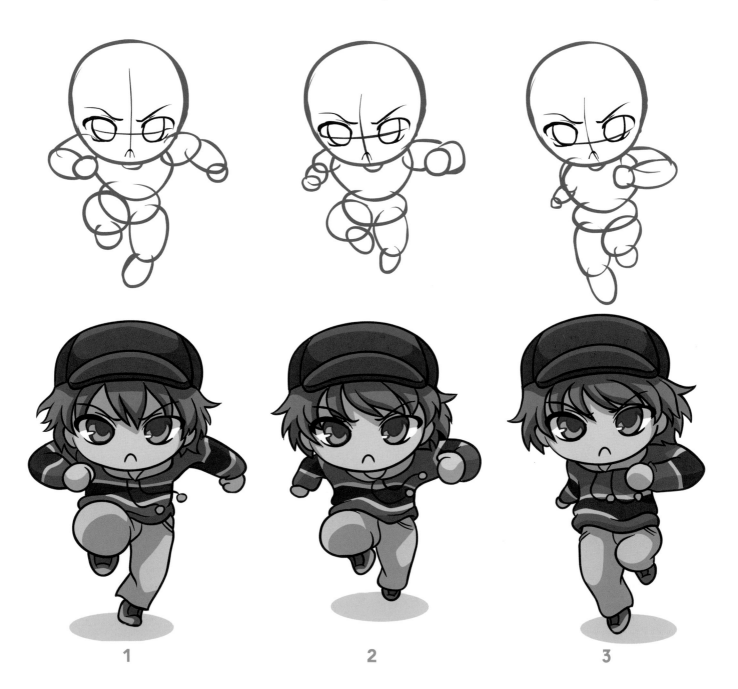

1                2                3

part of that leg. As the leg begins to straighten out and travel toward the ground, it "unbunches" and becomes slender once again upon impact.

To give him humorous body language, keep his shoulders up and tensed throughout the run. Note, too, that when the knee on one side rises up, the arm on the opposite side travels back. It's just like when you walk: One leg goes forward, while the opposite arm goes back. You draw the arm to look small when it's in the "back" position and big when it's in the "forward" position. Again, this is due to the principle of perspective known as foreshortening.

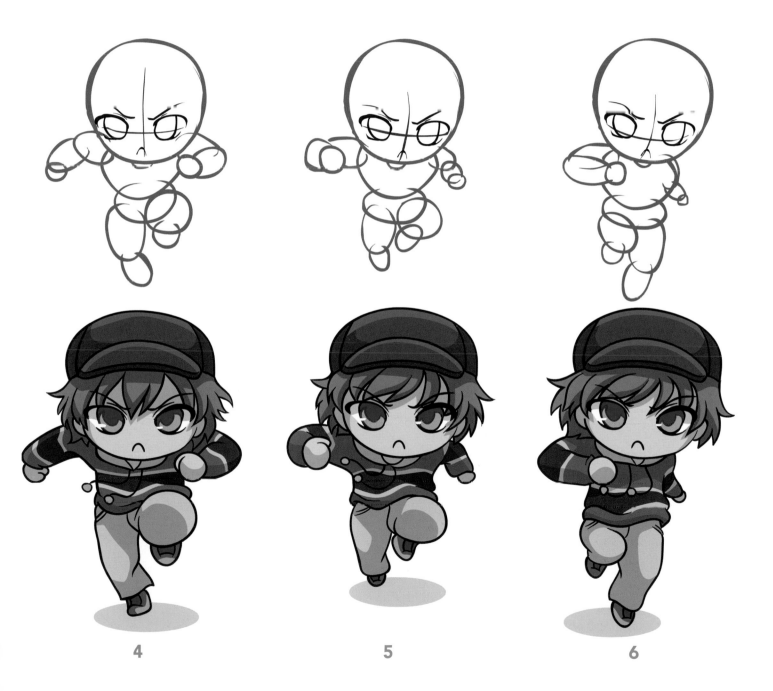

4       5       6

## Side View

The run requires a short leap through the air. Lanky characters take longer beats in midair than do our little chunky pals. In a run, the knees rise high in front when the foot lifts off the ground and high in back when the leg trails behind. The arms also swing vigorously. Throughout, the body leans slightly forward into the action. She's not running with her body stiffly straight up and down. The extremes in this cycle are drawings 1 and 4. The crossover step is drawing 2, and the subtler poses are 3, 5, and 6.

Note that the hair must react to the violent motions of the run. You can also see evidence of the kinetic

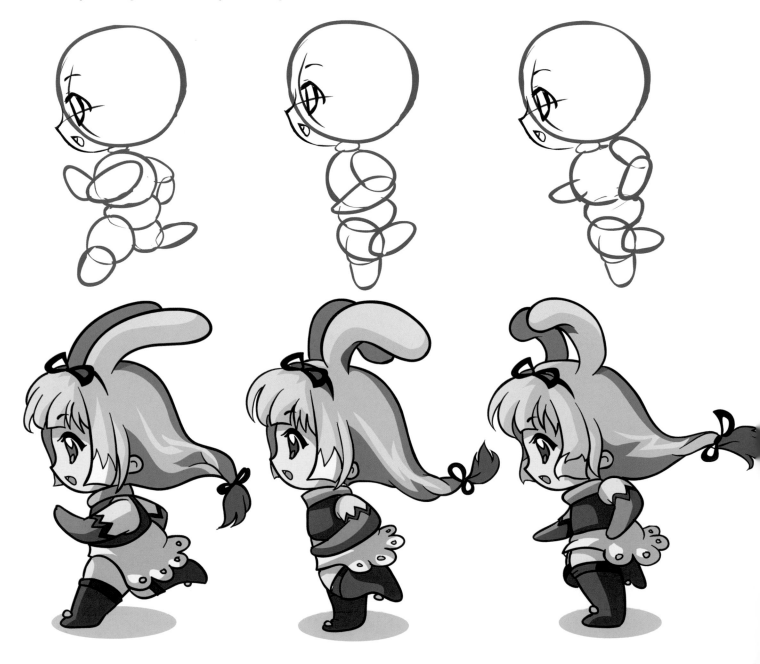

1                                2                                3

motion as the ponytails move forward and back and as the skirt trails behind, due to the principles of inertia. Instead of a closed mouth, here it's open; in a walk, the mouth is closed, but not in a run—when you've got to show the character panting.

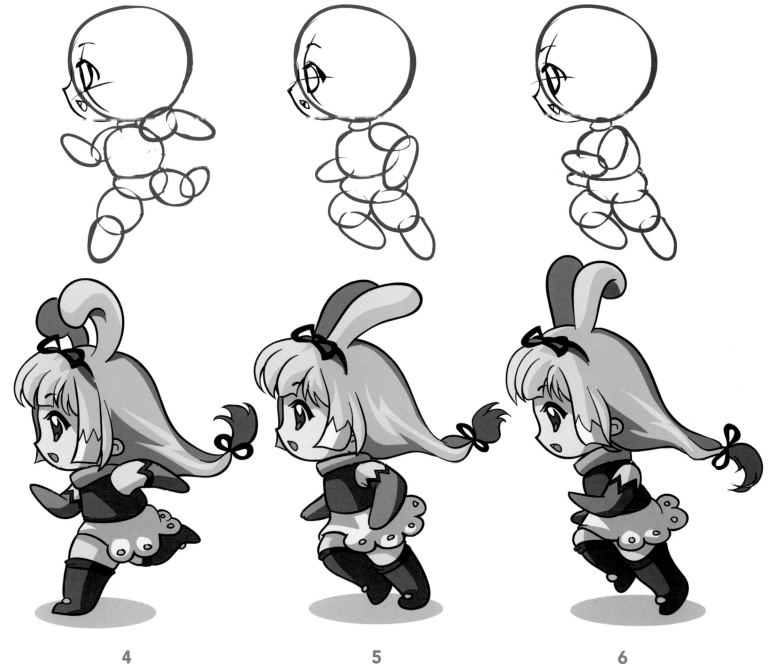

4                                         5                                         6

# THE POWER PUNCH

When throwing a punch in manga, the character digs deep down and really telegraphs that shot! No boxer would dream of reeling back so far before letting loose a punch, because the opponent can see it coming from a mile away. But the point is to exaggerate the moment to make it appear bigger. This principle is called *anticipation*. In other words, when a character is about to move forcefully in one direction, he must first cock back in the opposite direction. He "anticipates" the action. This increases the distance his action must cover from the beginning of the pose to the point of completion, which makes it funnier. Look at the anticipation in drawing 1: He pulls his arms way back and

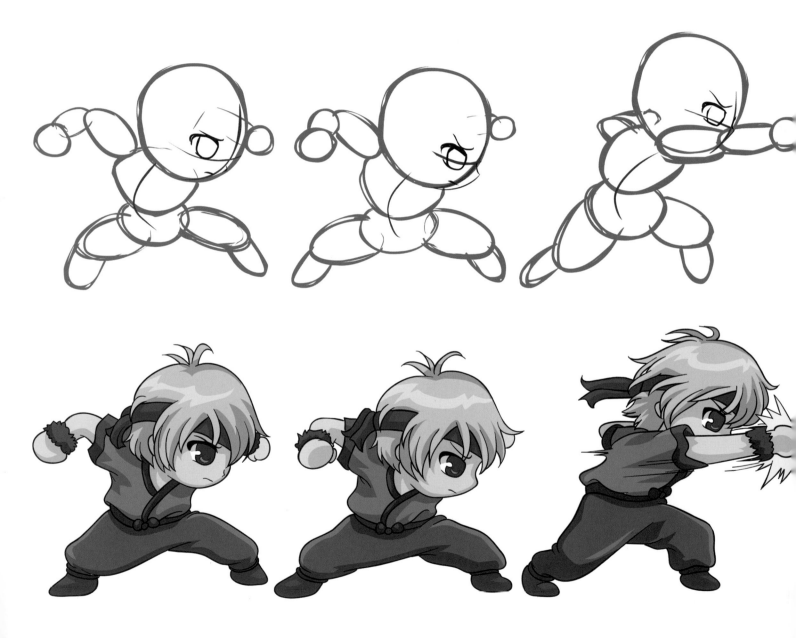

1          2          3

bends at the knees, storing up that energy and getting ready to uncoil! Drawing 3 completes the first punch (an extreme), and drawing 6 completes the second punch (also an extreme). And remember, as one arm punches forward, the other pulls back (opposite and equal reactions).

4                              5                              6

# JUMPING FOR JOY

Chibis are exuberant characters. As such, you'll probably have occasion to use the jumping-for-joy, chibi-style leap into the air. Here, we see another important principle of animation, called *follow-through:* One action starts another action, which starts another, and like a chain reaction, everything follows in tow. These things happen very quickly, but the sequence remains the same: Each step completes its follow-through movement to the end.

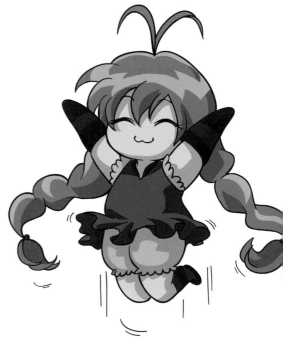

**1**          **2**          **3**

In this example, the girl first *anticipates* the action by suddenly moving in the opposite direction of the jump (drawing 1). The first things that leap into the air are her head and arms (drawing 2), followed by her feet (drawing 3), followed by the ponytails (drawing 4). By the time the chibi is on her way down, the hair is still on its way up (drawing 5)! And when she's back on the ground, her hair is still falling into place, as are her arms (drawing 6). The extremes are 1, 3, and 6.

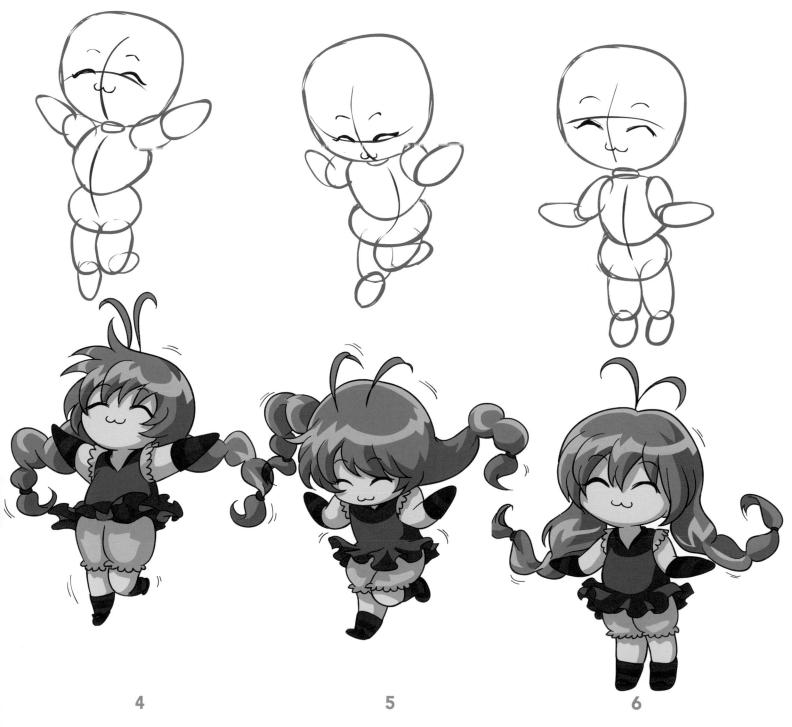

4          5          6

# Chibi Locations & Backgrounds

NOW LET'S GET TO SOME IMPORTANT TIPS and tricks you can use to create eye-catching, humorous scenes featuring more than one chibi and with the addition of a background setting. Like all things chibi, don't get bogged down drawing complicated scenery. Use enough detail to suggest an environment, and let your characters do the rest.

# STORY LINE SETTINGS

You want to open your story with a familiar icon—something that immediately communicates the location to the reader. Keep it cute and simple.

### HOME

*A chibi never lives in a Tudor-style, three-story mansion. Instead, chibis live in cute and modest cottages with curtained windows and a front door with flowers on either side. It should look well maintained and tended to. There's a working chimney puffing out a harmless stream of white smoke. The walkway cuts through a manicured lawn punctuated by a tiny mailbox. Is there a little picket fence around the property? I'll give you three guesses.*

## SCHOOL

*Here, we split the difference between a tiny schoolhouse, which would look like a throwback to the olden days, and an ultra-modern, faceless institution capable of serving two thousand students. Shoot for something down the middle. Also consider making the lines of the building curved rather than ruler-straight; this keeps the building cartoony and cute. And one note: Schools often fly a flag on a flagpole, but since manga and graphic novels get translated so often into different languages, you'll want to avoid choosing one nationality, because it would make readers from other countries feel left out. Best to eliminate the flagpole entirely.*

## FANTASY LOCALES

*The castle is the quintessential fantasy location. Most castles were built as redoubts (strongholds for withstanding months-long sieges and bombardments). But chibi castles are designed to be charming palaces, part of a fairy kingdom. Note that the castle, like many real castles, is perched atop a hill, which gives it a nice juxtaposition against a cloud-dotted sky. The turrets have spires on top that come to a point; these are highly fanciful and dreamlike. The heart motifs could easily be switched for flowers or simplified animal forms, jeweled emblems, or even all four suits in a deck of cards. A wavy lane ambles all the way from the entrance to the foreground, adding a storybook type of perspective to the illustration.*

# LOCATION PINUPS

Now we'll do a few *pinups*. Pinups are illustrated scenes that take up an entire page. They're used to add impact to manga stories of every genre. Don't overuse them, but employ them judiciously to add variety to what otherwise would be a monotony of pages of sequential panels. You may see pinups two or three times throughout your average graphic novel.

Because the pinup scene is so large, backgrounds that might otherwise be comfortably omitted from smaller sequential panels are well suited to this larger format. Don't draw those backgrounds meticulously, however; just give an impression. Remember, the backgrounds are chibi style, so you don't need any art lessons in perspective to draw them. I think I heard a collective sigh of relief as you read that last sentence!

### SLUMBER PARTY!

*This basic layout has all four girls arranged in a circle so that the eye follows them in a continuous loop, which keeps the reader visually involved. Also, each girl makes eye contact with another girl, which is a method of directing the reader to notice each character rather than to focus on just one.*

*Vary the sitting and lying positions, as well as the design of the pajamas and types of hairstyles. There isn't much overlapping of the characters, because that would ruin the merry-go-round, circular effect of the layout.*

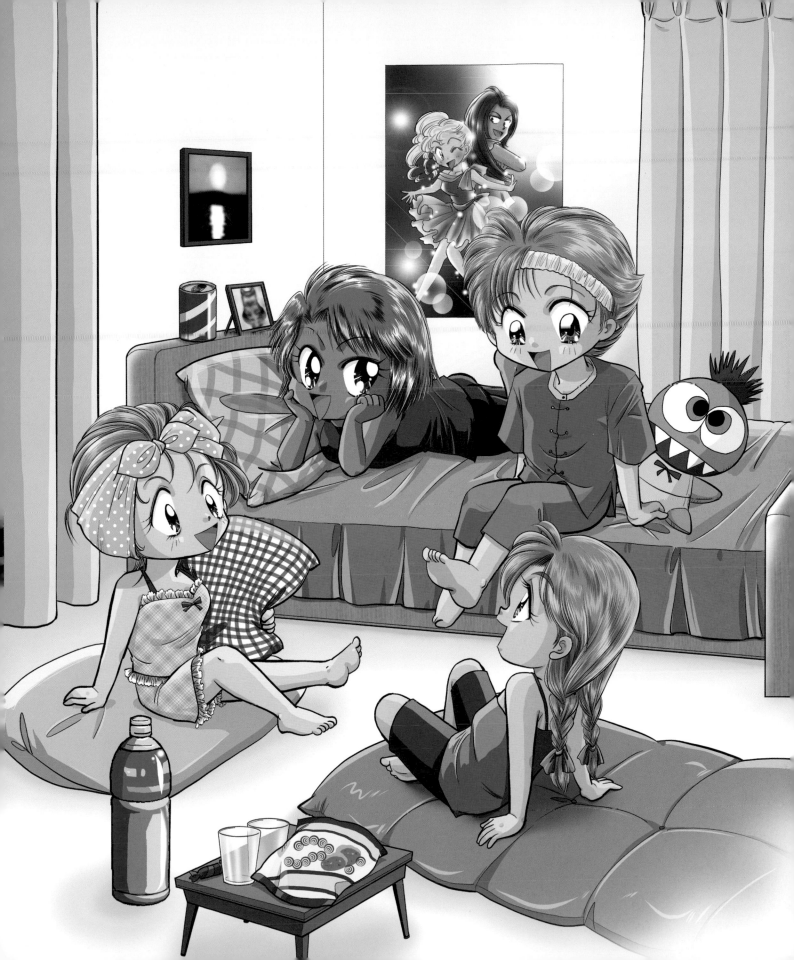

## PINUPS ARE ALSO USED TO...

- Enlarge a scene in which there's a lot of detail that would otherwise be lost.
- Show action that's more clearly seen when enlarged.
- Show numerous characters.
- Establish a setting.
- Make a greater impact on the reader.
- Change the rhythm.

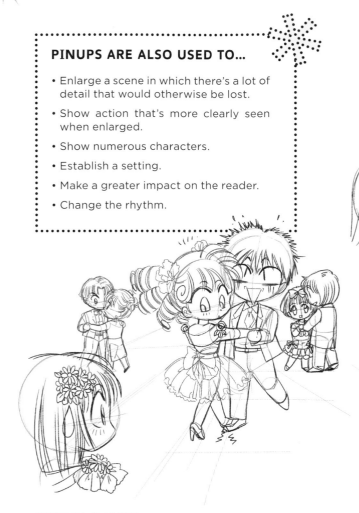

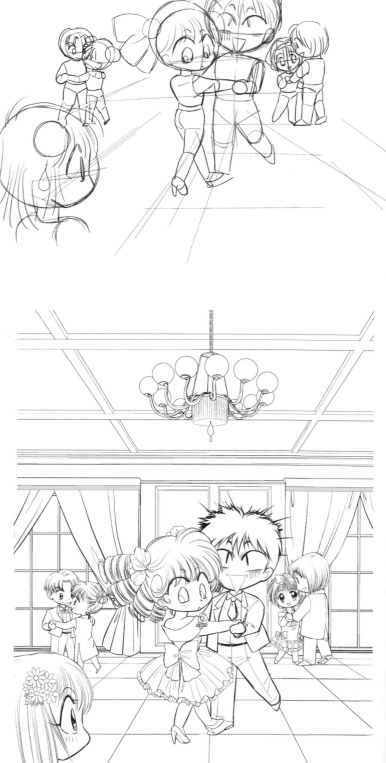

## SCHOOL DANCE

*We've got a silly couple in the middle of the dance floor, bookended by two other couples on either side. This forces the reader to notice the couple in the middle. It's good to direct the reader's eye this way. Adding to the symmetry are two floor-to-ceiling windows on both sides of the room.*

*This is yet another humorous situation in which the two main players are each having different experiences but sharing the same action: dancing. She's dancing modestly, whereas he's dancing up a storm. We get the feeling that she hardly knows this guy! Yet his electrified hair shows that he's already deeply in love! Turning the dancing gal's head so that she glances over her shoulder lets the reader see both dancers' faces. If she were looking at her partner, we'd only see the back of her head, which would rob us of her important reaction. This device is called a* cheat. *By cheat we mean that we've turned her head toward the reader more than would naturally occur in order for us to see her clearly.*

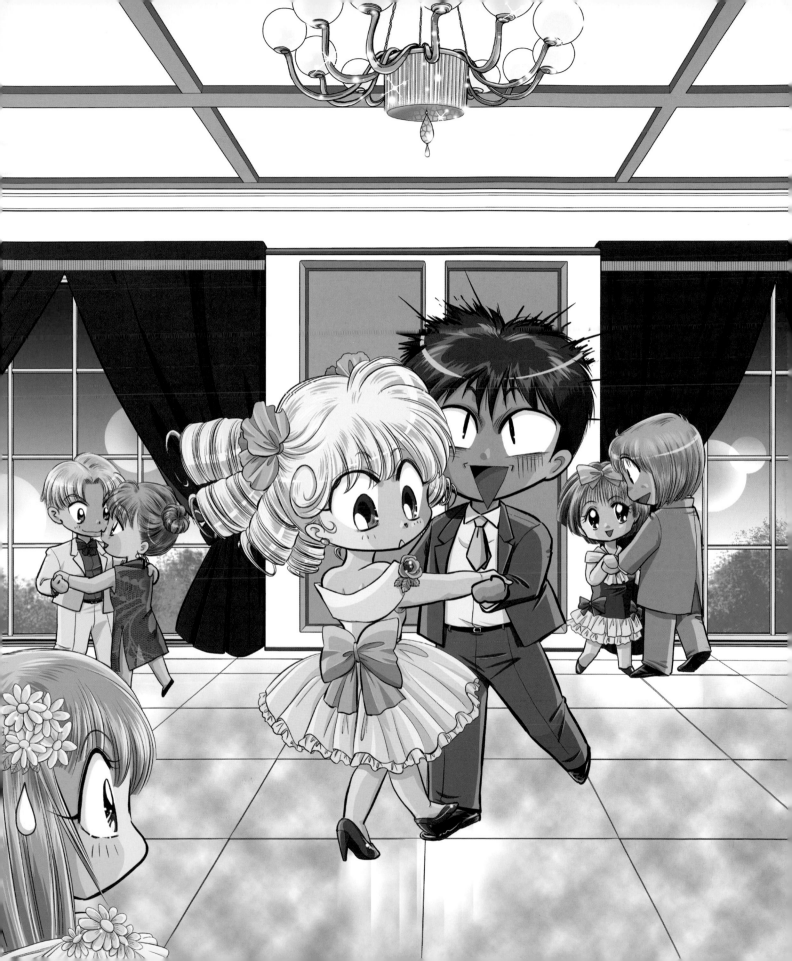

## CAMPFIRE COOKOUT

*Boys can be food-gobbling pigs. And I'm speaking here from personal experience. It's a wonder that girls have ever put up with us! This scene contains small groups of characters laid out in a semicircle, surrounding the campfire. There are groupings of twos, threes, and fours, for variety. Notice that each group is involved in a different action, which adds interest to the scene. One group is hacking from the smoke, the next is cooking over the fire, the next is talking animatedly, and the last (the main couple) is walking and eating. By varying each group's activities, you give your reader a reason to linger on each area, which is what you want as an artist.*

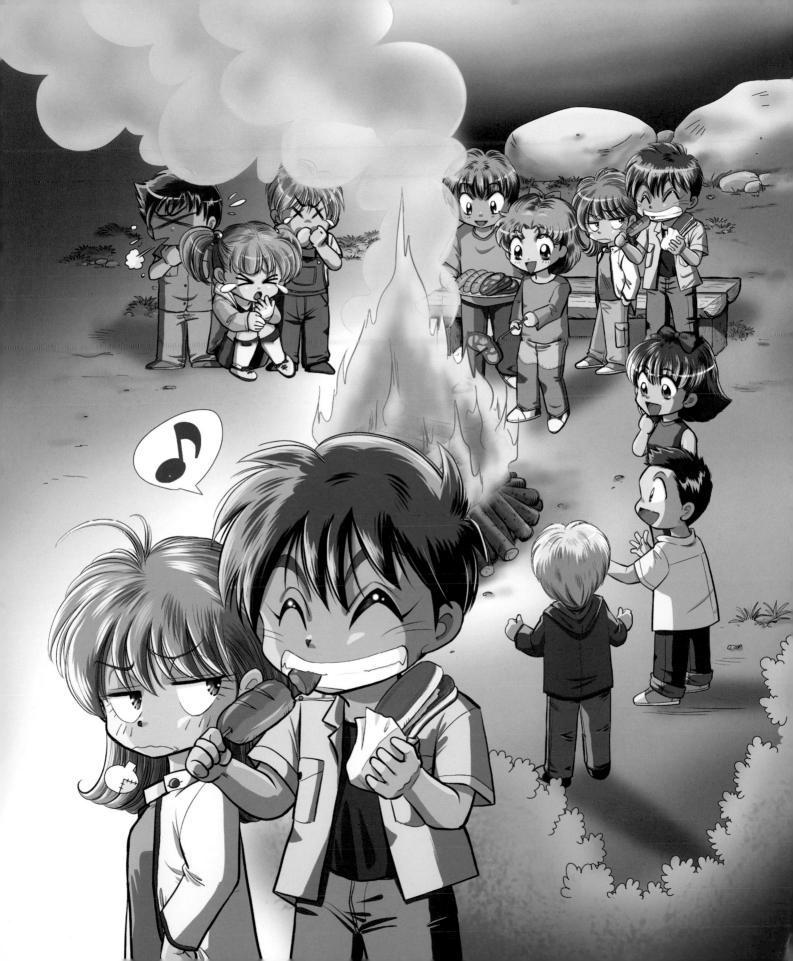

# *Index*